Drawing and
Painting People
A FRESH APPROACH

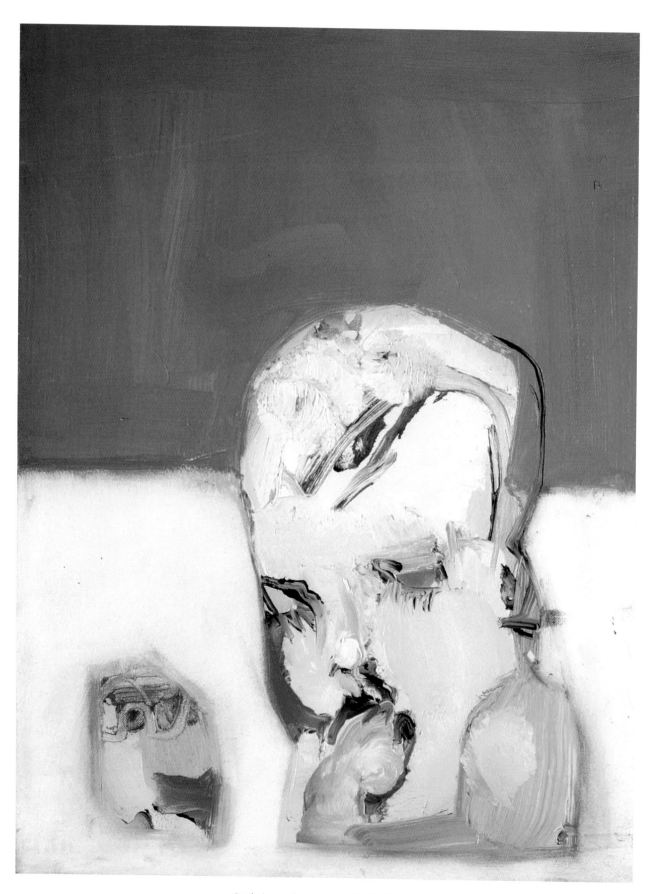

Bathtime, oil on canvas by Emily Ball.

Drawing and Painting People

A FRESH APPROACH

Emily Ball

THE CROWOOD PRESS

First published in 2009 by
The Crowood Press Ltd
Ramsbury, Marlborough
Wiltshire SN8 2HR

www.crowood.com

This impression 2011
© Emily Ball 2009

British Library Cataloguing-in-Publication Data
A catalogue record for this book is available from the British Library.

ISBN 978 1 84797 088 6

Typeset by Simon Loxley

Printed and bound in Times Offset (M) Sdn Bhd

CONTENTS

ACKNOWLEDGEMENTS

This book is dedicated to John Skinner, artist, tutor and friend, for his inspiring teaching and generosity with his experience and passion for painting. He is a fantastic painter who I consider myself privileged to know and work with.

The following people have all also made it possible to write this book: Jane Nash, friend and writer, whose wit and perceptiveness kept me focused on what was important and gave me the confidence to write it in my voice; Gail Elson and Katie Sollohub, who have taught and painted with me for many years – we have shared inspiration, experiences and the highs and lows of being artists together; Katie Sollohub for also being a beautiful model; Georgia Hayes, Roy Oxlade, Rose Wylie and Gary Goodman for their fantastic paintings and wealth of knowledge that they generously shared with me during many conversations; my students, who enthusiastically experiment and take risks with their work and, as a result, encourage and sustain my passion to teach; George Meyrick, who fastidiously and tirelessly photographed all the paintings and drawings; Jeff Hutchinson, who beautifully photographed the artists at work and Katie modelling; Rob Walster at Big Blu Design for his sound advice and feedback about my writing to 'keep it real' – just as I would teach it; Seawhite of Brighton (suppliers of art materials and family-run company from whom I rent my studio), where I paint and teach, for their support, vision and belief in what I do; Mum and Dad (George and Lesley Ball): for positively encouraging me to choose a career that was not financially secure and ordinary: and for generally being lovely; Luke, my wonderful and supportive husband; Will and Eve, my beautiful, bright children – my inspiration and motivation to do extraordinary paintings.

For more information about Emily Ball and her work, visit www.emilyballatseawhite.co.uk and www.emilyball.net.

INTRODUCTION

In 1992 I discovered a well-thumbed, plain blue, slim, hardback book written by artist and teacher John Epstein. I was searching for inspiration in the library and on this occasion found a gem. The essays and illustrations within it were the beginning of my understanding of why I find particular methods of working important to me. They felt like a philosophy grounded in something solid and true to my consciousness about creating paintings, but with many possibilities branching off from it.

This was the beginning of my journey to discover what was important to me as a painter and teacher. I incorporated the idea of working with a combination of sensation and observation into my work whilst doggedly pursuing my passion for painting. I then discovered another very important person. This was John Skinner, an artist and teacher who was based in Dorset. John is mentioned a great deal in this book and I have dedicated it to him as a thank you for his inspiring influence and generosity as an artist, teacher and friend. The experience of being taught first-hand by an artist who is so dynamic and eloquent has made a lasting impression on me as an artist and tutor.

During my career I have had the opportunity to work with many remarkable, single-minded people – students, professional artists, writers and teachers – who have been an inspiration to me. They are included in the list of acknowledgements at the front of this book. Some of them feature in the following chapters to illustrate exercises and to demonstrate some possible outcomes of the suggested ideas. As well as illustrations of my work (and that of some of my students who have generously agreed to its inclusion) and the work of John Skinner, this book includes paintings and drawings by Roy Oxlade, Rose Wylie, Gail Elson, Katie Sollohub, Georgia Hayes and Gary Goodman. All of us have taught or still do teach. Many write as an extension of their creative practice or as a tool for critical debate about their work for lectures and articles. Whatever the order in which these activities are undertaken we all practise what we preach, continually testing our theories and challenging our own preconceptions to extend and develop our work. No resting on laurels amongst this lot!

The Purpose of This Book

This book is not intended to be academic, nor is it one that celebrates the usual craftsmanship or accomplished style that many people aspire to attain. I want my own work to be a true and intuitive response to my subject. I have invented, borrowed, adapted and tested many creative exercises to help clarify and unpack the process of creating personal, beautiful and often challenging paintings and drawings.

In this sense this is not a 'How To' book, but a book that illuminates the way in which some contemporary paintings appear whilst offering some ideas for unpacking the creative process to enable a greater understanding of the possibilities of painting and drawing. If you feel bored or stuck with your work and want to know how to move forward then this book is perfect for you.

This book is about:

- celebrating the best that painting can offer (qualities that are sensual, physical, poetic, beautiful and poignant);
- rigorous, non-fussy, vital painting and drawing;
- getting rid of the 'flab' in your work;
- stripping away the pretentious, arty, slick cleverness; and
- giving confidence and courage to artists and students to take risks.

The purpose of painting and drawing for me is to find out what my experiences of the world around me look and feel like, through a painterly visual language. As an artist paints and draws they discover their subject. Each piece of work requires an intuitive and responsive approach. Creating it is a sensual, practical and visual process: one that challenges your preconceptions and conditioned ideas. The artist embraces this challenge, allowing the work to take them in new directions that they could not have anticipated. In doing so the artist is prepared to take a risk, to leave behind the familiar and welcome the unfamiliar.

From the moment we are born we are responsive and search

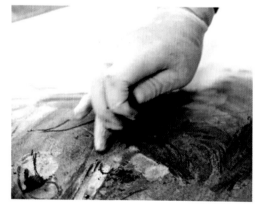

A montage of hands showing
a range of touches.

out ways of stimulating our senses. This enables us to discover the world around us, to invent it to suit our needs and, importantly, we find out about our significance and relationship to that world. This need and desire continues for the rest of our lives. John Epstein's book contains his energetic and direct charcoal figure drawings. The use of the charcoal was searching and gave form to the poise, weight and character of the figure. There are also short essays and one of them in particular has been absorbed into my teaching and philosophy about painting and drawing. It simply states what is obvious, although it is so often under used or even overlooked. It reminds the artist that before any plans or assumptions are made, before any brush is loaded or charcoal is grasped, there is a sensitive and receptive tool

attached to the end of each of our arms. This tool can relate its experience back to the artist and it can influence directly the look and feel of the image beyond what the eye can see and the head can imagine:

> A picture is made up of marks. It is made by hand.
> To understand the mark, the hand must be appreciated.[1]

The hand:

a) is not naturally steady

b) wants to move

c) wants to touch

d) wants to hold

e) wants to dig, to unearth

f) wants to encompass

g) wants to fondle

h) wants to stroke and to rub

i) wants to pull

j) wants to pinch

k) wants to scratch

l) wants to demonstrate its owner's nature in its movement, and it wants to stay in contact with hands of the past

m) when stretched out in front of us, is the furthest part of the body into the world

n) reaches out and draws in

o) is the first to touch others

p) is a divining rod, a blind man's probe

q) will unlock the door.

The significance of the hand, in the context of the practical activity of making a painting or drawing and its contribution to the feel and content of the image, cannot be underestimated. Whilst there are now available to us so many different ways of making images that are efficient and seductive in their effects; it is interesting that the hand still seems so important. The reason for this is that the hand reveals the individuality of its owner, its movement, pressure and sensitivity being inextricably linked to the artist's desires and personality. The drawing or painting will have an integrity and originality of its own revealed through the actions of the hand. For all our sophistication, intellect and technology we are all creatures that respond to and understand the world around us through our senses. The visual sense is obviously one of the essential tools that enable the artist to create images but it is not exclusively the sense that gives the most creative stimulus and information.

'Drawing and Painting are the Same'

This is true but is not recognized by many students. In this book, therefore, I have not positioned drawing as either something you necessarily do as a preparatory piece for a painting or as something you use to plan with or copy from. Drawing and painting will be 'side by side' throughout the chapters that follow. Drawing can:

- be the beginnings of investigating and studying a subject;
- be done in response to an ongoing painting;
- happen during and on a painting; and
- act as a trigger (but it is never going to be helpful if the desire is to copy exactly).

The Chapters

In all of the chapters there are some or all of the following: practical exercises, creative philosophy, an artist's work and their thoughts about the process they go through and my own thoughts gained through both teaching and painting.

- Chapter 1 deals with the visual language of painting and drawing: manipulating it, playing and inventing with it. It introduces the concept of how to combine sensation and observation to create imagery.
- Chapter 2 is a very practical chapter that should take the scary factor out of attempting to draw a human head.
- Chapter 3 focuses on the importance of the gaze and expression of a person. This is a good mix of practical exercises and examples of artists' work.
- Chapter 4 explores ways of responding to the whole figure, its sensuality and movement, clothed and unclothed. It also discusses the relevance of creating direct and vital images that do not copy a fixed, realistic viewpoint.
- Chapter 5 looks at the figure used in a context. The space, setting and treatment of the figure reveal the artist's motivation and interest in their subject.
- Chapter 6 examines the exciting process of creating work in response to the work of another artist to create new contemporary images.
- Chapter 7 uses work from each of the artists featured in the book to revisit the many themes that have been discussed. This gives an opportunity to see how the ideas have been applied and to hear from the artists themselves about how they have tackled the work.
- Chapter 8 concludes the book and prepares you for coping with the ups and downs of working on your own to develop your own philosophy and creative practice.

Truth and Beauty – What is Real

Right from the start of my teaching career I wanted to be a positive, proactive tutor who responds to the needs of the individual rather than teach a particular style. I am interested in finding ways of 'unlocking the door' to a creative space for my students. I provide exercises and watch how, through a simple set of moves, students can find themselves completely engaged and respond to the materials and subject. Finding and maintaining this creative space can be a tricky business. All too often a self-conscious state blots it out, returning the work to something safe and predictable. Teaching, for me, is about giving people confidence. I try to unpack the process of drawing and painting using exercises that contain surprises. My job is to keep

generating new ways of moving forward to prevent my students from getting 'stuck'.

The passage I have quoted from John Epstein, about the hand, remains a very important influence even though for me this teaching was not a 'first-hand' experience. However, John Skinner did have 'first-hand' experience of being taught by John Epstein, and I was curious to know what his teaching had been like and what had made a lasting impression. He emailed me these thoughts:

> It was a strong group with a good rapport. John would often turn up with a handwritten piece of writing and hand out copies. I still have a badly kept one about desperation. 'You only work well when you are desperate...' He occasionally would do a bit of drawing with a coloured felt-tip or biro. He also got people to talk about their ideas and we once had a slide show of things that people wanted to talk about. I remember showing slides of some late Turner studies; he commented that they looked like the inside of the body. He was always making unexpected connections. A few times we had two models working together. He pinned up a print of a Gauguin painting or maybe a Delacroix and told us how much the models reminded him of this image. Another time the models danced together.
>
> He never told us what to do but I think tried to create an atmosphere in which new things could be found. There was no specific instruction as far I can remember. He was very encouraging and sympathetic and liked new ways of working. The classes were calm but intense. I worked on the floor so that I could get close to the model. I used compressed charcoal and chalk and water. I am not sure how long I attended for, possible one or two terms 1980–81, but these sessions allowed me to really get over some barriers and push forward with my work.[2]

You Are an Artist

It is more of a challenge to make students aware of the skills they already possess than to give them new skills. Every person has the ability to create great drawings and paintings if they really want to do so. The most frustrating students to teach are those who do not listen, will not take a risk and do not realize that they have so many of their own resources. Like a parent with their child you want them to become independent, resourceful characters who can go out and do it on their own.

Unless one retains a belief in art's ability to move the viewer and nourish the spirit, then art ceases to be a special kind of activity and becomes humdrum as any desk job.[3]

The Painting *Is* the Idea

Much of what I talk about in the chapters that follow concerns ways of either not copying what is in front of you or not following a pre-planned idea of what you think it should look like. It is sometimes a difficult thing to accept that you can just 'wing it'. Importantly, it needs a shift in our thinking. You are not painting an idea. The painting is the idea. It does not come naturally because we have been used to illustrations and associating a story with an image, to give it meaning, rather than responding to the work purely visually, physically and emotionally.

None of the artists mentioned in this book set out to illustrate an idea that they have about a subject. The painting and the subject become inextricably linked and the artist comes to understand and expand the subject through the painting as it evolves. The artist also specifically creates a visual language to respond to a given subject. The connection and focus is pertinent to the artist and influences the way in which they handle the materials and move in the space of the image.

As an artist I set myself challenges and take risks. As a tutor I encourage my students to do the same. Training and habit seem to impede the process of allowing ourselves a true response to things and our aesthetic censors seem to have very narrow boundaries as to what we perceive to be ugly or beautiful. Refreshingly, though, what I witness frequently in my own work and that of my students is that the best pieces emerge from a procedure of undermining the ordered and 'nice'. Often when there is a struggle or dissatisfaction, or perhaps boredom, with one's work, then to challenge yourself aesthetically is an uncomfortable but effective method of pushing you to a new place. The ingredients that are put together to create work of great beauty and presence can be surprising. The final look belies the struggle, the scraping, dragging battle with the paint that created the finished painting or drawing. The viewer is just caught up in the experience of the subject and the paint.

Suspend Your Judgement

Throughout this book I offer not only practical advice about being more expressive and poetic with your work, but I also unpack the stages through which the work goes. The artists whose work illustrates the book create tough and beautiful

paintings, but they are not necessarily going to appeal to you instantly or be accessible. This applies when you look at your own work. As you experiment and take risks with your work it will be tempting to return the work to something more comfortable and familiar. Sit with it, work a little harder, consider how it makes you feel, let it wash over you, walk away and then come back again. You have to get past the first reaction that might challenge your aesthetic taste. Good taste is a dubious quality. Rose Wylie described it well when she said to me, 'I find good taste, as it's often ignorantly used, very questionable. Usually, it is taste that simply confirms the opinions of the speaker.'[4]

John Skinner also feels that students and the public alike might widen their definition of what a painting could look like and how it can affect the viewer:

> If people want to gain more understanding of painting, they have to work harder at it. Most people like the kind of art they liked when they were thirteen, that dreadful, nostalgic, prepubescent roses-round-the-door stuff. They want the certainty that young children want, whereas adult art is much more sophisticated. As an adult I want to see and produce proper, grown-up art with a full range of meaning. Proper, grown-up painting has layers of meaning – like a Nereid getting in a car. [Illustrated in Chapter 7.] [5]

Close and Personal

I have deliberately referred to the artists by their full name and first name rather than the more conventional and formal procedure of using just their surname. This is because I am not attempting to articulate a contemporary critique of their work, I am instead shedding light on their working practice and their motivations for working. Unconventional paintings require an unconventional way of discussing them. I am also one of them, a painter, not an outsider looking in. I empathize with and share many of their philosophies and passions. The tone of my writing is thus deliberately personal. I want the reader to feel that the artists are sharing their thoughts.

In fact, this whole book is about sharing and inspiring others to paint. I am pleased to be able to celebrate all the work of the contributing artists. This book is also about how fantastic people are: their characters, their generosity, their striving to find beauty and significance in the things that they do and see. Writing this book has made me reflect on these special people and the times that have helped me form my particular methods and reasons for painting. It is interesting that for me the affecting experiences have been the thought-provoking, rigorous exercises and the passion of the people who have taught me, worked with me and inspired me. Their positive energy, and their ability to reinvent, to move forward and – so importantly – to have a sense of humour, have been a great inspiration to me.

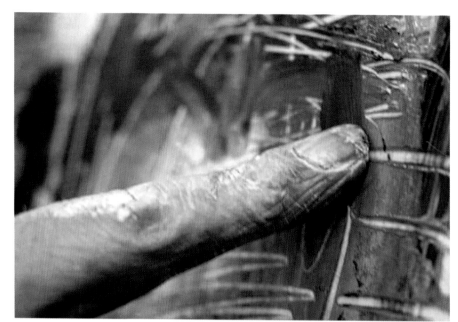
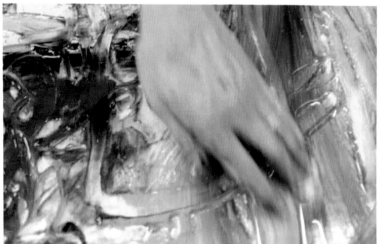

A montage of marks being made.

MARK MAKING – A DICTIONARY OF POSSIBILITIES TO CREATE A VISUAL LANGUAGE

What is the Purpose of a Mark-Making Exercise?

Mark making is an essential tool, without which no work can be created. Creating an exercise around this means that you make marks on a piece of paper, using your chosen materials, not to create an image but with the intention of limbering up hand, eye and brain as you make contact with the tools, materials and sensations. You should seek as much variety as possible in the marks that you make. It is a reminder and refresher for yourself about the activity in which you are preparing to engage; rather like a musician might do their scales or an athlete warm up and gently stretch their muscles in preparation for the task ahead. It is about making a 'dictionary of possibilities' and investigating the versatility of your materials to enable you to create individual and poignant paintings.

All artists desire to be more articulate and inventive as they work. How to avoid those 'stuck' moments is a frequent request of both students that I teach and artists that I work alongside. Mark making offers the possibility to extend and develop your work. Without any subject in mind you are left free to play and focus purely on the language of paint. This freedom encourages you to experiment, take risks, rework things and make visual comparisons. It offers the opportunity to extend your repertoire and address the problem of repeatedly using the same old marks and colours when you work.

As you use your materials you can be conscious of improving the quality, definition and inventiveness of your marks. If you have been inspired by the touch and textures of other artists' work, or the sensation and shape of things from your experience, then this is an opportunity to test them out and see how they feel using your materials. Respond to the marks. Let them guide you and seduce you, and then invent new marks that can become fresh additions to your vocabulary.

What is a Mark?

A mark can be a single blob, line or smudge done in a very simple 'one-hit' action. It can be developed through several moves by repeating the action in layers, in order to emphasize and clarify it. It can have attachments or other types of marks contained or buried within it. These layers and attachments emphasize the character and form of the mark.

Every mark has a direction that leads the eye from one area of the image to another. This direction can also be descriptive of the surface of the subject as it rises, falls, dips, folds or judders; in making the mark the hand travels at a particular speed, which affects the feel and energy of the mark. The quality of a mark also changes depending on the weight behind it, which can involve pressing hard or gently caressing and producing even or fluctuating strokes.

Every mark has a scale in the context of the space of the paper and in comparison to other marks.

Every mark has a surface quality and character given by the consistency of the material that makes it. For example, paint that is applied thickly, straight from the tube, has a sculptural lusciousness. In contrast, thinned paint can have a transparent delicacy. Charcoal that stabs the paper in a staccato fashion will be black and puncture the white space. In contrast, charcoal that has been rubbed evenly onto the surface of the paper, with the hand or rag, and then lifted off gently around the edges with an eraser will create a soft mark that melts into the space of the paper.

Every mark can create a physical response or association, for the artist and viewer, being comparable to a tactile experience or adjective. With this in mind the surface quality can be deliberately manipulated to heighten that experience. (*See* the exercise 'The Touchy-Feely Exercise', specifically dealing with this concept on page 22.)

Every mark has a form. This fact is not always instantly recognizable, particularly in those marks that are simply made or are irregular in shape. Form, in the context of mark making, means that the artist must have a heightened awareness of the shape

and structure of the mark. This requires the artist to be positive with their gesture and application of the materials, and to shape the mark more clearly if necessary. In doing so the mark will acquire more personality and the artist will make a stronger connection to it and use it more effectively.

To help the artist with this idea of every mark having a form, they should remember the following:

- A mark must have a beginning and an end.
- It must start and arrive confidently.
- It must be purposeful, searching and define a space.
- The character of the form is informed by all of the other qualities: direction, scale, surface and 'touchy-feely' association.

If you consider and use to the maximum effect all of these qualities then immediately your work will begin to have a strength and presence it may not have had previously. You will also become more aware of the potential in the visual language you have created.

What does a mark do, what is its job?

- A mark defines a space and leads the eye around the image.
- A mark can be a big gesture encompassing and condensing many qualities of a subject or it can be a small but important contribution to the visual orchestra.
- A mark acts like your sense of touch across a surface. When you are responding to a given subject, for example the head, your mark corresponds to a specific sensation of, say, skin. You are deliberately moving the direction of the mark to follow the rise and fall of the face and manipulating the surface quality of the paint or charcoal to give you a tactile feeling that is true to the subject. You continue to build these sensations on top of each other and then each mark meets and combines with other marks. The image is beginning to form.

The challenge is as the work develops, and the number of marks increase and overlap, the picture surface becomes more complex. So it may help to think of yourself as more of a surgeon or a scientist. You can look at something, dissect it, arrange the elements, and focus and experiment purely with the qualities that interest you.

What makes a good mark?

Quite often the best marks come as a surprise. The creation of a successful and useful mark is governed by the way in which an artist attacks or approaches the task. If you can give yourself permission to play, or perhaps even to produce what you have previously decided are really bad/ugly marks, it gives a psychological release: a feeling of anti-preciousness, a method of testing one's developed aesthetic judgement. As adults our acquired knowledge, expectations, likes and dislikes undermine this engagement with the practical process.

The foreword of Gaston Bachelard's book *Poetic Imagination and Reverie* asserts that the distinction between good and bad is of no value: 'Good taste is an acquired censorship'. The colours and marks that may not be in 'good taste', as you experiment and search, may feel out of character for you to make. This can be just the shock to the system that is required to refresh and extend your vocabulary, which is very important to remember when grappling with a new language of marks. Our aesthetic likes and dislikes can hold back the progress and value of the work. 'Taste' is a fickle thing and often hides the true desire and meaning of the work.

Is it beyond redemption? Or could it be 'crap into gold'?[7]

Many of the freshest ideas, innovations and most exciting work come out of those desperate moments when all seems lost and the artist has to change and relinquish areas of the painting in order to salvage the work. Things get interesting when you consider them to be 'crap': there is nothing to lose and anti-preciousness becomes a releasing ingredient. In order to salvage it you have to be positive, inventive, clear and dynamic, and more often than not the end result is better than all the previous ones. The artist has to respond, invent and let go of preconceived ideas.

With this in mind I always encourage my students to keep all their work for at least a year before they 'file' any of it in the bin. With my own work I often find that the pieces I dismissed as weird or a mess at the time of their creation often have exciting elements that I pick up on and develop at a later date. I was just not ready to see it at the time because it did not fit with my idea of what I thought it should be like.

Developing the accidental can greatly assist with this process. This involves noticing qualities that have come about through intentional, or random, layering. These qualities are then extended and repeated further. The original mark may grow, by absorbing other marks into it or by being given additional insertions or attachments. The surface texture, for instance, may be the predominant characteristic that you wish to exaggerate. It is up to you to recognize something and develop it to see how it feels.

If you never push this far you never move forward and it does not take long before you become 'stuck in a rut'. It is hard! This

is where many artists give up and lose courage. If we can undermine the lazy, comfortable option and instead find a new sensation with the marks then the reward is a continual reinvention of our work.

What is Mark Making Not About?

The most common causes of ineffective mark making are:

Always using lines. This is a common rut into which it is easy to fall; many students are wedded to using lines. A line is a fantastically versatile mark but if you insist on using it exclusively then ensure the qualities of the line are rich and varied (in terms of their thickness, direction, length, straightness or speed of application).

Having all your marks travelling in the same direction. This is another common habit that can make for a very bland, repetitive feel to the work.

Doing lots of swishy figure-of-eight movements. This is part of the previous pitfall but also leads to a tendency to create patterns and thin, half-hearted inventions.

Doing what you already know about. Try working in a way that feels uncomfortable and unfamiliar. Challenge and build on what you know.

Filling in. This is something children are taught to do at school. Going over the edges seems to be frowned upon or considered sloppy. Leave your brain in your pencil case on the desk and try filling in this way! If you have decided that a space needs to have a large amount of a colour or indeed that a form needs to be solid then you need to consider the following:

- Spaces should have as much form as objects.
- Forms and objects have surfaces that change in direction and quality.
- When you wish to cover an area with colour spread the material in a way that explores the space directionally, to give it form.
- Consider the density of the material, whether or not you wish it to be totally flat, with no marks at all, or rubbed and uneven, or built up with lots of marks that flicker and give movement and energy to the image.
- When spreading colour or tone through a space remember that the space defines the forms/objects.

Consideration of these qualities enables a contribution to the work that is much more informative to the subject and helps create a more exciting physical surface. Rather than just neatly filling in up to an outline it is interesting to nibble into the shape and redefine it, for example. This then creates fantastic junctions: colour meeting colour, edges meeting edges. Overlap areas of space and form and then redefine one area against another. This is much more visually rewarding and contributes to the overall feel of the work, unlike the tidying up option.

Avoiding overlapping and connecting marks together. Students often treat mark making like doing a textile sample sheet and lay out the individual marks in isolated spaces. Although there may be some visual virtues to this arrangement the way in which marks overlap and jar against each other can bring them to life in another, very different way. This is not an action that seems to come naturally to our ordered way of going about things, so it is important to be intentional about this in order to gain the maximum possibilities from your ingredients.

Leaving marks to trail off. This is the visual equivalent of losing the thread of what you are saying, mid-sentence. It is also common to fall into creating a charcoal line or brush mark with a flippant flick at the end, like a horse's tail.

Scrubbing. This is a panicky reaction to an area that has 'gone wrong'. This type of obliteration generally leads to sludge-coloured piles of porridge-like paint, both on the work and the palette (although it may be a 'crap into gold' situation that can be celebrated and developed). When scraping off, or rubbing an area with a rag, make it travel in a direction that contributes to the image and form. Be thorough and clear when changing or removing an area; do not change your mind halfway through the process. Decide to make a change. Do it. And then stand back and review whether or not it has helped.

Repeating yourself. Repetition does not stimulate you to create new marks. Instead it can lead to pattern making. This is not to say that pattern as a visual tool is not valid and effective, but in the context of developing a visual dictionary it can lead to a state of self-hypnosis and sameness.

Rules are made to be broken!

I know that the rebellious child in us all will now want to deliberately do what I have said to avoid. In fact, in researching and compiling this book my students challenged me when I gave them the list of suggested things to refrain from doing. So I asked them to do a really 'bad' piece of mark making: full of filling in, swishy marks, repetition and generally anything that

**A conversation between marks by Gail Elson
(oil paint on paper).**

felt really naff and irreverent. They did a fantastic job! The pieces of work looked great – although not because they had specifically chosen to do the 'wrong' mark making but because they had done them 'positively badly'. The intention was clear, so the resulting work carried itself well because of it.

So many fellow artists have confessed to rather enjoying 'filling in', but there is a big difference in impact from marks that are done tentatively, without purpose and investigation, and those that are carried out with confidence, courage and direction.

In summary: play, surprise yourself and be clear.

A Conversation Between Marks

A practical mark-making exercise that is extremely helpful for encouraging invention and versatility is creating a 'conversation'. This is an exercise I created to fill a gap in my students' understanding about the importance of making marks overlap each other. Students are often nervous, and not naturally inclined, to create dynamic little clusters of information. I took the structure of the following exercise from a painting I had seen by artist Fiona Rae. She had created nine little abstract paintings; each one was constructed of nine marks or moves. She is quoted as saying she wanted her paintings 'to have an unsettling quality, as though they were about to fall apart'.[8] She achieved this by making each application of paint with the brush touch, attach, dissect or squash the previous marks.

Why is this so important? By combining marks in this way you are instantly making forms; you are inventing new shapes, textures and colours simply from the effect of taking one area of paint through another. By slicing through a shape and floating marks over the top you are also overlapping different viewpoints and sensations of space. An artist has to be completely engaged and must watch what happens at every stage, so they can grab opportunities and respond intuitively to each mark.

Very importantly, this process also undermines our inclination to seek patterns, symmetry and order. Always *planning ahead* means that you miss opportunities. *Improvisation* stimulates the artist to invent, select and challenge their habits and preconceived ideas.

Selection Through Editing

The process of editing can be fun and liberating but it can also require a steely nerve on occasion. When you have had the opportunity to create a page of random marks as a warm-up you can then take the exercise a stage further. By the time you have finished experimenting and playing with marks the page

Exercise 1. The 'Conversation' Exercise

YOU WILL NEED:

- an A1 piece of paper
- selected paint or oil sticks
- brushes, rags, fingers or whatever is necessary to be inventive.

TO BEGIN

- Make your first mark on the left-hand or right-hand side in the top third of the paper. The intention is to end up with six clusters of marks, spaced relatively evenly over the whole page.
- Before you make the second mark, consider the quality of the one you have just made. Is it fluffy, heavy, luscious, thin and so on? Look at the direction in which it moves.
- Now make the next mark contradict the first in its physical character and direction, and also make it attach, overlap, dissect or insert into the first mark.
- Add three more marks, each time considering the above process.
- That conversation is finished: you are ready to move to the next one.

TO PROCEED

- Repeat the process above using a different set of marks, each time really pushing the idea of making the marks seem to move on from having a conversation to having an argument. Aim for the sensation of doing it and for the final result to be uncomfortable, contradictory and give an impression that it is about to fall apart.

TO FINISH

- When you have finished all six clusters then assess their success in relation to each other. Which feels more exciting and unexpected in its arrangement? Which seem to be lacking in punch and invention? The artist's eyes should be equivalent to the wine taster's sense of taste. They must be tuned in to see the subtleties of colour, surface and position.
- Those conversations that look weak compared to successful ones should be revisited and reworked.
- Do not rub out areas. Instead strengthen the less confident marks. Literally repeat them on top of the old mark. Perhaps even change the colour of the original mark. The artist must use the visual qualities and arrange them in an order that intensifies the experience.

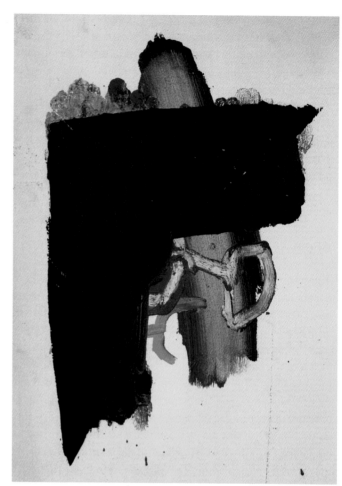

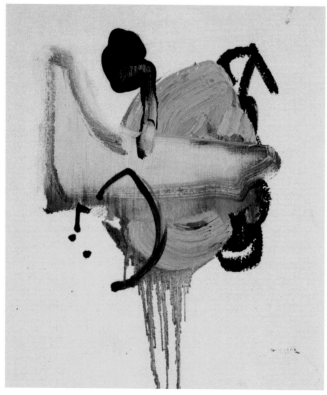

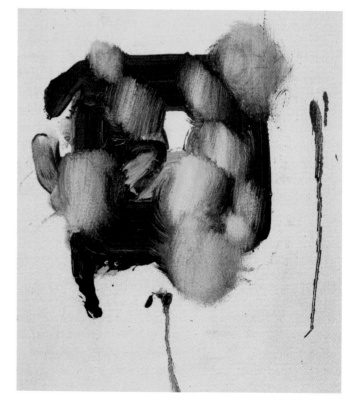

ABOVE AND OPPOSITE: **Conversation pieces (oil paint on paper).**

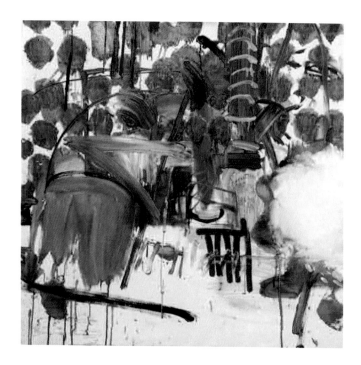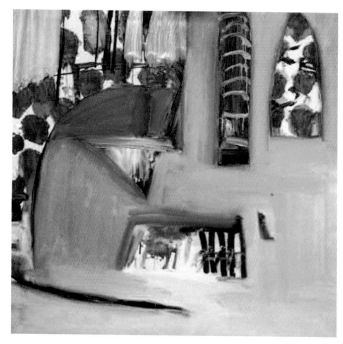

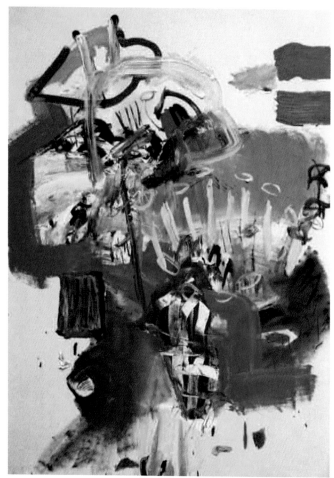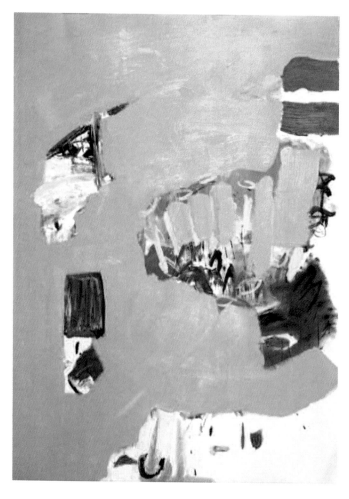

Edited mark making: before and after (oil paint on paper).
Top images by Janet Branscombe, bottom images by Gail Elson.

generally looks chaotic. Marks are often buried or changed many times over. Areas of the work will have become very congested. The process of editing is about selecting only the best, the most interesting marks, and eliminating the rest. This will exercise your ability to make judgements about which marks you feel are worth keeping and which feel over-familiar, without enough character. What are you about to do is an excellent example of 'anti-preciousness'.

Mix a large amount of a good colour. Your choice of colour is important: it will create a mood and also, if successfully chosen, it can lift and animate the colours that exist from the original mark making. With this colour, paint out everything except those marks that you felt had some value above the others. It is important to edit thoroughly and smoothly, paying attention to the clarity of the edges (where the colour meets the edge of the mark). This could stay as an edited piece of mark making or you can continue the process and after editing proceed to work and extend the original marks again into the edited space and colour.

Editing is a powerful tool. It is used to de-clutter and refocus a painting. This gives the artist the opportunity to force a radical change but in a way that helps to unify the whole image and creates a composition within the space of the paper or canvas. It has been used on more than one occasion during the process of creating many of the paintings illustrated in this book.

A Visual Portmanteau

Marks are an invented visual vocabulary in response to a particular sensation and experience of a subject, both observed and felt. The arrangement and layering of marks have the potential to bring back the sensation of the subject in a condensed way. They can give form to something that only existed as a feeling or a sensation. So you can set out knowing what it feels like but until you paint it you do not know what the feeling looks like.

Often serendipity is helpful when we are struggling with splashing paint around. As if by magic bits of paint slide, drip and splodge, and sometimes their arrangement seems to miraculously suggest a quality that we have been searching for but have not known how to create deliberately. However, this does not have to happen by chance or desperation each time, but often by intentional process. This process began in the previous 'conversation' exercise, where you can use the overlapping, slicing and contradiction of marks to generate new combinations and forms.

A further development of this is to apply it to a specific subject and create a visual portmanteau. This has similarities with the literary process. In writing, a portmanteau is an invented word combining the sounds and meanings of two others. There

are lovely examples of this in Lewis Carroll's *Alice in Wonderland* in the 'Jabberwocky' poem:

> 'Twas brillig and the slithy toves did gyre and gimble in the wabe.
> All mimsy were the borogoves and the mome raths outgrabe.[9]

The term 'slithy' has come from combining the words lithe and slimy, 'gyre' is to go round and round like a gyroscope and 'mimsy' is a combination of flimsy and miserable. The portmanteau thus invents a form and image for a sensation that otherwise would have no visual or literary translation. The marriage of words, sounds and rhythms in this way gives the reader an overall sensation and mood. It has its own meaning. The atmosphere and forms wash over you and you understand it on its own terms.

A visual portmanteau can offer the artist and the viewer access to a sensation as opposed to an illustration. It enables the artist and viewer to experience the subject more richly and intensely through the *invented painterly language*. Once a piece of work is begun in this way then it inspires the artist to continue exploring the subject in a more positive and inventive way.

A Sense of Touch

Students often refer to being nervous and anxious about 'making a mess' or dealing with the chaos of marks on a picture surface. Yet if I give them paper or cardboard to cut and stick they are absorbed, focused and having a lovely time. Like being a child again. When I watch my own very young children painting, drawing and building I am always struck by how single-minded they are and how completely they are caught up in the moment. They make no damning judgement as they are going along about whether or not what they are doing has any value to anyone else. They purely engage in the activity. They use their whole body, exploring with their fingers, touching and developing a physical awareness that is essential to their understanding of the world around them.

For you as an artist, using sensations to inform your response to things is essential to developing a successful and pertinent language in painting and drawing. It can be combined with observation to powerful effect, enhancing an image and bringing back the sensation with greater intensity. I find this a very exciting and powerful ingredient in the development of a piece of work as, quite literally, at our fingertips we have information that can be used to stimulate and extend the physical qualities of a painting and drawing. If we utilize this, the work acquires a presence and depth that goes beyond illustration. For many of

Exercise 2. The Touchy-Feely Exercise: Applying and Practising the Visual Portmanteau

This exercise provides an opportunity for exploring how to apply specific marks to a particular sensation. I have used it as a very effective 'ice-breaker' at the beginning of a day's drawing. (It is helpful if it follows on from the free mark-making exercise so that everyone is already feeling limbered up and versatile). The idea is very simple and is a little similar to the children's game of identifying something by touch whilst blindfolded.

YOU WILL NEED:
- A1 cartridge paper
- charcoal
- a rubber
- rags
- soft pencils
- white chalk
- black chalk
- masking tape
- plastic bags or jiffy bags.

Also gather together a variety of objects with good tactile qualities. For example:

- feathers or perhaps a feather Boa
- dried flowers (not too delicate, but the spiky, papery qualities are interesting)
- a small toy (such as a dinky car or lego)
- a stone (such as a flint, a weather-worn stone from the beach or even a fossil).

Keep each object hidden in its own plastic bag – the element of surprise temporarily stops students trying to plan ahead, or anticipate what their work is going to look like. A student is handed a mystery bag and they have to plunge their hand inside to feel the object. They should then draw their response to the sensation of touching the object (not what they imagine the object looks like). They should create a rich vocabulary of marks that correspond to the tactile qualities of the subject – such as cold, furry, sticky, smooth and so on.

TO BEGIN
- Do not try and guess what the object is. It will not help you do a better drawing, in fact quite the contrary.
- Keep your eyes closed as you explore the object with the tips of your fingers. This enables you to be more attentive to the subtleties of the sensations and not distracted by visual clutter around you.
- Hold the object in the palm of hand, squeeze it, turn it, feel the change of temperature. Is it hard, soft, sharp, bumpy or smooth, or even a combination of some of these things? How heavy is it?
- Keep your eyes closed and start to draw.

TO PROCEED
- Keep turning the object in your hand as you draw, so that there is no fixed viewpoint and you are constantly travelling over it and returning to areas several times over.
- Only draw one sensation at a time.
- With your eyes still closed, layer one sensation on top of another. Do not worry about whether or not parts of the drawing are in the right place or going off the edge of the paper, this all makes for a more interesting drawing.
- With eyes closed students often draw more tentatively, with a lack of commitment in case they 'get it wrong'. Try to compensate for this and create greater contrast with your touch on the paper. Move your whole arm, work into the paper and change the pressure of your hand, pressing harder or softer. It also helps to remember to change the direction and scale of your mark.

TO FINISH
- After a few minutes of working in this way, open your eyes and look at the drawing and the object.
- Has the drawing captured the sensation? How does the drawing and the experience affect the way you see the object?
- It is useful to repeat this exercise holding a completely different object. The new physical qualities can be compared by your fingers and in the drawing. It will test your versatility and whether or not you can create the new language of marks necessary to respond to an unfamiliar subject.
- If other people are drawing the same object it is fascinating to see how their touch differs from your own. How does their selection and journey affect the marks and form? How do their drawings feel? Do you recognize and connect with the marks they have made?
- Try another drawing with your eyes closed and then continue developing the drawing with your eyes open. Do not try and tidy up the drawing, instead develop the marks and layering to clarify the image.

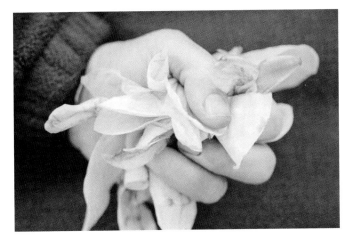
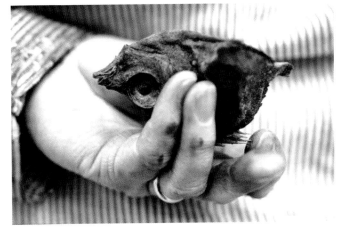

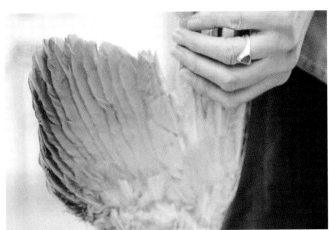

Looking with your fingers.

my students this is the greatest revelation, and they soon find that combined with observation it means that they can refresh their work, extending and sometimes even dispensing with traditional methods. (Methods that I find can lead to rather an antiseptic approach to learning and creating.)

What are the virtues of looking with your fingers?

Using touch as a method of extracting information about a subject undermines our assumptions. When drawing and painting any subject many artists and students rely almost exclusively on what they think it looks like. It is easy to generalize about the shape and feeling of it, and often the feeling of it never comes into the work. How something appears, however, is not always how it is. Looks are deceptive. To combine observation with sensation bridges this huge gap in our knowledge and understanding. The information gained is not superficial; it

is a personal investigation and selection. By touching the subject you are also gaining a personal viewpoint and individual experience that will inform the image.

Even if it is not possible to actually touch a subject, either because it is too far away or just not allowed, it is possible to imagine the sensation and to focus on the physical qualities. Although the work that results does not look like a copy of the object it can stand alone as a powerful image that evokes the experience of the subject with more intensity and interest. It can make you want to return to a subject again and again, and it makes it possible to paint it and know that each work will look different from the last.

The drawing or painting becomes a process of layering the different experiences as you feel them over the top of each other and linking, to create a form. It is an accumulation of experience that combines together to make one image.

The exercise demonstrates how one can create a visual portmanteau applied to a specific subject. This can also be applied to all motifs in a painting or drawing and I will discuss

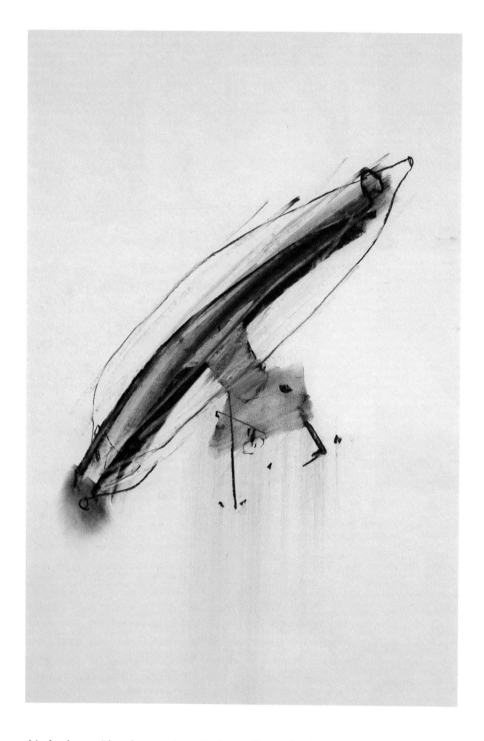

Drawings by touch: a lego toy (left) and (opposite) a feather boa.

this further, with reference to artists' specific works, later in the book.

By investigating a subject closely, as a physical and emotional experience, there is the potential to make new connections: to extend the subject with metaphors, to reinvent the familiar. The familiar saying that we often 'draw what we think it looks like not what it really looks like' can be found to be true when you realize all the fantastic information from a subject we have missed by just looking and copying from it. The ordinary and everyday become fantastic as a source for imagery – not only that, but the artist has the facility to continually reinvent them.

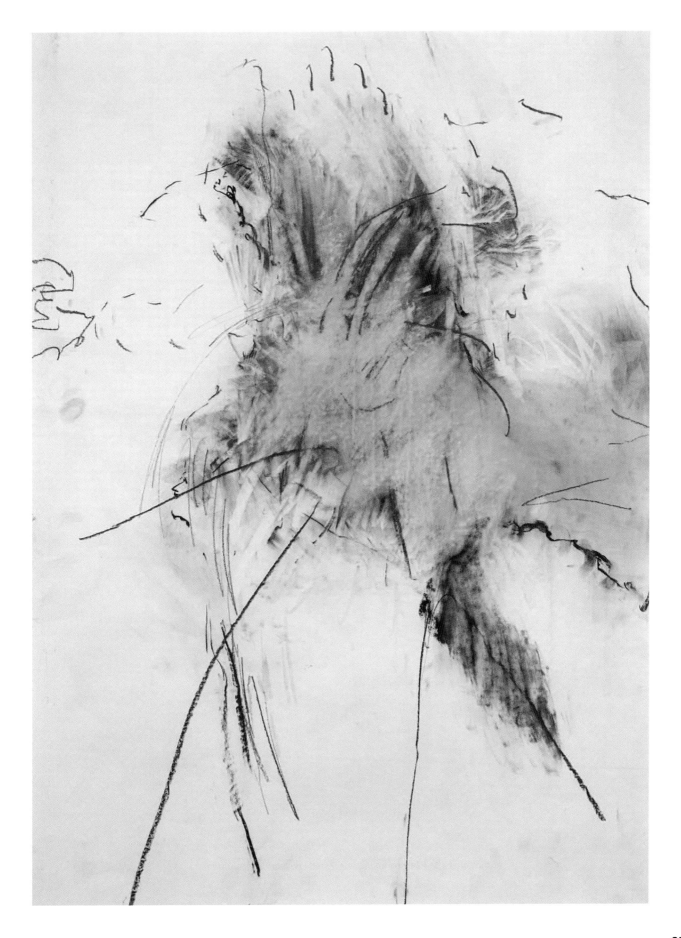

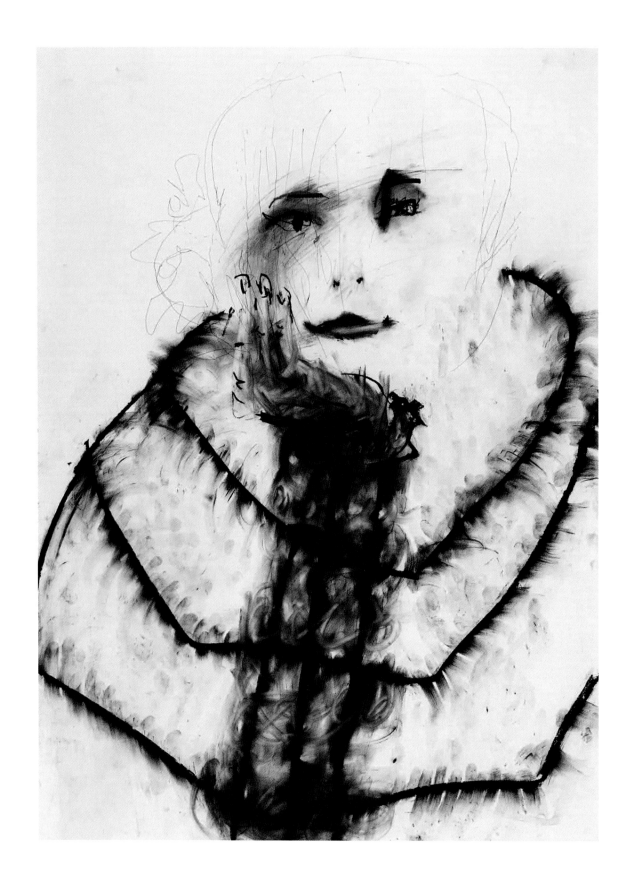

Amy **by Janet Branscombe (compressed chalk and felt-tip pen).**

DRAWING AND PAINTING THE HEAD

By entitling this chapter 'Drawing and Painting the Head' I have perhaps made it sound very impersonal. I deliberately chose not to refer to it as portraiture because, in the context of my teaching, this has always had the wrong associations for me. My reasons for giving it a very impersonal title are to allow a new view of the subject to be possible and for you to have a more personal relationship with your work, as opposed to making a copy of the way you think a person looks. The methods and approach that I suggest have the potential to release you from a conventional process and staid idea of creating a portrait. As a result you will learn to know your subject in a tangible way, learn things you did not know and better still your work will give you some surprises.

The methods of working that I discuss in this chapter remove the apprehension and fear of drawing and painting faces that many students have. There is no doubt that it is a challenge to create images of the head but really it should be approached with no more trepidation than any other subject. I also like the fact that referring to 'the head' means that immediately the sculptural form of the whole head has to be considered and included, not just the face and features. Some of the illustrations give practical 'how to do it' examples, others give the finished results created by students and artists. The approaches offered are applicable to working directly from first-hand experience (knowing the models and drawing directly from them), but there is also reference later in the chapter to working from second-hand images such as photographs and artefacts.

I talk a great deal about working with charcoal as opposed to pencils and pens, not because these are not perfectly good materials but because for the benefit of this chapter I want to encourage an approach that is more tactile and painterly. Charcoal can be applied quickly, with a sense of urgency, and moved and manipulated easily, making it possible to respond directly to the whole head.

Painting the Head

Although there are many exercises in this chapter that are specific to drawing the head, the link between drawing and panting is closer than many students realize. The versatile and evocative qualities of charcoal correspond directly to those of paint: the physical action/direction of the marks and the tactile sensations that the surface qualities give back are shared between the two mediums. The real difference is that one is dry and the other wet and/or sticky.

Ink shares both qualities. I will give examples of ways in which this material can be helpful to bridge the gap in our understanding of how to link drawing and painting together. By slowing down and unpacking the process of applying the materials it gives us time to appreciate the potential of the medium's ability to slide, puddle, drip and mix on the canvas or paper to give new marks. Rather than regarding the results as a dreaded, mushy mess that needs to be tidied it becomes possible to see how the marks can be combined and used to describe the sensation and physical presence of the subject.

By the end of this chapter, after trying the exercises in it, you will see why it is important to make your paintings more like your drawings and then return the favour by making your drawings more like your paintings, in order to allow the work to go beyond the predictable. Nothing of interest really begins to take place unless this is taken on board. It is a very different mental and physical engagement, one that makes the artist more conscious, sensitized to the potential of the subject and the process.

The Drawing Gym

There was an occasion when I was teaching a 'Drawing the Head' course when, reflecting on what it should feel like to do a drawing, I described it as bungee jumping with charcoal. I have never been bungee jumping but I can imagine the sensation of adrenalin, anticipation and terror. Drawing should not

Exercise 3. Exploring the Head: Self-Portrait with No Mirror

 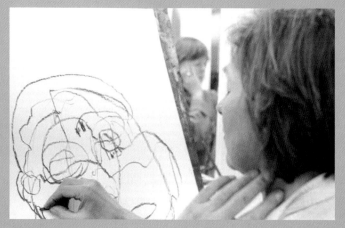

Self-portrait by touch: in progress.

This exercise is a great introduction to working from the head. You are your own model, readily available all the time. You will be able to appreciate and understand what cannot always be seen from a fixed viewpoint. For this drawing you will need your confident line and particularity because you will be creating a drawing only from the sensations you pick up through your fingers as they travel across your whole head. It is not about reproducing an image of what you think you look like. If you concentrate exclusively on what can be observed it only gives part of the story. You are adding experience, sensation and a layering of time to the work by doing this.

YOU WILL NEED:

- a piece of paper
- a stick of charcoal
- a rubber
- a rag
- a sensitive touch.

TO BEGIN

- This exercise could take between 5 and 15 minutes to do, depending on your level of concentration and how fast you draw.
- Once again, I feel that it is better to start this drawing with your eyes closed to help with concentration and to allow the drawing to go where it wants.
- You will be feeling your face using the tips of your fingers and the whole hand whilst simultaneously drawing the sensation you are feeling.
- Start at the tip of your nose and let your hand that is not drawing touch and travel around the shape and surface.
 You can retrace your moves to give yourself time to make a drawn response and to understand the shape and feel. Simultaneously your charcoal should be moving across the paper, corresponding to the moves and changing surface sensations that your fingers are picking up. Make the charcoal marks correspond with the rise and fall of your fingertips across your head.
- Never allow your fingers to lose contact with your head or your

charcoal to lose contact with the paper. When you have explored one area then get your fingertips to travel to the next area of the head, all the time recording your sensations in the drawing.

- The most common weaknesses in these drawings always arise from not applying enough pressure to the marks. Just because it is not possible to see what you are drawing does not mean that the marks should be tentative, thin and fluffy.

TO PROCEED

- Work slowly and steadily so that you can keep up with the changing sensations and also give yourself time to develop the right mark. Be aware of the pressure with which you draw. Some areas will require a very delicate touch, it may feel right to draw other areas in a broad and robust way.
- For the purpose of this exercise avoid drawing an outline to give clichéd almond-shaped eyes. Instead travel across and over the lid, lashes and eyeball with the intention of exploring the way the eye sits in the head, how the eyelid opens and closes and how all the details sit together to create a gaze.
- Treat the surface of the face like the terrain of a landscape.
- Return to a feature several times if it interests you or you want more information.
- Your hand needs to travel over the whole head, not just the face and features. The drawing will have more sculptural qualities, form and character if you have explored the top, sides and back of the head too.
- Be aware of changes of surface and how you will represent them: soft skin, hard bone, ledges, dents, hair, and smooth, tight or soft contours and so on.
- Travel down the face and under the chin so that your drawing does not stop at the jaw line.

TO FINISH

- Once you feel that you have finished, open your eyes and look at your masterpiece. Study the kind of mark making you have created as a result of working by touch not observation.

You can do as many of these as you wish. You might try variations such as doing it using both right and left hands in turn and can then compare the feel of the two images created by different hands.

be relaxing, therapeutic or cathartic – it is a demanding, physical and mental process. Perhaps it is an artist's equivalent to that adrenalin rush of leaping off a bridge attached only by a piece of elastic!

To flex your muscles and feel prepared to face the fear you only need a piece of charcoal, a rubber, a rag and a large piece of cartridge paper.

A confident use of line

Line is the most favoured mark when drawing. If it is the only type of mark to be used then it has got to do an awful lot of work to be expressive and responsive to a subject. A lazy line, lacking in any particularity will do you no favours. You need to give your line a workout:

- Start drawing a line with your charcoal and, as you start, vary the pressure as you push the line across the paper. Perhaps start from a thread and gradually make it thicker, blacker and chunkier.
- Change the direction of each line and the speed at which it is created.
- Differ the character of each line – perhaps from wiggly, knotted and soft to straight, dynamic and sharp.

Surface sensations

- On top of the sheet of confident lines you can now randomly insert and overlap improvised mark making.
- The placing and character of the marks can contradict, block and pin down the lines beneath them.
- Some of the marks can be complex, others could be as simple as just a rubbed-out area.
- Some marks could sit snugly between the lines, others could bounce and leap out of the page.
- When you do any drawing from now on you need to be this direct, clear and playful with its arrangement.

Challenging assumptions

Can you remember being taught at school, or college, to start drawing a head by drawing an oval or egg shape? Since when does anyone have a head the shape of an egg? This takes into consideration nothing about what the head is really like. It can have hair, for a start! The irregularity of a person's silhouette can contain a remarkable likeness without the need to put any features or details anywhere near it.

I have asked students to do a very quick exercise to prove this

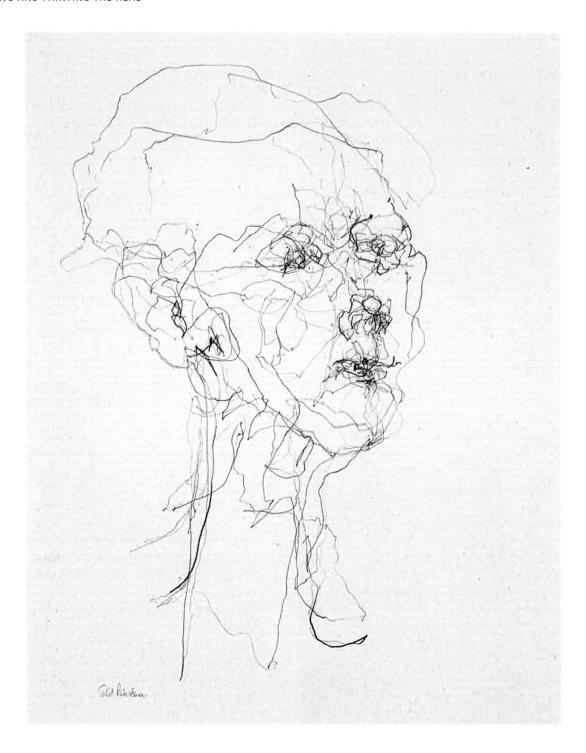

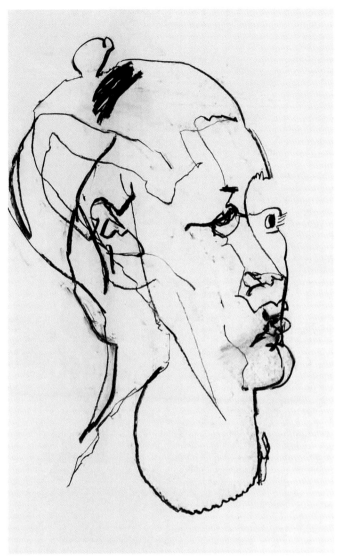

ABOVE AND OPPOSITE: **Drawings using a single travelling line.**
(Opposite image by Juliet Robertson; above by Emily Ball.)

point. It requires nothing other than a large piece of paper to show them that the shape of a person's head is not a stylized idea but a fantastic opportunity to find a shape that is unique to the sitter. All you do is stand opposite someone and observe carefully. They may choose to turn their head, giving you more or less of a profile or full face. They may decide to tilt their head too, or keep it straight. Whilst looking carefully, tear out the silhouette of their head and shoulders (using as much of the whole sheet of A1 paper as you can). If there is a group of you doing this exercise it is a good to put these up on the wall and see if you can recognize each person's silhouette. I find that ripping the paper is preferential to cutting as the quality of the line is more like a drawn line and the reduced control of tearing increases the character of the shape. No more eggs please!

Imagine you are an ant

After you have experimented with confident lines and completed a self-portrait by touch the experiences will have given you the facility to create a virtual, tactile journey when observing someone else's head. Your charcoal becomes both the drawing tool and the fingertips touching and picking up information. Imagine that you are an ant running across the surface of an undulating terrain of skin and hair. Your drawing is the trace of that journey. You are taking a line for a walk. A walk that follows and echoes the changes in direction, both the hard, resisting surface where bone is close to the skin or the mobile, soft, flexible sensation of skin, flesh and muscle. Your drawing is evidence of this investigation. The route you take is not one that has been conveniently mapped out for you; the journey will be more fruitful for the drawing if it is unexpected and random. This means avoiding as much as possible drawing around the edges of the focal points in the head and instead making the journey to find them as important as arriving there. Weave your way across and over forms to investigate thoroughly the different sensations of the features before you are satisfied to move on.

- This drawing needs to be done at a steady pace; not too fast, otherwise the marks will be rushed and vague, but not so slowly that the energy of the drawing suffers and you lose interest.
- If the charcoal is not lifted off the paper for the duration of the whole drawing then all areas of the head link together and overlap to create the form of the head.
- I would also recommend not looking at the paper. Even at the risk of the drawing spilling off the edge in places.
- As you draw it makes you notice the little things. You might want to investigate an area more than once. This will not only accent the drawing but also help your understanding of the subject.
- I also sometimes suggest that you start at the tip of the nose, the part of the face that projects furthest out into the space beyond the head. This means that you are starting from within the face and makes it harder for you to draw an outline around the jaw as your starting point.

Charcoal Dust Drawings

This method of drawing is a great way of getting rid of feelings of preciousness or fear at the prospect of making a mark on the pristine white surface of the paper. The crushed charcoal that is used to start the drawings makes the process adopt a tactile, three-dimensional quality. The contact that your hands will have with the materials and the paper are as though you are

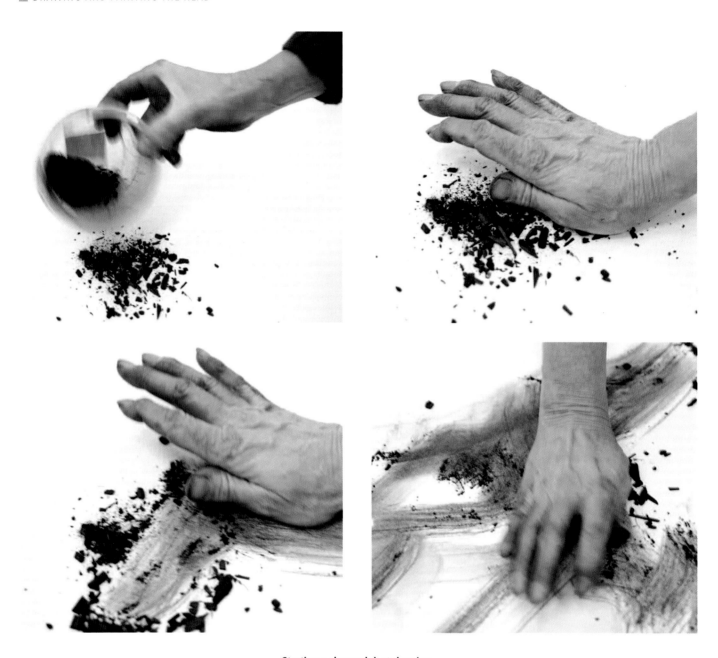

Starting a charcoal dust drawing.

touching and holding the head in your hands; this is a two-dimensional version of pulling and pushing a piece of clay or plasticine.

- Crush the contents of a box of charcoal and throw in a couple of coloured chalk pastels. Bash it up in a bag (by standing on it or using the bottom of a sturdy container to crush the contents). You don't have to be too brutal and energetic about it, though! It is best to have a certain amount of fine dust but it is also very beneficial to have some bigger splinters and chips to add texture and interest to the drawing. You can store the crushed charcoal in a pot for use on other drawings in the future.

- It will be necessary to start this drawing by working flat on the table or floor to prevent the dust just falling on the floor or easel ledge.
- Once again, follow the principle of drawing your own head by touch to maximize the sculptural opportunities and your understanding of the shape of the head.
- Work quickly, and only for a few seconds, at pushing and pulling the charcoal dust, with the bottom of the palm of your hand, into and across the shape of the head.
- If you overwork it at this stage you will just end up with dense, grey smudge. It is helpful to have some areas that judder or scatter with scrapings of charcoal as well as the areas where you may have pressed more heavily.

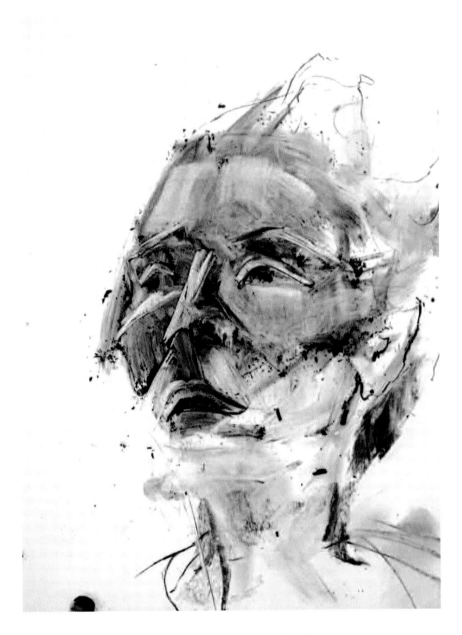

Drawing in progress by Jane Aylott.

- After a few seconds stop the smudging process and shake off the excess dust (into a pot to use another time).
- Now draw the features amongst the smudges with a stick of charcoal. Do not feel tied by the position and proportions of the original smudge; it is there as a trigger as well as the first layer of the drawing.
- Now you can work with a rubber and the piece of charcoal to clarify the form and shape of the head and the features.
- The whole image has evolved from smudging, adding, changing, reducing, enlarging, rubbing away and redrawing, so this process can continue in any order until it feels resolved.

The Equivalent in Paint

Charcoal drawings are very immediate and direct; it is a quick, seductive process providing a trigger for the paintings to follow. With a few scalpel-like lines, a smudge here and there, and a detail there, a feeling of form and of the subject might appear. It is the same in paint. Well, everything except for the speed at which a successful painting can appear. It is possible to do a quick painting but it is more likely that it will take a long time; there are usually many layers and much scraping off, moving and reworking before the image appears as a painted equivalent to the feel of the drawing. However, many of the actions are just the same as with charcoal drawing. The directional marks

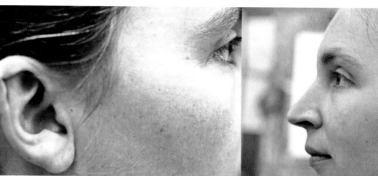

Moving around the model.

follow the form and create areas in which to put the features. The paint can be rubbed back, and fresh paint can be applied and changed and layered again, wet on wet, wet on dry, again and again until the image appears.

Nevertheless, paint has extra virtues that charcoal cannot replicate. Its thick stickiness and sliding mutability means that it can be more elusive but also more versatile. If you are not alert to what is happening at all times the possibilities can, quite literally, slip through your fingers; but equally they can give back an extraordinary connection to the subject that is physical and poetic.

My two paintings called *TV Mother Hug I & II* illustrated in Chapter 6 (pages 108 –109) show pairs of heads that have been work and re-worked over a period of months before I was satisfied with the likeness and feel of each one. If you reflect on what you have done to create the charcoal drawings and then look at these images then it will become less of a mystery as to how they have been created.

The method of pushing chalk dust over the surface of the paper to find the form of the head can be used to begin a drawing but also to change a drawing. It can amalgamate and link areas together, enable you to find the shape and also create a density or sensation of weight to the subject being drawn. It also sustains the idea of the drawing being a method of searching for an image. It is constantly moving and changing, in a state of flux, until all the possibilities presented by the marks and the areas selected come together and 'feel right'.

Multiple Viewpoints

Another way of opening up the possibilities for a new image is to layer different viewpoints on top of one another. The model stays still and you move around (or vice versa), and each time you are selecting, adding and building layers of information with the intention of ultimately creating a single image from the gathered marks and shapes. This would appear to be some-

thing that does not come naturally. Most students when presented with this idea for the first time panic at the thought of having no recognizable order to things, no logical plan of action. However, a lack of planning is extremely important for the appearance of the work and the artist's engagement with the subject. I like the sense of urgency that comes from drawing in this way: the feeling of anticipation as you step into the unknown, regarding the chaos as fertile ground in which the seed of a new idea will grow.

Each stage in the process is very simple. What is not so simple is the self-discipline required to look at the whole image and find ways of unifying it in the most direct and sensitive way, a way that has empathy both with the subject and the qualities of the marks gathered. This is far more preferential to tidying it up and returning it to something so familiar that it presents nothing new to you about the subject.

I would recommend that you do not spend too long at each stage and selection. In a teaching situation I never let students have long enough to get too comfortable or absorbed in copying from the model.

Remember, there is no magic formula or order in which things should be done. Instead there are a range of options that you can play with and to which you can add your own discoveries and ingredients.

- Start by creating a form with charcoal dust (just take a few seconds over this).
- Move your position, though not necessarily to the same distance from the model as previously, and repeat the charcoal dust action in response to the new view.
- Move again. Begin drawing with charcoal, putting in only what interests you. Do not attempt to draw everything you see from each different viewpoint, just select.
- Deliberately allow some of the previous marks to be obscured, buried beneath new ones so that they are changed, lost or perhaps enhanced by the new additions.
- Once you have experienced between three and four moves you may well have enough on the paper to play with.

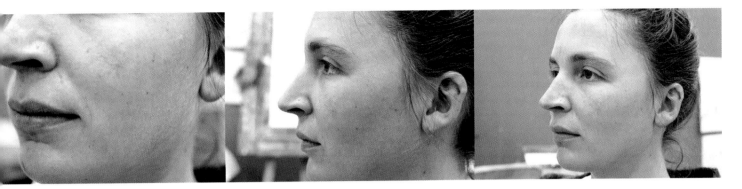

What you are looking for is still only one head, but one that could appear out of an unlikely assembly of marks.

- You can use a rubber to clear areas so that you redefine the drawing and improvise.

This method gives you a problem to solve and the potential for your practised, predictable formulae to be challenged and refreshed. It forces you to dig around and find the image and to be surprised.

Second-Hand Images

Working from first-hand experience and observation is important and deepens one's understanding of the subject, but there are many artists who work from second-hand images such as photographs, newspaper cuttings and magazine images. Marlene Dumas is an artist whose work I admire and who does just this using inks and watercolours. She has created many paintings of heads using this seductive and tricky medium. However, rather than working on a small scale, as one traditionally thinks of watercolours and inks, she works on a huge

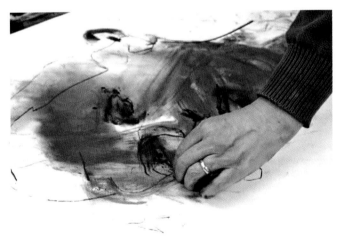

Charcoal drawings in progress.

Exercise 4. Three Colours, Three Brushes, One Head

Paint can be a misunderstood medium. It is accused of being messy and muddy, and unable to capture subtle or delicate qualities of a subject. Students are often reluctant to work with layers of wet paint because they do not want to create 'mud' as paint drags through other layers, infecting the other colours. Far from being a disadvantage this can often become an asset: mixing colours and enjoying its versatility, a sculptural surface and happy accidents are among some of the benefits. If you are mean with the quantity of paint that you are prepared to mix then you are already shutting down its painterly potential. Do not underestimate just how much paint is required to give oneself the permission to experiment and discover the rich possibilities it holds.

This next exercise is designed to force your hand a little. You will use generous quantities of paint and work wet over wet to create an image of a head.

YOU WILL NEED:
● a sheet of paper
● one very large decorator's brush
● one medium-sized brush
● one thin rigger brush
● a rag.

TO BEGIN
● Pre-mix three pots of colour of a range of hues and tones (dark–pale), they do not necessarily have to be natural colours.
● Take the largest brush first: load it with one of the colours and make broad directional marks across and over the surface of the head. Remember how the surface rises and falls. Let the brush travel across and through the head in the way that you would have pushed the charcoal dust. The idea is not to cover the whole head with the first brushful of paint. Just make three or four generous moves and then stop.

TO PROCEED
● Next, take the medium brush. Load it with the next colour and make smaller moves through and over the previous marks but in the opposite direction, not mimicking what is there but developing the structure of the head.
● Next, using the fine rigger brush and the third colour, add further marks and details on the top of the other marks.

TO FINISH
● Pick up the large brush again and use it to reaffirm some of the first marks. This will potentially bury and obscure some of the other

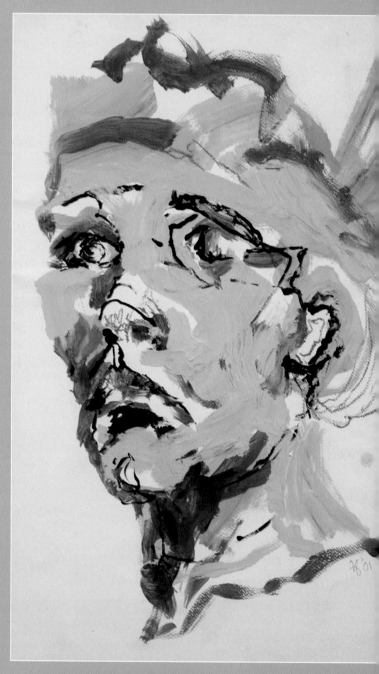

Wambui by Vanessa Pease (oil paint on paper).

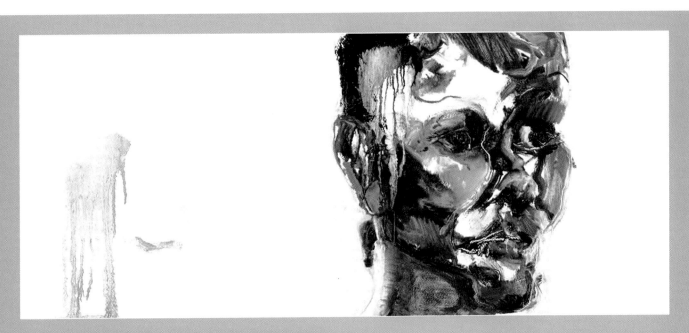

ABOVE: *Wambui* by Juliet Robertson (oil paint on paper).
RIGHT: *Tyrone* by Kate Jerred (acrylic on paper).

marks but it also begins to pull the image together.
● Continue working in this way, taking it in turns to use each brush and each colour until you feel the head has appeared and feels resolved.

Two of the illustrations for this exercise, by Vanessa Pease and Juliet Robertson, show that the final image may have areas of unpainted paper within the form of the head. These are confident and direct images created in only about twenty minutes. The third image by Kate Jerred demonstrates how over a longer period of time, the colour and layers can build the form of the whole head and features using subtle and beautiful ranges of colour and tone.

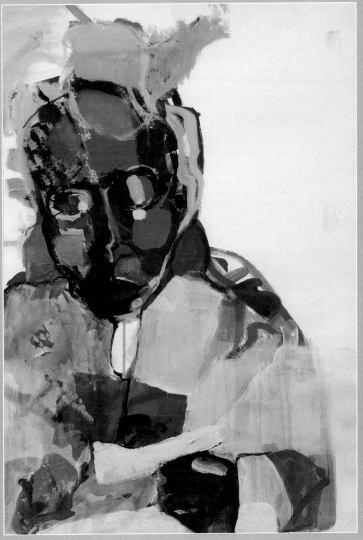

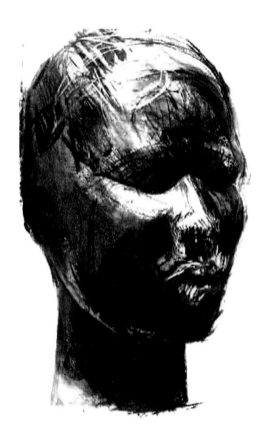

OPPOSITE: *Head* **by Libby Goddard (black ink on paper).**
ABOVE: *African Head* **by Emily Ball (charcoal and ink on paper).**

scale – making the risk larger and the process even more of a challenge. She works on the floor by pouring, tipping and dabbing puddles of ink. In some instances she dips her brush into a pool of ink on the paper and drags the ink out to continue drawing the features.

Drawing with a wet medium, such as ink, can provide an effective bridge between the process of drawing and painting. The diluted ink when washed across the surface of the paper creates its own delicate edge, an edge that is far more beautiful and subtle than one that can be drawn or mapped out. The fluid, unpredictability of the ink – how much it sinks into the paper, how much it runs, bleeds and separates as it meets different areas that are untouched or wet – encourages the artist to improvise and go with the serendipity of the results. The medium enables the sensuality, sensation and form of the subject to be discovered even if the artist is totally removed from a first-hand experience.

Making them yours

To create ink head paintings you first need to go hunting for some striking images of people in magazines and newspapers. I think it is sometimes better to embrace the detached anony-

mity of the process and choose images of people you do not know rather than use photographs of family and friends. Also you need to find a powerful image – a gaze and expression that is strong, one that stops you in your tracks.

Before you make any ink paintings in response to the borrowed image I recommend that you try mark making with the ink to discover its properties. Your touch, tools and paper will affect the results. The following suggestions will help you to get the maximum potential from the materials:

- Try different weights and types of paper. Heavy, rough watercolour papers do not always give the best results. Sometimes medium-weight smooth papers, either watercolour or cartridge, can help the marks to be clearer and more fluid. You may prefer an absorbent surface, or perhaps a more slippery one.
- You may prefer to work flat on a table, or being on the floor may make you feel more physically involved and playful with the work.
- There are many different qualities of black ink available. Some are blacker and more permanent than others. Try using different dilutions, with some very thin, almost like just slightly dirty water.
- Reworking the surface when it is wet can become difficult and will muddy the impact of the marks. Working confidently and at a fast pace is usually most effective.
- Experiment with your tools. Try brushes, rags, pipettes, pots of water for pouring and washing – even old-fashioned, household floor mops can be fantastic for making marks.
- Put a brush in the puddle of ink and then drag out marks from there.
- Have several pieces of work on the go at once to allow some to dry off before reworking and to minimize the temptation to fuss with them.
- Working on a bigger sheet means that you can pour the ink, puddle it, lift the paper to jiggle the surface liquid and pour it off again.
- Experimenting with dampening the paper a little (or a lot) before applying the ink can cause the ink to disperse, bleed or fray at the edges in a variety of ways.

Once you have explored all these qualities and warmed up to the process you can create a series of ink paintings in response to your found image. Let the ink do what it wants to do naturally on the paper. Make use of the accidental qualities of the ink to help find the features and form of the head in an unexpected way. Libby Goddard's head painting demonstrates how the features can be created from the subtle washes and the frayed and dispersed edges of the inks. The lines and marks bleed and float along the inky surface to create a piercing gaze, bringing it alive, making it a first-hand experience again.

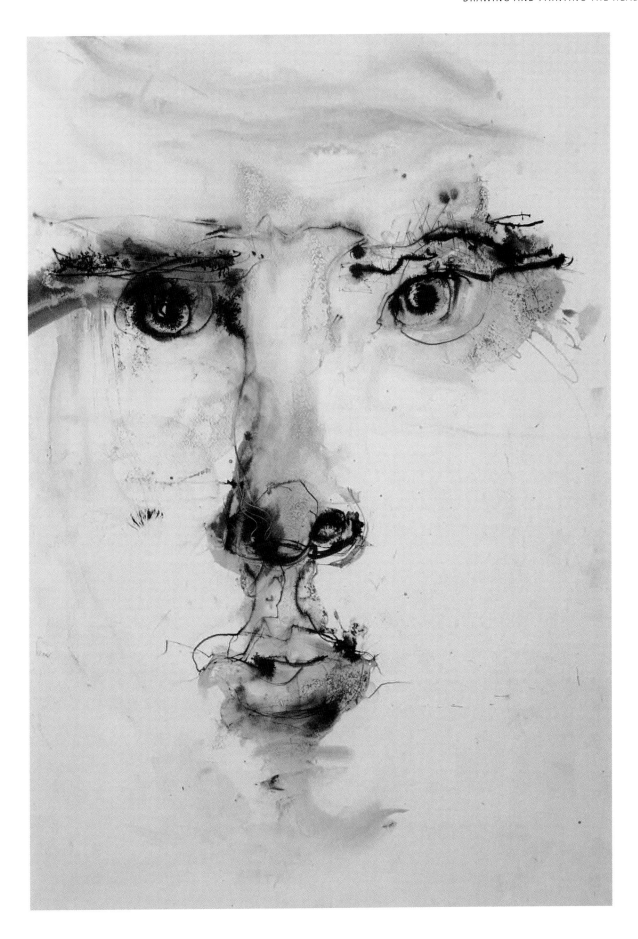

Chinababy **by Georgia Hayes.**

Connections with the past

I borrowed a different kind of image when I made a drawing of an African sculpture. In 1995 I visited the Africa Exhibition at the Royal Academy and drew in the gallery. There were so many fantastic sculptures but there were a handful that particularly caught my attention, one of which was a cap mask made of wood. The wear and tear from the termite holes, the aging of the wood, and the burnished embellished surface combined with the beautiful proportions of the features made it irresistible for me to draw. I found the head and gaze haunting even though it was an object used by another culture, in another time, with no connection to me. I felt compelled to draw it.

When you analyse this it seems improbable that an object with which I have no connection, no first-hand experience, that is distanced by history and time can affect me in this way. To create an image and/or to be moved by an image is testament to its potential ability to stir a timeless recognition, a way that affects our existence, that touches a nerve about the human condition. The timeless, constant reality of our mortality is displayed; our curiosity about other people fulfilled.

I discovered this through a 'hands on' approach, an engagement with the materials and surface of the object, not just an internal, intellectual debate. The wear and tear of the object, and the cuts and holes in the surface, were my starting point for the drawing. Using inks and charcoal I crawled over it, pulling and pushing the surface, finding the features and making them project out from and sit in the beautiful form. The scars left by the carving tools were a gift as their repetitive direction built up the form of the mouth, nose and eyes. The black polished surface lent itself to being relived through layers of dark charcoal and ink.

Chinababy

I saw the drawing *Chinababy* when I met Georgia Hayes for the first time at her home. I was really moved by it, and envious because the drawing had qualities in it that I felt I had not achieved in the work I had done of my own children when they were babies. What was really surprising to me was that she had done this drawing from a video clip. The reason for the beautiful qualities of the drawing became clear as she explained that she had found the story and image of the child poignant because they came from a documentary about the excavation of child mummies found in the China desert:

> There is a strong poignancy about a new life being buried and re-emerging mummified. It is something to do with the whole cycle of birth and death clearly stated. In this instance it was the sand and heat that preserved it rather than intention. Yet another birth when dug up. I am always drawn to this theme of time and absence. Of course it was an instant, quick drawing that just came together right and could never have been planned.[10]

What I find important about this is that I knew nothing of the subject of the drawing. I responded to the image on its own merits, the execution of the minimal marks and the simple fluid line of the head. When I asked Georgia what she felt made it a successful drawing she also noted the empty space, the way the image comes off the edge of the paper and the eyelashes on the edge of the cheek as all important to the feeling of the image. All these physical qualities given by the drawing had the effect of moving me to make my own connection with the fragility, vulnerability and tenderness of the subject. It made me reconnect with my own experiences and knowledge of my own children. Not bad for a bunch of lines and marks floating on a piece of paper, drawn from the TV!

There is therefore nothing impersonal or distant about the reference to the head in this chapter. On the contrary, the enjoyable exploration of its surface and form with the various materials is engaging and essential if you are to continue developing images of the figure further and strive for a likeness that is not a superficial imitation. By working as the exercises suggest you will have more confidence and understanding of the beauty and significance of the whole form of the head.

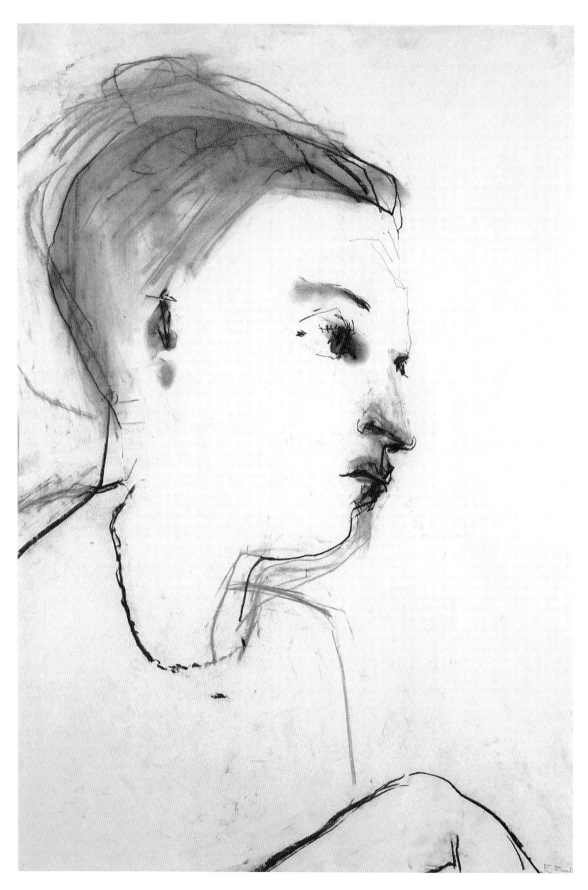

Expectant **by Emily Ball (charcoal).**

CHAPTER 3

THE GAZE

Notice the little things. Be particular.
Robert Henri [11]

This chapter explores what it means to capture the gaze and presence of a person in drawing and painting. I stress the importance of the artist being able to notice the particular qualities that enable the character of a person to make a striking image: the expression of the eyes, the shape of the mouth, the tilt of the head. There are exercises that suggest different methods of reinventing the visual language to take these elements beyond illustration.

My own work shown in this chapter, supported by images by other artists, illustrates how these qualities can be used successfully both to respond to a model or person you know, or to create images of oneself using observation, memory and sensation. The information gathered from these approaches is combined within one image, allowing the resulting image to move beyond illustration. The artist develops a heightened awareness of the particular qualities, be it a gaze or likeness, which can give back the subject to them.

Is It Important to Achieve a Likeness?

When I am teaching and we are working from a model, or each other, students have often asked me this question. Partly because I think they wonder how on earth they can get a likeness if they apply non-conventional methods to create a drawing and painting. But also perhaps there are different understandings of what is meant by a likeness. Should the final piece look like the person in a way that is photographically accurate for it to be a valid likeness? No. Should it be like the person? Yes, although a likeness can be visible in many subtle ways:

● You can give a selected, heightened response to that person,

catching just an aspect of them or a particular look or gesture that is familiar.
● You can do any number of drawings and paintings, each with a different feel and focus, capturing another momentary sensation or layer of their personality.
● Their gaze and character can be clearly distinguishable by the shape and spacing of their features, the tilt and turn of their head, or the expressive qualities of their mouth.
● Some images may appear to depart greatly from a conventional idea of the head and gaze, with apparent distortion, multi-viewpoints and exaggeration. Others appear in proportion and realistic but with an extra quality or emphasis that only becomes apparent as you study the piece.

In the 1990s I attended an exhibition of Picasso's Portraits in Paris and I remember secretly thinking that I loved the paintings but they could not possibly bear any likeness to the women he had painted. How wrong I was. The curators had displayed black and white photographs of the various wives and lovers alongside their portraits, and it was incredible to see their characters and to appreciate how he had achieved the impossible.

At first glance it can appear that Picasso has distorted an image of a head and exaggerated aspects of the person, yet the person is still present. The processes that any artist may go through in search of the image can seem perhaps brutal or even clumsy: scraping, layering and arranging the paint. Similarly, he or she may have blackened, rubbed, divided and edited a drawing to produce a minimal image that appears remote and even unsympathetic to a conventional idea or understanding of the subject. The key thing to remember is that the artist is present in the work.

A drawing is not so much the reproduction of the images of something seen, as a record of something made.
Peter Fuller [12]

A drawing of another person is as much about the artist as it is of the sitter. As you draw you develop an unspoken relationship

Exercise 5. Different Versions

You can do this exercise on your own or in a small group. The purpose of the piece of work you will create is not to get better at copying but to demonstrate what happens when using a process of repetition: it is about the benefits of not being able to copy exactly. It is about deliberately using the irregularities and subtle effects of altering a basic set of marks to witness a change of expression in the drawing.

YOU WILL NEED:

- a long strip of paper each (perhaps an A3 sheet cut lengthways)
- a piece of charcoal.

TO BEGIN

- At the top of a long vertical strip of paper draw an eye using just four moves. Make sure that they are a combination of clear and simple shapes and lines that can be repeated without too much difficulty.
- If you are working in a group, pass this drawing on to the next person.
- Memorize those shapes and lines and then fold over the top of the paper so you can no longer see the first drawing.
- Draw it from memory, as close as you can to the original drawing. (For the rest of this exercise either fold each drawing over once it is complete, if you are doing this on your own, or pass it on to the next person for them to memorize and fold over.)

TO PROCEED

- Draw another eye using the same number of shapes and lines but this time slightly adjust the placing of the marks in relation to each other (for example, not touching or overlapping, but slightly lower or higher then their original position).
- Fold over the drawing and try to redraw it from memory.

- Do another drawing, again with the previous shapes and lines but this time vary the thickness or weight of the lines. Fold over the drawing and try to redraw it from memory.
- Do another drawing in the same way, this time varying the scale of the lines and shapes in relation to each other. Fold over the drawing and try to redraw it from memory.
- Do another. This time start one of the shapes or lines at the reverse point to the previous drawings (that is, if you had drawn an almond shape for the eye in a clockwise direction the first time then draw it in an anticlockwise direction this time). Fold over the drawing and try to redraw it from memory.
- Do another. This time draw using the 'wrong' hand, the hand with which you do not normally write or draw. Fold over the drawing and try to redraw it from memory.
- Do another. Tilt the shapes and lines in relation to each other and change the space the drawing occupies. Fold over the drawing and try to redraw it from memory.

TO FINISH

- Continue this process, repeating and varying the drawing until you run out of paper then unfold the whole piece of paper to reveal the column of eyes.

If you study the results you will see that even though the changes you made were done with a limited and repeated set of marks there is scope for endless reinvention and changing of the expression of the gaze.

with the person who is your subject. An artist's gaze, and the effect of making marks whilst searching, can penetrate superficial prettiness and sentimentality. Whilst creating the work there is a strange ambivalent sensation of intimacy and detachment, all at the same time. Artists and students alike can feel that some of the best and most poignant work has arrived in spite of them, without their conscious permission. That somehow the piece of work has developed a life of its own. It is actually evidence of an unfolding revelation and train of thought.

It is not so much that the work is a separate entity to you, but that it is an extension of yourself. There is an intimacy and appreciation that deepens as the time and relationship unfold through the course of the work. You become the subject in a vir-

tual way, wearing the same skin, clothes, adopting the same posture. The resulting work is 'a record of something made', 'an image seen' but also evidence of an artist's particular understanding and interest in that person. It demonstrates a closeness to the subject and an ambition that the artist has for their work. It shows the artist's tussle with their materials and their desire to discover what their response to the person can look like. The work is produced as a result of a creative reflex.

Katie Sollohub was the model for my two charcoal drawings illustrated here. These drawings fall into the category of having realistic proportions but with an extra quality or emphasis given to her eyes. To do this I was playful in my descriptive language in exploring how to capture her gaze.

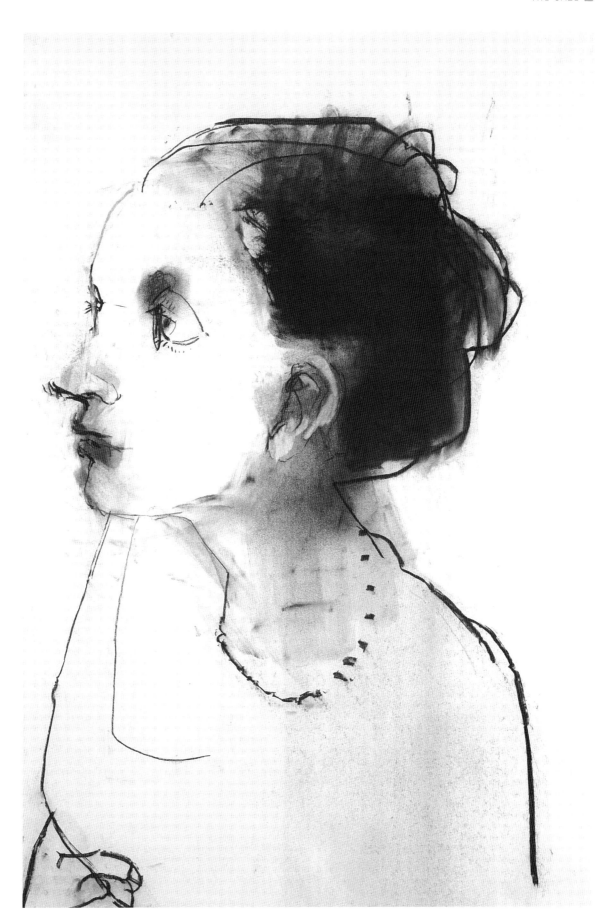

Expectant **by**
Emily Ball
(charcoal).

Exercise 6. Reinventing How You Draw (or Paint) the Eyes

YOU WILL NEED:
- paper
- charcoal or paint and paintbrush.

TO BEGIN
- From observation of a model or yourself create a collection of shapes and marks taken from looking at the eye – the eyelid, tear duct, lashes or eye ball – and lay them side by side on a piece of paper like parts of a jigsaw puzzle on a table, yet to be assembled.
- Either move your head or move around the model so that you have a new viewpoint. Now extract shapes and marks that are less obvious, such as shadows and folds, and add them to the collection.

TO PROCEED
- Move again and apply the principle of 'taking a line for a walk' (see Chapter 2) and find shapes that travel over and across sections of the eye – such as a shape that is created by a line travelling and joining up again as it falls across the eyelid, eyeball and finishes at the tip of an eyelash. These new shapes are not defined areas, edges or boundaries that can be seen but they are still 'true' and taken from the subject. They connect sections of the eye to each other.
- You now have a varied assortment of components or shapes and marks on a page. Put this sheet up onto the wall for reference.
- On a new sheet of paper refer to one of the shapes or marks that you have created and copy it. Randomly take another shape and deliberately connect or overlap it with the previous one (try to select shapes that do not logically go together).
- Look at the second mark and repeat it on top of the previous marks, though this time change the scale and reposition it.

TO FINISH
- Look carefully at the emerging drawing and add a third type of mark, this time with the intention of finding a gaze.
- If the gaze has not emerged try another shape and play with the assembly of all the marks together.

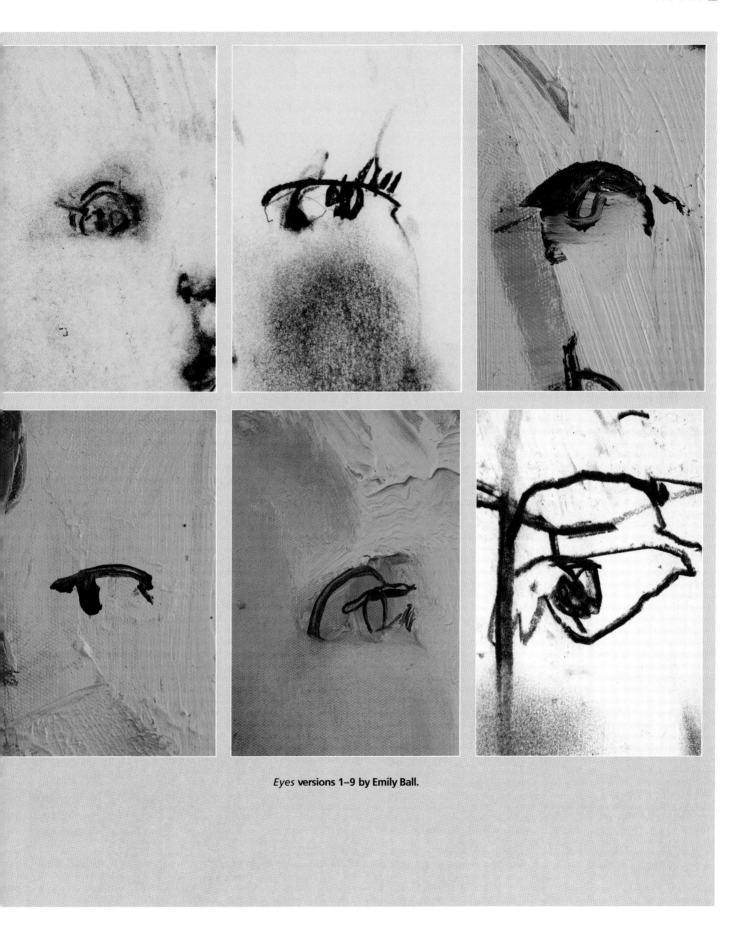

Eyes **versions 1–9 by Emily Ball.**

Her expression was calm and contented. She was expecting a baby and was feeling good. To draw Katie is always a treat because she has such beautiful, clear features, a strong personality and a penetrating gaze. As I drew I was very conscious that these qualities must be mirrored in the drawing. I was kneeling on the floor, right next to the chair where she was sitting, looking up at her. The first things to be drawn were the eyes, mouth and nose. The tilt of her head had to be carried in the position and the characteristics of these features. Everything else had to find its place in relation to these. My marks and touch were economical, yet playful and confident. Fluffing and scrubbing would not do the job if I were to capture her strength and serenity.

The Gaze

The gaze has it all. Capture the gaze and the rest of the image works around it. It is a wonderful motif and I have always been fascinated by all the different components that connect together to make it function and sit in the head, looking out at the world beyond itself. It has the ability to express so many emotions: scorn, anger, love, happiness, a charming wickedness, a dreamy distance, sadness, fear and anxiety. Yet this range of expressions is difficult to capture if the selection and delivery of the marks created to describe the eyes are generalized and clichéd. What can be both frustrating and fantastic is realizing how the slightest change to the character and position of a mark can change the gaze and mood of the image. To demonstrate this I have created a game for drawing eyes, which is a visual combination of Chinese whispers and Consequences, where a set number and type of shapes and marks have been used.

The previous exercise is great for making us aware of the huge potential of a limited repertoire of marks used in subtly different ways, but there are other ways of creating an extraordinary and powerful gaze. You can invent a new language of marks. However these marks need to be invented and discovered with your specific purpose in mind.

I created Exercise 6 after watching so many students avoid and struggle with drawing and painting features, especially eyes. Many who tackle the head skim over the fact that the eyes sit in the face (not floating on the top) and they move and have connected parts. Simplification is a good thing but this sometimes leads to generalization. It is possible to arrive at a pared down and direct image by finding some rather more unusual details and shapes to work with that still capture a specific character and gaze. Commonly the eyes are drawn using a fixed viewpoint and perhaps a clichéd single almond shape. It is helpful, however, to appreciate and use the other shapes and attachments that can help to create the type of gaze for which the artist searches.

This exercise does not give you a formula or technique, but it does promote the idea of playing with the elements and selecting them from different viewpoints to create a gaze in a way that is powerful and full of character. The illustrations shown are from the many paintings and drawings I have done in response to my children. It was always critical in the work that the gaze captured an aspect of their character and I found that each version I created tested and extended the way I tackled the job.

Kisses and Closeness

My drawing of my daughter, Eve, as a baby is one of my favourite drawings – and I am very critical of all that I do. There is a rigour in the way the marks are placed in the space of the paper and their definition is very clear. Every feature holds a quality about Eve and is a tough uncompromising bit of drawing. It evolved at a steady and considered pace with no redrawing. Everything happened clearly and confidently. The paper I chose to work on was heavy but soft and untextured. It was very unforgiving, making it difficult to remove all evidence of the charcoal if required, and this made me aware that I did not want the debris of old misplaced marks showing on her blemish-free face. I wanted no history. I wanted to state her succinctly, powerfully, and capture her, as she was then.

The first focus of the drawing was Eve's cheek. I made the shape give back the plumpness and the flawless, clear softness. The top of her cheek also acted as a shelf for the eye to sit and rest. The eye on the right-hand side of the drawing is hovering above the cheek. The plumpness of this cheek has been described with a very condensed and invented method. The line buried in the soft rubbed charcoal conveys the edge of the cheek but the way in which the cheek continues beyond it gives extra fullness and movement to her face. Her mouth is extraordinary. I have never seen anything so versatile and expressive. Its ability to protrude, change shape and convey her mood is a critical part of capturing her in a drawing. Finally, even her hair had to have form and character.

When Eve was born I could not think how I might tackle the task of drawing her. She was like a doll, porcelain with a bow mouth. I remembered some Japanese prints that I had in a book and revisited them to see if I could find a way to approach it. Using these prints as a trigger I have explored ways of painting and drawing Eve's head and hands over and over again. I noticed the economical way and expressive method they used for describing hands, faces and sculpting the hair. I recognized that this could help me find my own pertinent, pared-down language to describe her.

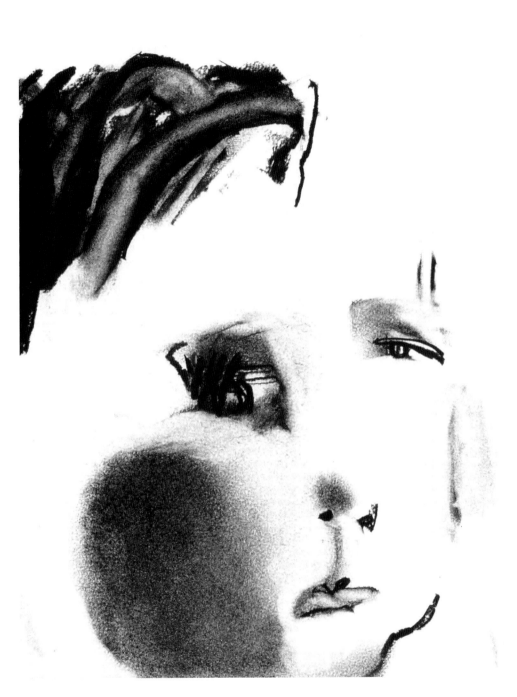

Kisses and Closeness **by Emily Ball.**

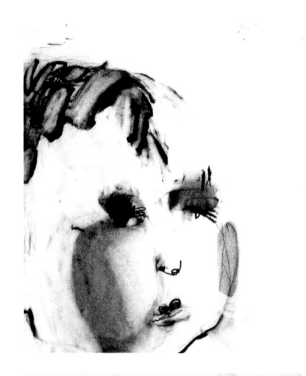

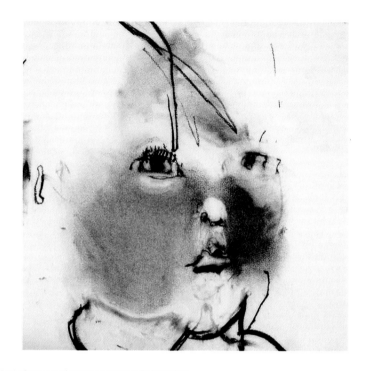

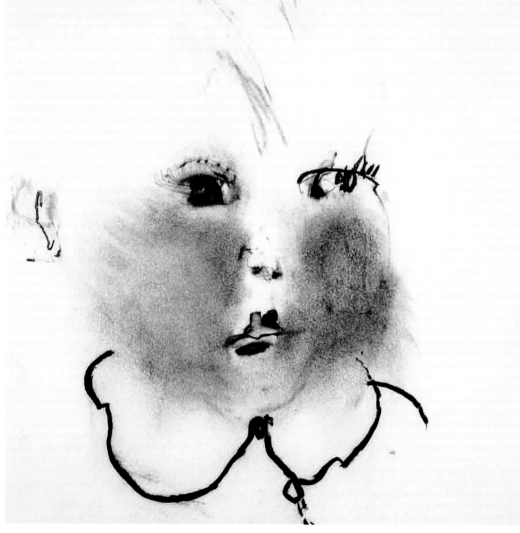

Evie versions 1–3 by
Emily Ball (charcoal).

Trial and Error

Unfortunately drawings like this do not happen all the time. Moments of clarity require limbering up for the hand and eye. They require an intimate knowledge of the subject and an unfaltering desire to get a likeness that is not superficial and general but palpable and particular. Every time you see an image or experience something you are affected and you change, sometimes in a small way, sometimes profoundly. You never go back to where you were prior to that moment. To be affected in this way means that you are constantly reassessing the effectiveness of the marks you are making and what is important about the subject.

The drawing of Eve arrived through a process of doing drawings from drawings. The first was done from observation and all subsequent ones were created in the studio using repetition, testing and shifting the image but not copying. The final image was the last of six. From the outset of making the drawing I was not interested in replicating what was in front of me. Instead I was searching out which combination of marks could give me the telling gaze, the particular tilt to her head, how she brought her hand to her mouth, the fall of her hair – anything to give me information about this small person and the moment. It is possible to capture a moment, give it form and make it exist in your work forever.

This drawing is, for me, evidence in my own work that the eyes or gaze can express human sensitivity, vulnerability, strength of character and, in the case of Eve, the way in which she scrutinized whatever fell in the path of her gaze. This drawing has the ability to both melt me and remind me of her dynamic, single-minded personality.

Charlotte **by Rose Wylie.**

Confronting the Cliché

I have chosen to illustrate Rose Wylie's drawing because she has achieved a likeness of her niece Charlotte in a very direct way, embracing the clichéd and stereotypical methods of using almond shapes for the eye and drawing around the mouth. I like it as a drawing but also because she makes no attempt to sweeten her work, to make it more palatable to those who might be a little squeamish and easily shocked by her directness and selection.

It is an image that came from a photograph of her niece's partial profile; it was rather near the camera and therefore white and out of focus. Earlier in this chapter I discouraged the use of the cliché. A cliché is by definition overused and over-simplified. It has become an impersonal symbol, but Rose relishes the challenge of giving back value to it and delights in its ready-made accessibility. She is also attracted to the Egyptian conventions of depicting the human figure using perfect profiles, with the face represented in profile but with an eye seen from the front. Rose cleverly and wittily uses the things that others with 'good taste' would not touch. They interest her and provide direct ways of creating individual images.

The drawing illustrated apparently took a long time to draw, even though it appears to be so swift and confident. Knowing the person you are drawing or painting can be both an asset and a handicap. The desire for a likeness, a tangible feel of the person as you know them, seems all the more critical. You feel that the work can only have value if their character as you know and experience it are present within the image. This is an asset because you will recognize it when you have got it but it raises the stakes considerably and narrows the margins for error and generalization in order for it to be satisfactory. As Rose experienced when drawing Charlotte, and I know from drawing my own children, many attempts and umpteen subtle changes have to be made before their likeness may arrive.

It can be powerful to have a person's gaze looking back at you out of the image, but equally captivating is the gaze of

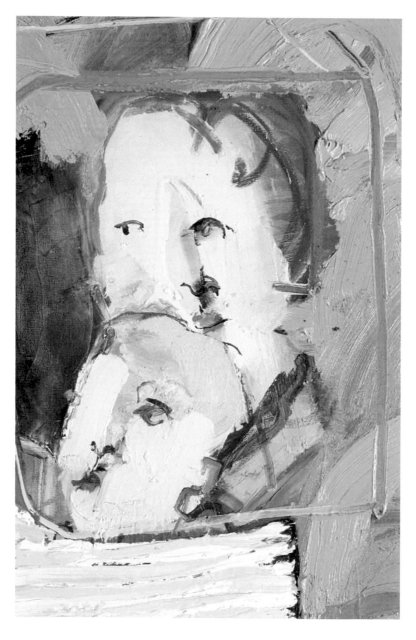

ABOVE AND OPPOSITE: *Two Heads are Better than One* **by Emily Ball.**

someone who is completely absorbed in something beyond you and the space in which you, the viewer, are standing. The two mother and son images shown are details from a pair of paintings called *TV Mother Hug* (I will explain more about the origin of the whole paintings in Chapter 6, in connection with transcription). They are paintings about William and me, chilling out on the sofa. We are both gazing, transfixed at a TV to the left, beyond the painting. Although it is not possible to see any other part of the bodies of the figures, you know they are embracing. The relaxed, nestled and trusting position of Will's head against my chest, and my head bent forward resting my chin against the top of his head is all the information you need to know. It is a tender and loving cuddle.

The application of the paint is very physical. The directional movement of the paint – pushing, pulling, rising and falling – explores the surface of the head, in the same way that the charcoal dust studies demonstrated in Chapter 2. Channels, ledges and corners are created in which to sit the features. The slant, tilt movement and overlap of every shape and mark that go to make up the eyes have been tailored to describe the absorbed and tranquil gazes in the direction of the TV. I can remember that I was particularly pleased with the way I had described the mouths in these two paintings. The generous, full, ice-creamy paint for Will's mouth and the economical small wrapping mouth for me are given by the trial and error of the paint pushing and pressing together, by overlapping marks made with a

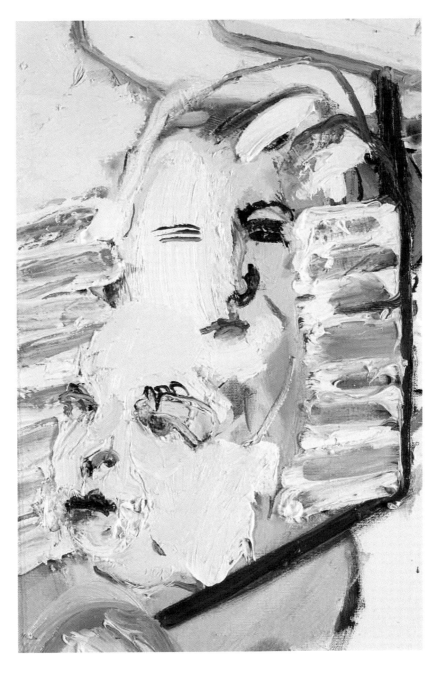

brush, by adjustments made using my thumb or fingers. The quality of the paint surface is an important part of the success of the image. The animated texture gives a palpable feel of the heads and animates the expressions.

The Mouth as a Monet Landscape [13]

The mouth is sensual and iconic; there are fashion models' lipstick mouths, sexy mouths, anonymous mouths, expressionless but interesting mouths. The mouth is animated and expressive: it can be kissing, eating, laughing, smiling, screaming, speaking, pouting or pinched. Painter Francis Bacon talked of his fascination with the mouth and its glittery qualities. The wonderful colours and textures he likened to a Monet landscape, but he felt he never achieved that in his work – although this comparison may seem rather incongruous when you consider paintings like the *Screaming Pope*. The contradictory, and some might say distorted, qualities in his work meant that many people find his work horrifying and sensational. Yet he claimed that this was not his intention, rather it was to create a likeness without illustration.

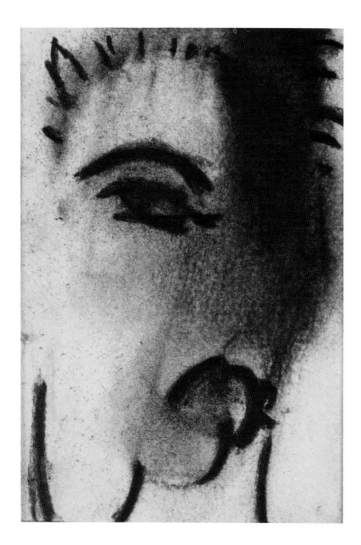
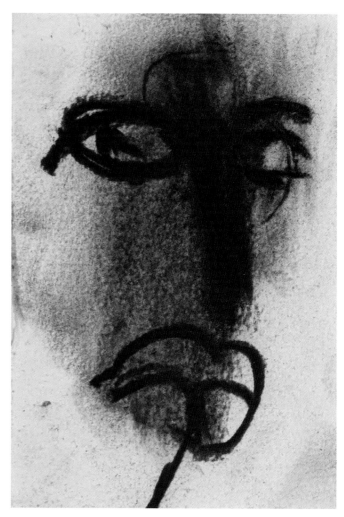

ABOVE AND OPPOSITE: *Heads versions 1–4* **by John Skinner (charcoal).**

'Like' but not like

Over the years that I visited John Skinner's studio in Dorset, to attend painting and drawing courses, John often showed us video clips of Francis Bacon being interviewed about his paintings to help us understand how an image could be condensed and intensified. He spoke of three little paintings of heads by Francis Bacon that he had seen and been very struck by at the Marlborough Gallery: 'They were like old master paintings but absolutely modern.'

The four small head drawings by John, as illustrated, were part of a larger collection made to test out and explore the problem of how to create 'expression without illustration' for a large painting that he was doing at the time. In these drawings the mouth does not necessarily have a continuous outline. A line coming up from chin meets, inserts or attaches to the mouth, having the effect of pushing the shape and fullness of the mouth outwards, making it protrude. The economy of the

drawing means that with just the eyes and mouth clearly defined, and their relationship to each other, John has created powerful expressions. Each head is turned to look at you. The mouths wrap around the face. The surface marks on the face – blackened, smoothed, graded and rubbed – give form and volume to the head. In some the nose is not present at all, in others it is just represented by a vertical mark travelling though the face, both dividing and linking the motifs. These drawings demonstrate the versatility of the marks and the potential of this theme and variation for finding expression.

Capturing the mouth holds different challenges to the drawing and painting of the eyes. If the mouth is closed then the potential for movement and changing shapes is absent. The sensuality of the mouth is achieved by playing with a limited number of elements: the fullness or thinness, its softness, its shape, its ridges and the relationship of the bottom lip to the top lip. So you have to apply the marks in a sensual, directional way. You can apply the principles of layering multiple viewpoints

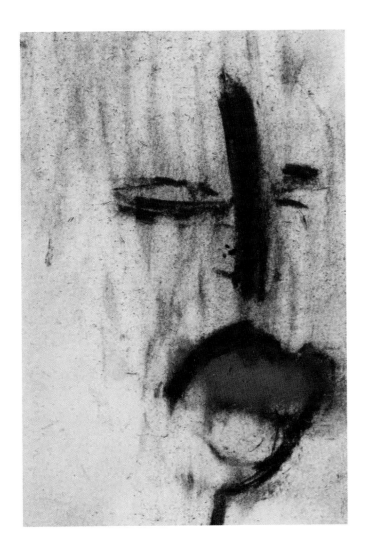

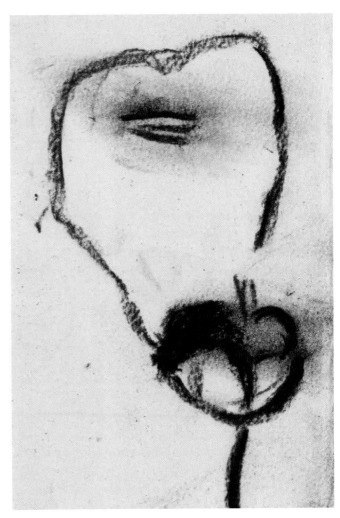

and shapes over each other, as with the drawings of the eyes, but often the subtlety of a smudge and slight tilt, droop and curve can give sufficient expression without creating any more complexity. When I reflect on all my illustrations of mouths it reminds me that when I am looking and working I am very conscious of where the bottom and top lip meet and push together. I think of each lip as a ledge rather than accenting the outside outline and I always connect the mouth in some way to the nose to help accentuate the form and character.

Cleaning my teeth

Throughout my career as a painter and teacher I have done the occasional self-portrait but it has never been a subject that has interested me enough to pursue in any great depth, at least in the traditional sense. Until, that is, I found myself stuck for a subject. For some reason I had reached a big crossroads with my

work and felt at a loss to know where to find my next subject. So I decided to paint an experience: cleaning my teeth.

It had been the last thing I had done before I left the house that morning to come to the studio. It was a fresh memory and a well-practised ritual. This gave me more confidence that I could make a sufficient enough connection with it to attempt a painting. I had no mirror while I was painting, instead I concentrated on the memory and sensation. Sometimes I closed my eyes whilst working to help my concentration. It was a curious sensation just focusing on the space inside my mouth and reliving the experience of the toothbrush scrubbing my teeth. The resulting image is a strange assembly of a disembodied head, a hand and a grubby, splashed sink. The painting is not the best painting that I have ever done, with hindsight there was the potential for much more generosity and invention, but I still feel it has something that I find intriguing and unusual. This subject is perhaps unfinished business but no Monet landscape!

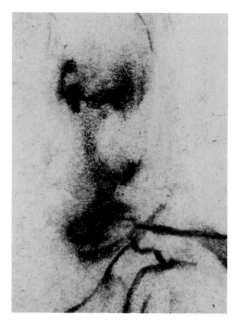

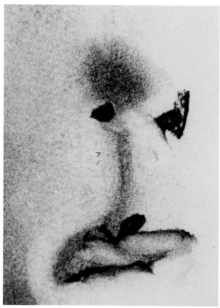

The mouth versions 1–8.

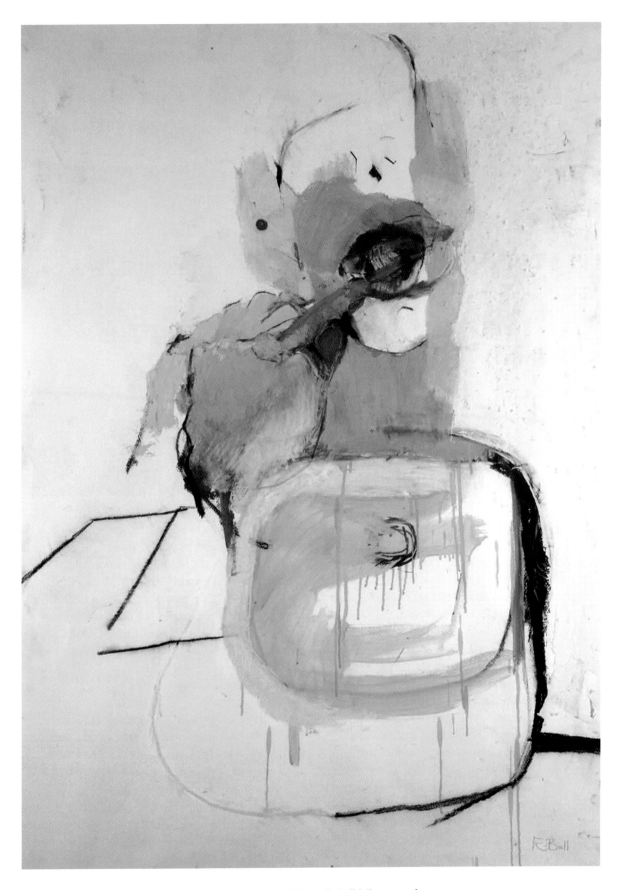

Cleaning my Teeth **by Emily Ball (oil on paper).**

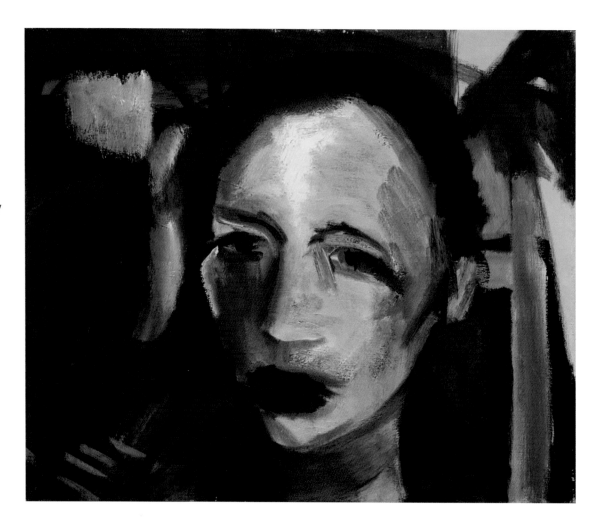

Painted Lady **by
Katie Sollohub
(oil on canvas)**

Time, Familiarity and a Story

Katie has painted a number of self-portraits but the two shown here really stand out for me. They are images not of how she sees herself but are the product of a process, where time and materials combine with an unfolding narrative in the work. Her interest in self-portraiture began in 2000 when she started taking instant photographs of herself whenever she wanted to record her face, often in times of distress, excitement or indecision. In 2006 she began to paint from these images. Before this she only very occasionally used herself directly as a subject for paintings, and when she had done so experienced the problems common to this approach. Namely, the double-edged self-criticism that one meets when working face to face with one's own reflection, not only in the mirror but also in the developing image on the page. Both parts of the process can be very uncomfortable. Working from photographs allowed her to step away from the mirror, and in some ways away from herself.

She found that the most important quality in the photographs was the composition and format, so central in each one: face on, camera held in her hands, space around the head completing the story, setting the scene. There is also the emo-

tion visible in the face, that she feels that she has managed on occasions to paint, but sometimes it seems impossibly elusive. Once taken, the self-portrait photograph stays as a record of just that moment, whereas a painting is ongoing and will change with her, with each alteration capturing a fresh observation at the moment of painting it. The other striking observation is that when working directly, from a mirror, she is working with the image she knows well, the mirror image seen each day. When working from a photograph, she is working with the face that other people see. Katie explains:

> The two paintings that you have chosen were painted
> directly from the Polaroid photographs only, not using
> a mirror. Both photographs were taken some years
> previously. In some ways the distance between the 'me'
> now and the 'me' in the image is an advantage, as I can
> paint without the emotion that could otherwise distract
> me. On the other hand, it can seem so remote from me
> that I can no longer engage with the 'self' portrayed.
> Then there is the difficulty of working from a photograph,
> and how to keep the image alive. I have several ways of
> doing this. If I am lucky, the image comes out well at first

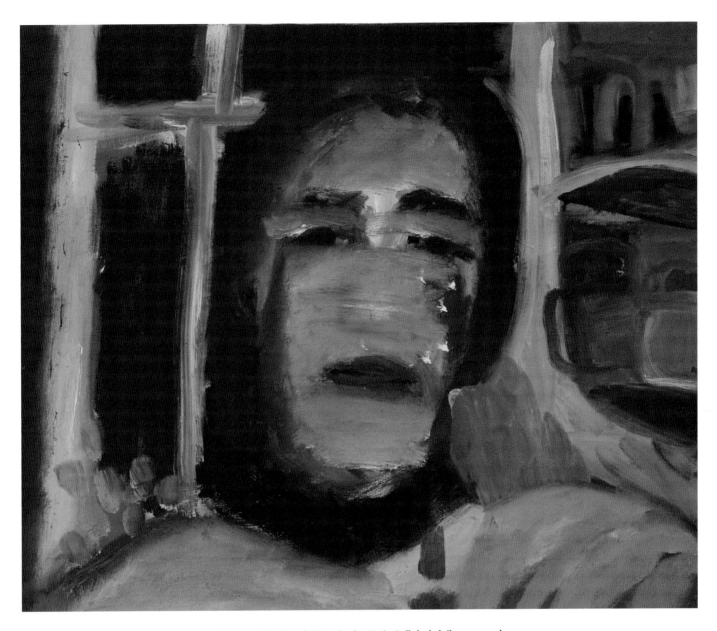

Without My Usual Disguise **by Katie Sollohub (oil on canvas).**

approach, and then I leave it like that for a while. More often, the image looks far too flat, and I keep the same paintings on the go for as long as it takes.

After three or four sessions painting *Without my Usual Disguise* (2006) I wiped off the face that just was not working, and the resulting smear across the face said much more about the image, the story, than any more controlled attempt had managed. *Painted Lady* (2006) took longer, as I had to completely rework the image, referring to a different photo than the one I'd originally started with. This helped develop a fresh feeling to the new face, with traces of the old one, brush strokes, colour, etc., still visible, and adding to the final result. The main problems that recur in each one are the eyes and the

mouth. Once they are there, the rest of the painting can sort itself out in terms of colour and composition.

Search and Reveal

Ann Symes has used an altogether different approach to creating a self-portrait for her piece entitled *Release*. Many people find this image haunting and sad, but I find it very powerful and fascinating to see how the image has emerged out of the marks within it. Ann's process of working is very organic, unplanned and intuitive. She finds her own pace of working that sometimes means long periods of not creating work at all. This is not procrastination, but for her is a necessary brewing time. The

need to work builds up, gathering steam, until suddenly it seems that Ann is working with an intensity and focus that excludes everything else. I talked to her about the work *Release*:

> It was one of four that started as large mono-prints, with actually very little in the way of marks in them, but intuitively I was convinced there was a head in there. After searching and searching the image started to reveal itself, giving me a starting point so I began to draw into the print until that very emotional head emerged which both shocked and excited me to realize the depth at which I'd been working. I just kept going until I had unintentionally produced a body of work. I didn't have a mirror. I used imagination and intuition and 'felt' my way into the drawing without thinking, becoming lost in it as I worked. I also felt very strongly that I was drawing something out of my subconscious and there was a huge feeling of release when I had finished – hence the title.[14]

OPPOSITE: *Release* **by Ann Symes (mono-print and compressed charcoal).**

When is the person present?

By approaching the process without the need to copy a likeness your experience is richer. The person is more present to you and in the unfolding work. You need to make a leap of faith and trust your response and the layering of observation, sensation, memory and invention to create a true likeness, one that goes beyond illustration. If you know the person well then recognizing them within the image will be more easily apparent to you. The subtleties of their posture and gaze will seem more obvious and the resulting image will be more captivating and personal, both to you and the viewer.

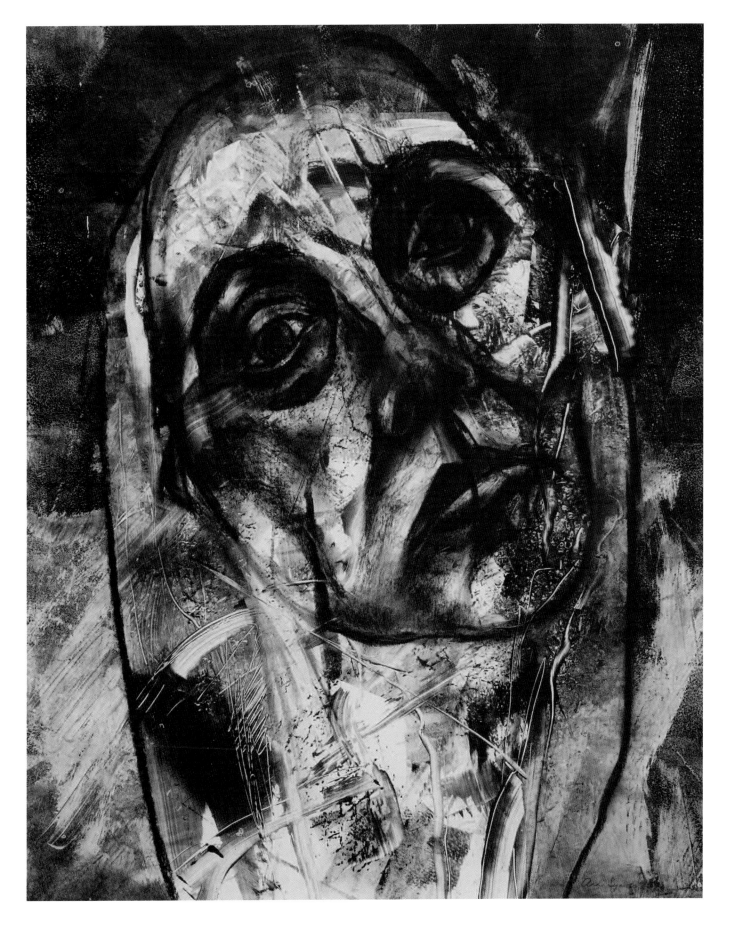

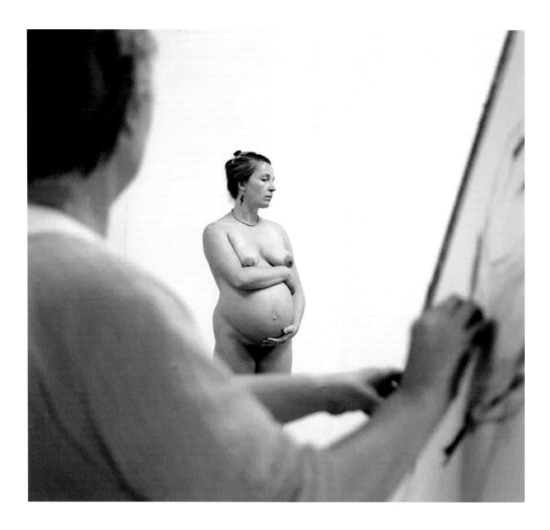

Unclothed images of the figure have a timeless quality.

THE PRIMITIVE, THE GODDESS AND THE NOW

The Female Form as Goddess and Eternal Subject

Why is the figure an eternal subject? Human physicality – fragility, strength, movement, beauty and our amazing capacity to experience the world around us using our senses – has something to do with it. An even stronger motivation is self-examination. We are fascinated by our own species, we like to watch others and contemplate the meaning of life. The illustrations and exercises in this book demonstrate a way of bridging the gap between making copies of what the figure looks like and making images that have a palpable presence, evolved from a cocktail of information that includes the sensations.

The thoughts, images and ideas in this chapter are connected predominantly to the female figure. However, many of the exercises could be equally lifted and used for depicting both male and female forms. There are three main strands of inspiration that I mix and match throughout: the artist's sensations, working directly from a model, and reference to ancient sculptures and myths. This chapter looks at the female form as a subject for drawings and paintings, both clothed and unclothed. Unclothed images of the figure have a timeless quality about them, without reference to costume, history and fashion. The clothed figure adds some mystery and distortion through the character and form of the clothing; pattern and abstraction are available for the reinvention of the form of the body, leaving the attention and focus for the head, hands and feet.

At the beginning of Chapter 2 I explained why I chose not to use the term 'portrait' and instead entitled it 'Drawing and Painting the Head'. I have equally resisted the idea of referring to the discipline of 'life drawing'. This is really only to distance my approach from the more prescriptive processes associated with this discipline. The tradition and craft of measuring and getting the proportions 'right' can produce work that sometimes seem tight and impersonal. Being tied to these conventions in an attempt to copy what one thinks the subject looks like is, in my opinion, a waste of a wonderful opportunity. The 'rightness' of a piece of work does not come from hav-

ing the anatomy correct, according to a traditional convention. It is the proportions of the drawing, the 'rightness' of the feel of the work and contact with the primitive and intuitive response that creates a work of beauty and significance.

> The primitive links all periods of art history as a profound source of human response. It is what is enduring in art.
> **Roy Oxlade** [15]

Then (Cave Paintings and Ancient Art)...

The word 'primitive' immediately links us to prehistoric art and cave paintings. However, in relation to the work discussed by the artists represented in this book, it is not a reference to paintings that are crude, created by untrained artists, or that lack sophistication and thought. Although there is not the space in this book to discuss cave art in any great depth there are three important points connected to cave paintings that are key to our understanding of the importance of the 'primitive'. I feel that these points can begin to clarify and dispel the prejudices and misunderstandings about work that appears to dispense with skill, craft and intellect.

1. Knowledge

The most popular belief amongst scholars is that cave paintings are evidence of mankind's first cognition of man as different from animals. This is, of course, impossible to prove but author Gregory Curtis, writing specifically about the cave paintings in France and Spain, says that:

> They represent the first time we know of that we humans summoned all our intellect and vision, all our knowledge

Reclining Man '84 **by Roy Oxlade.**

and skills, and all our longings and fears and focused them on creating something that would last forever.[16]

2. Selection

The artists were very selective in their choice of subject matter for the paintings. Not only were their subjects animals, as opposed to, say, plants or the weather, but they were a few significant, specific animals. If the images just represented those animals that they hunted for food then there are vast numbers of different species of animal that are missing from their wall menus. It has been concluded, rather, that the animals painted were somehow symbolic representations of their cultural values, in a mythological and spiritual way.

3. Training and skill

These beautiful drawings and paintings were repeatedly created over thousands of years with skills passed down from one generation to another. Each artist was aware, as any artist is today, that the quality of one mark was better than another. Why would they make time to do these amazing paintings unless it was a

necessary and vital engagement with their own thoughts and a way of grasping and making sense of the world around them? Is it any wonder then that their images feel familiar and are beautiful to us, even now? They are timeless. It is exciting to realize that images can be created that are poignant and that make us connect to ourselves and our own spiritual mythology whether they were made 30,000 years ago or last week.

… And Now

The motivation for the desire to link with the primitive comes through the process of finding a visual language that seizes the moment, that embodies the sensation of the subject. Our desire to create is driven by a need to get to know ourselves; to reaffirm our reality and remind ourselves of the experiences that make us who we are, at a very basic level. Embracing this primitive aspect of ourselves through drawing and painting provides opportunity for the contemplation of something more poetic, a desire to grasp what is fleeting, ephemeral and mortal before it fades and is forgotten.

Homesick for the moment

Perhaps it is because I am now a mother, perhaps it is because I have hit forty – most definitely it is because I am an artist – that I am all the more struck and sensitized to the transitory nature of life. It is exciting, beautiful and awe-inspiring all at the same time. I want to recall it, hold it and explore it all over again to make sure I did not miss anything. This is a kind of grieving and celebration of the passing of the moment, but at the same time it is not sentimental or nostalgic. It can give you the ability to be both there in the experience and also standing on the outside viewing it from every angle, pausing and stretching out the special bits.

The ability to empathize with our subject is a huge asset in creating the work. Through sharing physical sensations, orientation in a space and emotional experiences we are able to use that knowledge to inform our work, to create a visual language that corresponds physically to the subject.

Painting as Poetry: Going Beyond Illustration

A standard definition of the term illustration is 'an example used to explain something'. It is a visual translation of what we think

we see, a reproduction of how we think something looks from a single viewpoint. However, when you are painting you are not explaining anything; you are giving form to your sensations, you are inventing an image that did not exist before. The viewer should therefore treat it as they would a piece of poetry or music. The viewer must make a response too by allowing the image to wash over them, to ask how it makes them feel and not what it looks like.

The viewer may never know the artist's intentions but this does not prevent them from appreciating or being affected by their experiencing of the work. Francis Bacon acknowledged and deliberately used the artificial nature of paintings. They do not exist naturally. They are made by human skill in response to something natural. Paintings are not copies but selective responses to a subject, not just in terms of aesthetics but also of feelings, combined with the fact that the artist can layer time and action on top of one another. Time compressed, dissected, paused. Days, hours, minutes.

Next Cardigan **by Rose Wylie.**

The human body in all its glory – the inspiration for the work.

A visual shock

A visual shock is often experienced with the unfamiliar. When considering the work of other artists whose work contains this primitive edge, it is not how the work looks that is important, it is what you take from their philosophy and the ways they find to embrace their practice.

The exercises in this book are neither created to make this a failsafe process nor the images comfortable. They simply have the impact of waking up the artist, making them sensitized to the possibilities of the visual language. When you are accessing the primitive you are striving for marks that are not without skill but are without calculated slickness. They should be stripped of comfort and delivered in a way that makes the artist feel like they are on the edge of their seat as they make it. They must be tough and economical, without reliance on showy flourishes. The work is conceived out of an urgent necessity with the mark or tool that seems to do the job at the time, regardless of whether or not the viewer will like it.

Many students that I teach have a desire to work in a direct way and to be less illustrational. I think the drawings illustrated here by Roy and Rose have an awkward and primitive presence that I enjoy. They are stripped of the 'correctness' of the expected craftsmanship and you are left with tough, yet beautiful drawings. They give me a visual shock that I find beautiful in an unexpected way. They make me think about and see the subject again, as if I was seeing it for the first time.

To create work that has these qualities you need to use a strange mixture of calm assessment, scrutiny and empathy, combined with a workman-like practicality and playful generosity. You drink something in with your eyes and senses and then, as one of my students eloquently describes it, 'you proceed to be sick on the canvas or paper in front of you' with scrapings, splashes or overlapping blobs of paint until an image that harnesses those fleeting and essential moments forms itself in front of you, under your hand and guidance. In this sense you are embracing the primitive and the intuitive. In these moments planning, measuring and intellectual debate are of no help whatsoever.

Playing the Game

This chapter contains some exercises that will help you connect with this idea of making a response to the figure in a more direct way. Before I describe them, however, I want to examine the process of creating the work itself, like an unfolding performance.

First, there is the human body: posed, naked, in all its glory. Skin, folds, bones, hair, flesh; possibly voluptuous, lean, supple, young or old, flexible, stiff, sagged or upright; a rich and varied character – the inspiration for the work.

Then we have the artist: earnest, nervous, ambitious, sometimes tentative, sometimes focused and clear; poised to observe, study and capture some quality about the body.

Our final character is the work itself: blank at first, potentially tricky and elusive, but with the confidence and playful hand of the artist, rapidly becoming the leading light and centre of the play. The inexperienced artist often overlooks the potential of the intuitive and often chaotic collection of responses they create. Not wanting to appear without skill or foolish they want to control and return the work to something familiar. The collaboration and communication then breaks down. The work and the artist need to work closely together at all times, choreographing the marks and moves in harmony.

This collaborative play is acted out on the stage of the paper or canvas. Within this space any number of amazing images have the potential to be made. The artist has the added role of generous director, letting the characters improvise: the model, the work and the artist. To make a captivating image all three must work together, responding, watching and improvising.

Exercise 7. Don't Plan, Just Respond

This exercise is fluid and fast. It is very effective at automatically cutting out the unnecessary and stopping the artist or student from planning. The drawing almost creates itself! It also removes apprehension from drawing the figure, and the resulting drawings have a surprising quality that all students who create them find exciting and inspiring. They also connect to primitive cave drawings in the way that the image is layered and affected by the marks beneath to make the form.

YOU WILL NEED:

- sixteen pieces of A6 cartridge paper (a sheet of A2 paper divided equally into sixteen)
- a small heap of charcoal dust (as recommended in Chapter 2)
- a piece of charcoal
- a model.

TO BEGIN

- Each drawing should only take between thirty seconds and a minute. This means the model has the opportunity to create poses that have much more stretch, bend, energy and tension to them.
- Start by attempting to put your body in the same pose as the model. You will be able to feel how the weight is being distributed through the body, where the twist and stretch is. Notice where your gaze lies and the position of each limb in relation to another.
- On your first piece of paper put some charcoal dust and, taking no more than two to three seconds, push and smudge across the space to explore the form and movement in a direct and non-fussy way. This brings together the whole pose in one action and mark. It is important to be aware of the direction of the mark. This will lead the eye through the form to bring out the character of the pose.
- Stop and shake off the excess dust, ready for the next drawing.

TO PROCEED

- Using your stick of charcoal, draw without looking at the paper. Stare at the model and make your lines as direct and confident as possible, sometimes continuous (not lifting off the paper). Remember that a line can convey not just the edge of something but also the weight and movement.
- Stop after approximately twenty seconds. Do not be tempted to give yourself more time as it will not improve the drawing (quite the contrary).

TO FINISH

- Do another fifteen drawings on the prepared paper, each one with a different pose, using this process. Then hang or stick them up to view them.
- So that you do not become too slick at what you are doing, try sometimes drawing the lines using the 'wrong' hand, or try staring at the pose for a short while and then drawing the lines from your memory, with your eyes closed.

To achieve the desired quality of drawings from this exercise it is essential that you:
- know what the pose feels like to perform;
- do not look at the paper;
- do not attempt to be tidy; and
- draw quickly (not rushing but *purposefully* and *deliberately*).

Fast figure studies by Richard Wallis, Geoff Huntingford and Mel Howse (all charcoal).

Talking about it is one thing but true understanding only comes through first-hand experience. The following exercises will enable you to apply this philosophy.

These drawings are succinct and beautiful. They are not an illustration of the figure. There is something inexplicable, primitive and poetic that happens when the body, which is so complex and beautiful, is condensed into such an economical little image made up of eloquent, floating and overlapping lines and smudges. There is a balance and magic about the drawings. Each form feels as if it could be held in the hand and every mark connects and talks to the others. Combining sensation and observation together in a piece of work provides new options for the way the figure is made into an image. It also enables the viewer to connect to the work in a physical and emotional way, reminding them of their own physicality.

A Venus in the Hand…

In John Skinner's studio in Dorset I remember seeing a row of tiny, framed drawings above the fireplace. These, I later discovered, were drawings made from rubbings of lumps of metallic rock. These wonderful, knobbly looking stones were gathered from Eype beach in Dorset. John did the rubbings and then enhanced and adapted the marks made to find each little Venus figure. From hard, static, cold, unyielding objects came drawings that feel fleshy, voluptuous, soft, moving, sensual and womanly.

The touch, the holding of the stones and the improvised response to the rubbings opened a door to a connection between subject and image that John has been inspired by for a very long time, the *Venus of Willendorf*:

> An image of this Venus figurine has followed me around since I was a child when I saw a black and white photograph of it in the back of a book about dinosaurs. I have never seen the real thing. I think I have seen a copy of it at the British Museum. It is the black and white photograph that remains for me. Some years ago while studying the photograph more carefully I noticed the – hands above the breasts – stance of the figure. I have tried to incorporate this stance into my paintings and have even asked my models to stand for me like this whilst I drew them. I have never been able to make a successful painting of this stance. Yet somehow it is fixed in my mind. I notice it everywhere.
>
> The figurine is called *Venus*, presumably to connect it with the ancient Roman mythic goddess of love and thence to the ancient Greek Aphrodite. The figurine is also presumed to be a celebration of fertility, though what this

means I am not sure. One's fertility, and especially that of women, is not celebrated in a substantial positive way at present. It is a difficult area. But that stance endures today and is remade again and again, connecting the modern to the ancient and the mythic. It is physically present.[17]

The little *Venus* does hold a kind of truth. It has 'a feeling of purpose and contentment, well represented in the balance struck between symbolic overstatement and the possibilities of real life.'[18] To be a woman, to have children, to feed those children and watch your body change, is amazing and the figurine condenses all this into a powerful, symbolic and memorable image of the essence of being. The satisfying nature of a shape and surface is something we judge not only with our eyes but with our memories and associations of physical experiences too.

Given the scale (11cm high) and shape of the *Venus of Willendorf*, with no feet to speak of to support its rotundness, it is felt that this figurine could have been made with the purpose of being held in the hand. In which case its strange and generous proportions would be explained very differently through the sensual experience of its feel in the palm of the hand, and through the fingertips. The desire to reach out and touch to understand a subject is natural, and gives a truer understanding of what it is really like.

Giving the sculpture the title of *Venus*, with its association of beauty, seems a little strange today when society's idea of beauty would see such a figure as obese, in need of tummy tucks and as generally unflattering. Yet I believe that there is something eternal and true about the pose, when connected to the theme of fertility and the sensations a woman feels when pregnant.

Exaggeration and Distortion

As with the generous shape of the *Venus*, celebrating all that is womanly, it is important to enhance what is important about a pose and situation when you are creating an image. When students are working from the figure I often ask them to exaggerate and distort the shapes in their drawing deliberately in order to strengthen their work.

One learns nothing about a subject by being conservative and predictable. The importance of exaggerated qualities in a painting and drawing are not there to shock or be ridiculous, loud or crude. They are there to help make the image clearer, more specific and more personal. When it is done with conviction, and empathy with the subject, the viewer will look at it and not feel that it is distorted, they will feel that it is perfectly proportioned and they will read it as a whole image. However brave and outrageous it might feel to attempt, once it is achieved

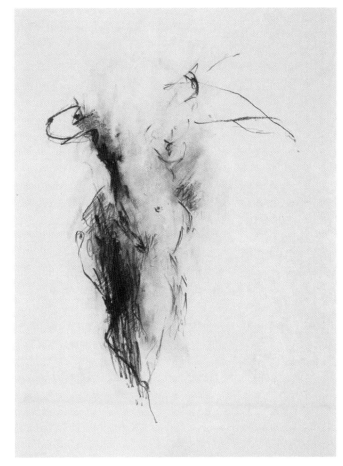

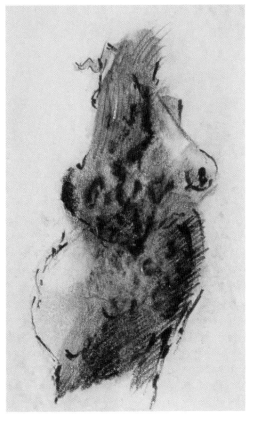

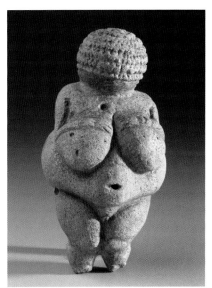

Eype Venus 1–4 **by John Skinner**
and the *Venus de Willendorf*.
(© Naturhistorisches Museum, Wien.
Photo: Alice Schumacher)

Exercise 8. Exaggeration and Distortion

This is a quick drawing exercise (it should take a maximum of ten to fifteen minutes) that I suggest you do about five times to really get into the swing of it.

1. USING CHARCOAL, PENCIL OR INK

YOU WILL NEED:

- about five sheets of A1 or A2 paper
- a stick of charcoal or a chunky pencil or ink and a brush (or perhaps a piece of charcoal tied onto a bamboo stick to create distance from yourself and the paper, therefore giving you a little less control)
- a model.

TO BEGIN

- With the model as the subject, look at the pose carefully and consider what is most important to you about the feel of it. (As for the previous exercise, it helps to do the pose yourself if possible.)

TO PROCEED

- As you draw deliberately distort, exaggerate and emphasize a part or parts of the body, and/or exaggerate the mark and shape to do this. You could elongate, enlarge, reduce, press harder, blacken or repeat a shape.

TO FINISH

- Review your work and repeat until you feel you have achieved the desired effect. The first time I ask students to do this they are usually too mild and restrained and the drawing continues to look bland and ordinary. Then they recognize that what felt clear at the time needs to brought up a notch or two in order to register on the drawing.

2. USING PAINT

YOU WILL NEED:

- paper, board or canvas
- a rag
- a rigger brush
- a selection of paints
- a model.

TO BEGIN

- Mix three different colours, of different hues (for example, a rich, dark green, tomato red and lilac). Make large quantities of each and make sure that they vary in tone, using either acrylics or oils.
- Look at the model and consider their pose carefully (again, try it yourself if possible). Choose a colour and, using your rag, create a generous and beautiful shape that exaggerates the whole pose (from top to toe).

TO PROCEED

- Choose one of the other colours and load your rag again and reinforce the shape: improve it, exaggerate it and perhaps move it to test if it is in the right position.
- Stand back and look at it. Is it an exciting and beautiful shape just on its own merits? If the answer is no then do it again. You can use your hand to slide the paint together to stretch the shape and then with either the first or second colour reiterate the form again to make it clear.

TO FINISH

- When you are happy with the shape load the rigger brush with the third colour and add just the eyes, nose and mouth. Assess the image again and decide if you need to include a couple of other marks with the rigger brush to help emphasize the pose or perhaps to reposition the features.
- Do the process again on a fresh surface to practise being clear and brave. Get a visual shock!

Not only is this exercise liberating but it also gives both artists and students a more deliberate touch. It is essential to consider what is important before you begin working, rather than just ambling along and hoping something will happen by itself.

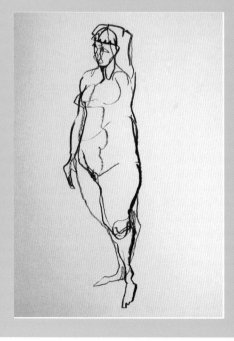

Standing Figure
by Steve Thompson
(charcoal).

the look of it will be an integral part of the work: deliberate and intentional.

While interviewing Francis Bacon, David Sylvester commented that Bacon's work is often viewed as being distorted and blurred, that it has taken liberties. Francis Bacon's answer is considered and contextual; he refers to his painting being created in a time when photography has taken away one of the potentials of painting to record and instead offers up the idea that painting can give instead a condensed reality.

> The artist has to really wash the realism back onto the nervous system by his invention.
> **Francis Bacon** [19]

The physical presence of the paint, the inclusiveness of the shape and the power to enhance and create a whole new understanding of a subject can be very effective if the artist can move into this way of celebrating their selection and organization of the work. It does not matter if you like Francis Bacon's work or not. His developed and finely tuned philosophy provides the artist a fresh avenue to explore and consider.

Giving a Gift (Preparation for Drawing and Painting a Moving Figure)

It can be difficult to generate a surprise for yourself when working alone in your studio. We get very used to our own work, our own touch and marks and subsequently we repeat constantly our habits and movements. Making the work becomes a form of self-hypnosis. Whereas to be faced with someone else's marks and selection can open up new possibilities and forces you to respond to the work without preconception. Your eyes have to roam the unfamiliar territory looking for some way in, some way to make a connection.

When I am working with a new group of students I find that this next exercise is very helpful for making them open their eyes to their repetitive habits and to stimulate their skills of improvisation, whether in drawing or painting. It prepares them to work from the figure in a braver, more opportunistic fashion.

The exercise meets with mixed reactions. Some relish the release and the lack of responsibility to the outcome of the work. Others feel a dreadful anxiety that they will 'ruin' other people's work, unfortunately revealing their low creative self-esteem. However, by the end of the process everyone always feels energized and surprised at the creative nourishment they have inin gained from the process.

Exercise 9. Giving a Gift

This is a group exercise, for between three and twelve people, which involves responding to and adding to a piece of work begun by someone else. I refer to this exercise as 'giving a gift' because:

- The act of generosity within the work is something that we need to permit ourselves to do (both physically with the materials and mentally with our judgement).
- It gives a contrast, a refreshing shift of attention and touch that can make one snap out of self-hypnosis.
- Change is an inevitable and necessary thing as the work develops, so let us not be negative about it!

YOU WILL NEED:

- a piece of canvas, board or paper for each participant
- any variety of art materials such as charcoal, ink, paint, rags and brushes.

TO BEGIN

- Everyone should start by creating a piece of mark making (as suggested in Chapter 1) with paints, brushes, rags and mixed media.
- After five to ten minutes of working leave all your equipment and work behind, in your space, and move so that you are standing in front of a piece belonging to someone else.

TO PROCEED

- Each person has to then respond to what is in front of them, sometimes working on top of and changing the previous marks, sometimes introducing a totally new touch and vocabulary.
- After a few minutes everyone should move again and respond afresh to a new piece of work.

TO FINISH

- Continue to rotate around the room until every person has worked on each piece once and then stop.
- You can discuss the visual effects achieved and how it felt to do the exercise. How do you take the positive experience back into your work?

71

Exercise 10. Drawing from a Moving Model

You can both draw and/or paint for this exercise. It is less 'step by step' than other exercises because the pace and subject forces you to react instinctively. The order of the steps is therefore a moveable feast – concentrate on the enjoyment and creativity of the experience.

INSTRUCTIONS FOR THE MODEL

- For the first couple of drawings or paintings I often start students off gently by asking the model to do a standing pose and every minute or so ask her to turn a little on the same spot. This helps students to get into the idea of how to select and build the work from a fixed distance from the model.
- For further work I ask the model to move at a very leisurely pace around the room, perhaps pausing along the way to perch on a table near someone or lean into their space to say hello and look at their drawing, so that everyone gets to see the figure from all the viewpoints, at close proximity and far away. Encourage the model to improvise and move however she feels she wants to at any given time.

ADVICE FOR THE ARTIST

- Remember, the aim is not to produce on a single sheet of paper twenty recognizable images of every single viewpoint you see as the model moves, or even on separate sheets for that matter. It is about finding ways of selecting and combining different information together to produce one image.
- If you only manage to put down two marks that feel good every time the model moves then this is better than fifty that are panicky and inarticulate.

- Take a few seconds to look before you draw. Remember the other exercises we have done: empathize with the feel of the whole pose.
- As the model moves you should draw and select from whatever is in your view at that given moment.
- Plonk one piece of information on top of another, allowing unexpected shapes and forms to evolve.
- Make marks that stroke and move across small areas of the body that will be layered on top of others.
- Take it slowly. Resist the temptation to rush just because you are anxious that the model is about to move at any second.
- Continue working even if you think your drawing just looks like a mess of marks and lines. The image will be pulled out of this chaos.
- At certain stages in the work it may be necessary to pare down the marks, edit, amalgamate or link areas together to find your image.
- Look for essential details that can help to pull the image together, such as the eyes, nose, mouth, hands and feet. In doing so you may find that the form of the body emerges without unnecessary tidying.
- You need to be watching the work like a hawk, ready to swoop in to seize a wonderful opportunity that has arisen from unexpected shapes and possibilities as they have fallen on top of each other.
- Remember my paragraph earlier in this chapter about the game. Your work might be completed in five minutes or forty minutes. It will depend on your drawing and how alert you are to the possibilities.

The Moving Figure

Creating paintings and drawings from a moving model is an exciting process and one that gives many more creative possibilities than working from a static figure. Whether it means that the model moves or the artist moves around the figure, it produces work that is a departure from copying and illustrating. It could be that the final image has the appearance of a back view but the image may be a result of multiple views layered on top of each other and then edited, for example.

Working from a moving figure encourages intuitive sifting and selecting. The movement brings a change of pace to the drawing, a sense of urgency and constantly changing spatial relationships: the figure to the space and the artist to the model.

All these things necessitate an impulsive response. With a problem to solve our brain and hand work more closely together. There is less time for worrying and attempting to transfer our ideas into an image; the resulting work comes into existence rather than being imposed. The form it takes is very real and tangible but on its own terms. The drawing dictates the aspect of the figure to focus upon, not your anticipated idea.

> The virility of drawing (and painting) lies in the immediate necessity to make decisions – with it departs the fears and the funk, and to that it owes its vibrant qualities. The hand works at high tension and organizes as it simplifies, reducing to barest essentials, stripping all irrelevant matter obstructing the rapidly forming organization that

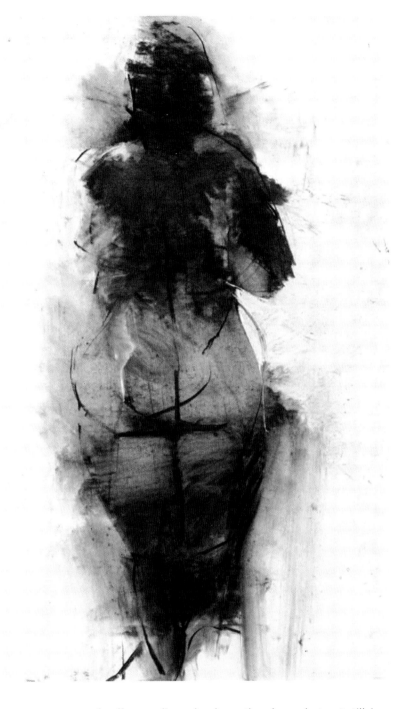

Turning Figure **by Emily Ball (charcoal).**

reveals the design. As the drawing shapes, so does its mood reveal the character in form combinations, all else is subordinated to this end on impulse. Style is ephemeral – form is eternal.[20]

David Bomberg

You could argue, 'Why make life so difficult for yourself?' I would respond that the idea of a posed figure and a single viewpoint is a very false situation. Our everyday experiences of people are often fleeting. If someone is sitting with you they are possibly talking to you, or engaged in some activity: sipping a cup of coffee, reading a book, on the phone, but not still (*see* Chapter 5 for more about this). Whilst consumed in our daily activities our physical distance from and viewpoint of others is constantly changing too. Whether shaking hands, brushing past, embracing or avoiding we are constantly making decisions about our physical orientation to people. These are our real contacts with others.

Working from a moving model in the studio is therefore good preparation for dealing with how to make a response to the world beyond ourselves. It provides a controlled environment in which to practise methods of coping, selecting and inventing

how you pull together an image of one figure from a bundle of overlapping snippets of information from multiple views.

The *Flora* story

The illustration of the figure painting called *Flora* is a very successful example of the results of selecting from a moving figure. She arrived after what felt like an unpromising start. I was on one of John's courses in Dorset and I had dragged myself to the studio feeling absolutely awful with a bad cold. I was putting down marks on my paper diligently as the model walked around the room, but my work felt woolly, unparticular and unengaged. John swiftly organized a remedy and suddenly instructed the model to come and stand right next to me, which she did – but not in standoffish way. She folded her arms under her breasts, lifted them up for me to have a better look and leant right into my personal space. It was better than any cold

Exercise 11. Sculptural Images from Vertical Lines

I find the most helpful description of this exercise is to imagine lines of threads hanging from the ceiling, perhaps half a centimetre apart. If a figure stood in this space the threads would fall across the body rather than vertically straight down. What you are drawing is where and how the form of the figure pushes and displaces the line. You are observing where the line touches the undulating surface of the body and recording how it rises and falls. As well as the influence of the sculpture this exercise also grew out of the confident line-drawing exercise in Chapter 2, focusing on the control and feeling of moving down or up the paper whilst exercising even pressure and speed.

Doing this exercise makes students aware of the importance of the following:

- breaking the repetitive habit of relying on the outline around the body to make the image appear;
- being patient about allowing the form to grow and appear gradually in the drawing; and
- being aware of the three-dimensional form curving towards them – the figure is not flat or symmetrical.

YOU WILL NEED:
- A1 cartridge paper
- a piece of charcoal.

- Start at the top and drop a straight line down the left-hand side of the paper with your charcoal. Make it a confident and steady line.
- Look at the figure and imagine the threads. You can do a few more straight lines at the side of the paper to warm yourself up to find the figure. When the edge of the model's body is in range then the lines will change direction and follow the contour of the particular part of the body it is touching.
- Every single strand will fall in a slightly different way, governed by the body shape underneath.
- Begin drawing strands down through the body, paying close attention to the subtle changes of direction on the figure. Draw from the top downwards each time.

- You do not have to place the lines the same distance apart, you can choose to leave larger gaps or concertina some lines together more closely.

The drawings produced have a very sensual and sculptural quality. You could devise many themes and variations for this exercise, adding in features amongst the network of lines, smudging and linking areas, and so on.

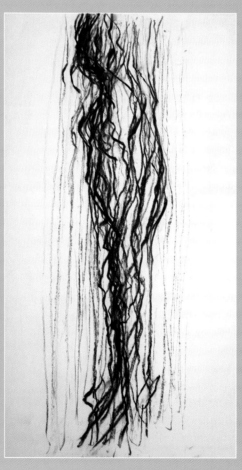

Emerging Figure by Steve Thompson (charcoal).

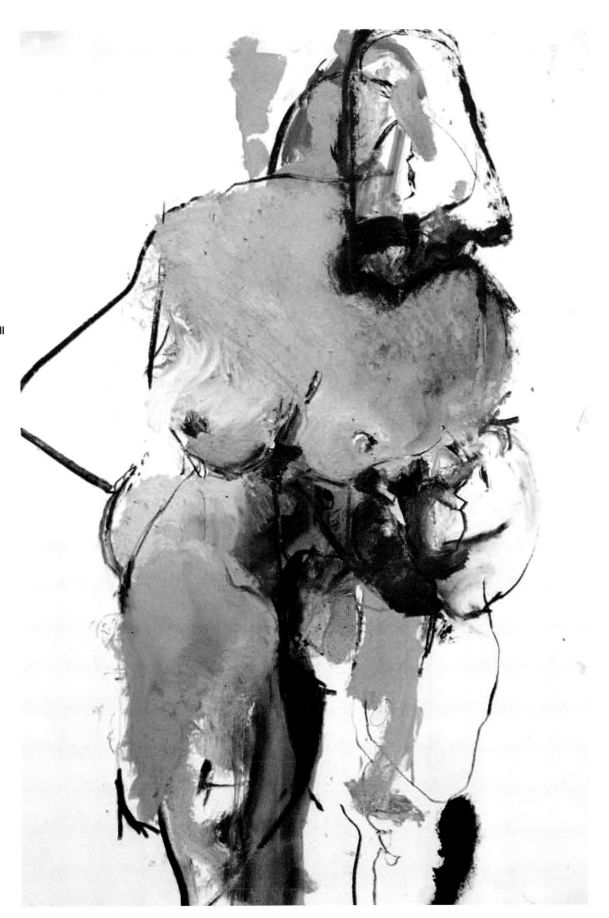

Flora **by Emily Ball (oil and charcoal on paper).**

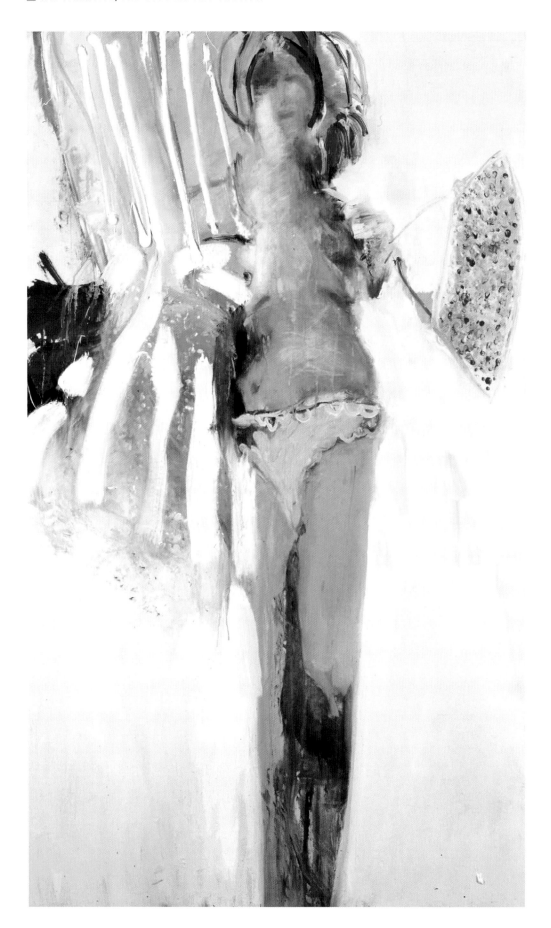

LEFT AND OPPOSITE:
Fluff and Feathers 1–3
by Gail Elson (oil on canvas).

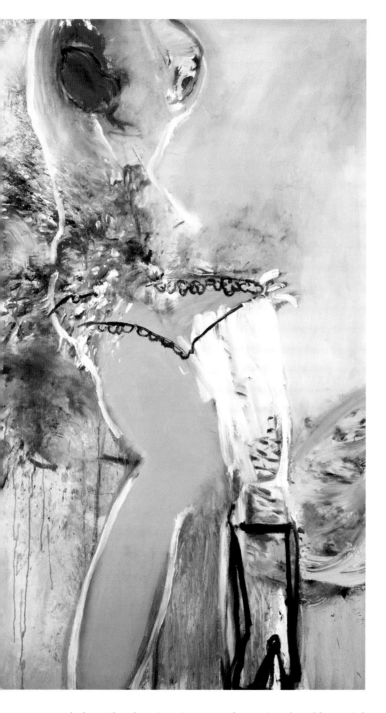

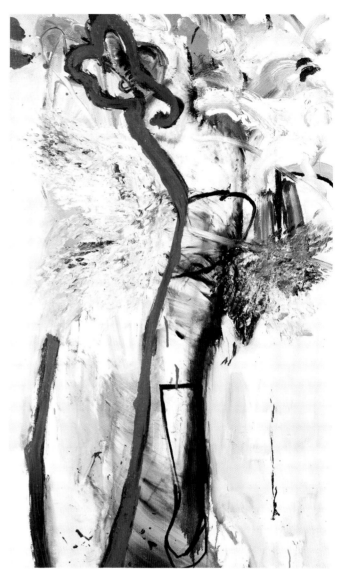

Flora was also a gift from the model. Her character and humour had come through in the poses she offered and this lifted the painting from being a product of a tired process of recording to a vital image.

remedy from the chemist – it was confrontational and fantastic! I painted with such a sense of purpose and celebration of this voluptuous woman standing next to me that in a very short time the painting was done. All the previous gathered and layered marks had been pulled together and the image of *Flora* arrived.

She was so named after the Roman Goddess of flowers, spring and fertility because of her abundance. The image and experience of creating the work had been such a 'gift' and reminder for me to stop messing about and being shy, vague and distant, but instead to be engaged, bold, sensitive and move in to find the figure with a sense of urgency and purpose.

The Clothed Figure

At the Africa Exhibition at the Royal Academy in 1995 (mentioned in Chapter 2, page 41) there was a room with Egyptian sculpture displayed. Once again a particular piece stood out for me. It was very small, but hypnotizing and beautiful. The sculpture is thought to be of Queen Nefertiti. All that remains of it is the torso. The modelling and detail give the feel of her body draped in a sheer, clingy, pleated dress. The way the fabric skims the body heightens the curvaceous sensuality of the female form, reveal-

ing more than it conceals. Seeing this inspired me to create an exercise (*see* page 74) to help my students to explore the form of the figure using this idea of line skimming the form of the body vertically.

Dressing-up

Over a five-year period Gail Elson produced a remarkable body of work connected to the sensual figure. They are autobiographical paintings, yet they are not self-portraits. Gail is very diffident about how she arrives at her work. She claims to have no ideas and to lack the ability to intellectualize her thoughts. Yet when she is painting she is the most incredibly articulate person. She may hesitate, falter and shy away from talking about her work but every brush mark and charcoal line carries a rich, confident and sensual language of experiences.

The three paintings illustrated on the previous page are from a series of works and were inspired by the film *Moulin Rouge*. Gail made small, quick studies of the dancing girls from the television. She was trying to capture the fluff and feathers, the reams of material, glitter, flashes of bright colour and glimpses of frilly knickers and flesh. From these studies she made further larger drawings, taking elements from each and playing with the feel of the image. However, she was aware that this was not enough from which to develop a successful painting. She needed a closer and more personal experience of the subject. A dressing-up session was needed; Gail was the model and I was the photographer. Gail recalls:

> I wore a pink sequined Indian skirt, a fluffy feather boa, high black boots, stockings, a pink bra, exposed flesh and had glistening lips. I was photographed as I twirled and danced. I wore the dress as I painted. I painted what it felt

Oscar Ladies 1–3 by Gail Elson (oil on canvas).

La Cornichienne
Poses in the
Glossies 3
by John Skinner (oil
on board).

like on my skin, how it moved and where it was heavy as I moved. Then there were more drawings and then still more photos.[21]

For Gail it was important to wear the clothes, to be aware of the sensual feel and weight of the fabric as it moved, to feel the space under the skirt and to feel sexy. After all, the *Moulin Rouge* dancing girls were about eroticism and entertainment. The three six-foot high paintings illustrated harness the humour, the sexy and the sensual qualities of the subject. They have a direct and primitive quality, which gives them their energy and seduction.

Following on from these painting came more women, this time with a different mood – less flamboyant but equally erotic:

The *Oscar Ladies* were painted after the *Moulin Rouge* triptych and were named after they were completed. A silver dress hung in the studio, limp on a hanger, and I began to make drawings in charcoal and acrylics. My subject became thin women in elegant dresses, tight lipped, a line for the nose and a repeated tight lip on a stick for the fanny.[22]

Gail worked rapidly over nine days on half a dozen six-foot-tall canvases. She went through a process of repeatedly applying the paint and washing it back and applying it again until the layered marks, the alchemy created with the paint, had simultaneously created the sensuality of the fabric and body. At every stage of making her marks she questioned and pushed the appropriate quality of the paint to correspond with the feel of fluffy, silky, clingy or glitzy until it felt right. One of the dress-

*La Cornichienne
Checks her Face*
**by John Skinner
(oil on board).**

es has a fabulous feel of the body being shrink-wrapped in a wrinkly skin. The paint surface has this feeling because an excess of linseed oil was added to the paint and the top layer dried faster than the bulk of the paint beneath, giving this beautiful wrinkled surface.

After creating the bodies and dresses came the faces. Their simplicity belies how tricky they are to capture. Each head was painted and repainted many times before Gail was satisfied with the character of the gaze. She was less concerned with the sensual texture of the surface to give the presence of the person but more with the expression and direction of the gaze and the pout of the mouth. The mouth is often mirrored in the dress as a description of the 'fanny' showing through the transparent fabric, like a modern-day Nefertiti. These pared down, tall, lean images hover in the space of the painting, their gaze and pout having a film-star posed quality.

Girls and Glossies

John Skinner's interest in the figure is ever present in his work. Throughout his career he has made paintings in response to models in his studio, people on the beach from his painting travels in the south of France and from looking at glossy fashion magazines.

From 2004–05 John made a beautiful collection of work titled *Girls*. I asked him how the work came about. His explanation gives us some idea of his train of thought, how he makes connections and uses them in his work, but it also demonstrates that all these things are just a jumping-off point for the work. It creates its own voice as it develops:

> I tried to paint portraits of Rowan and Mary and Sarah my
> niece but destroyed them. I saw the Armani Show in

81

Bilbao. The presentation of the clothes there was absolutely inspiring, better than any of the art. I was given tickets to London Fashion week (hideous). Then I was interested in the reversal of mores with the bra strap – clothes now being designed specifically to reveal the bra strap or with multiple bra straps. I said to Mary that they would do it with knickers soon and then we were at an Eroski supermarket in Spain and in the window was a mannequin with multiple pants showing above a skirt![23]

La Cornichienne

The series of *La Cornichienne...* paintings were all started at La Corniche in Sete and were a response to events that appeared beyond the doors of his camper van that was parked near the beach. John described what he saw: 'The girls doing exercises on the beach and in the water ... skinny dipping in a storm ... doing their makeup and just posing on the beach.'

None of these scenes are particularly remarkable when stated in this way. However, John extracted information from this spectacle and created images that stop you in your tracks, they are both beautiful and curious. Vivid and luminous colours spread across the figures and the spaces. In *La Cornichienne in the glossies 3* the figure is standing, head down, with her hands above her breasts in a pose that is not dissimilar to the *Venus de Willendorf*. Her body floats in a block of deep crimson picked out by the lines along the edge of her body. There is a simple yet effective rhythm of lines, stripes and straps: the chunky, vertical mint-green ones harness the space and contain the figure all in one move; the bra straps give form to the shoulders; the lines of the lapping sea echo the lines that describe the fingers and hands.

John has a sharp eye for details that give both content and form to the painting. He brought an important motif to my attention: 'If you look carefully you will see the Orion constellation in some of them. When I lay in bed in the van at night I could see Orion through the window. The moon is there as well.' After he told me this I went back to the paintings and looked and there was the small, pale circle of light lifted out of the paint surface. I had not noticed it before and was unaware of its significance. The following day I was driving home from work and saw the moon, full, soft and luminous. I recognized it but at the same time saw it as I had not seen it before. John's image of the moon in his painting had made me connect with what I was seeing, so I was conscious of it in a way that was more poignant and beautiful than I could have imagined. The way he paints his figures has the same affect on me – as a good painting should!

The Girl in Green was the last in the series. What you will not be able to see in this reproduction is just how glossy and seductive this painting is when seen in person. John likes shiny surfaces and paints onto thick, white, acrylic sheet with an oil paint and resin medium. The smooth surface allows the paint to sit in translucent pools to create a luminous and sharply focused image. When you see it in the flesh the image leaps off the wall as though there is a light shining behind it. On the girl's head there is no line beneath the chin to separate the head from the neck. The face, tipped to one side, melts into the neck and the scooped shape of chest above the dress. It creates a sensual area of milky, soft skin. The curvaceous form of the green dress shimmers with the help of the red shadow behind the body and the subtle layering of shades of green marks. It all seems so simple but it took a couple of years to complete, and yet it still retains a freshness and clarity. It is a beautiful painting. It demonstrates not only John's great skill with his medium but his ability to bring together all the qualities that have been discussed in this chapter in response to the figure.

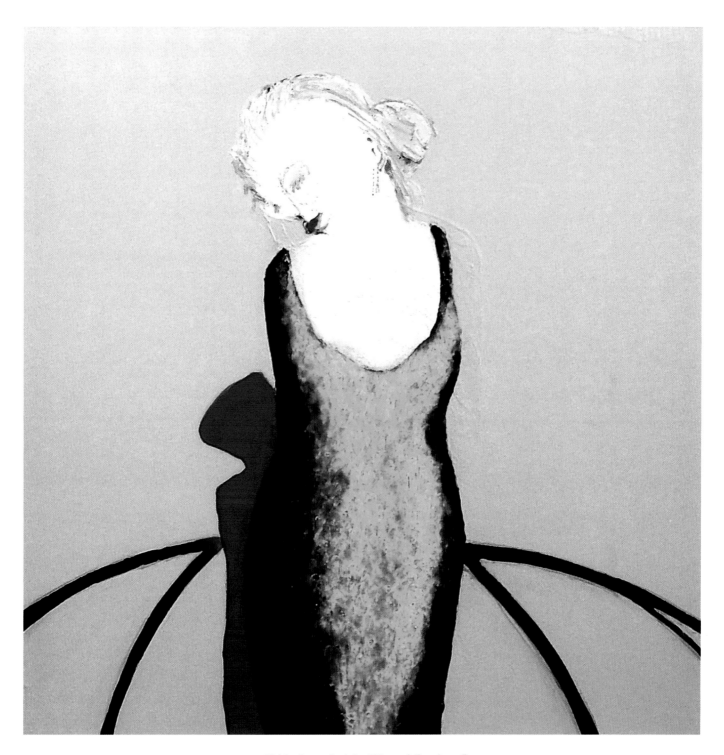

Girl in Green **by John Skinner (oil on board).**

Breakfast Time by Emily Ball (oil on canvas).

OUT OF THE ORDINARY

Emily's paintings celebrate the ordinary and prosaic qualities of life. They delight in capturing moments of the mundane, of taking a sideways glance at the familiar.

Jane Nash [26]

Creating paintings provides a space for contemplation; it is a love affair with image-making and a way of engaging and fulfilling a need to make a tactile, visual response to the world beyond ourself.

When I first began my career as an artist I used to take myself off to bleak bits of landscape, in all weathers, with a rucksack full of paints on my back and large canvases under my arms, ready to embrace the landscape with paint. For many years this very physical and raw experience worked well for me and my work, but there came a time when it felt like too much of a routine rather than an experience that seemed vital and enriching. So I had to look elsewhere.

I had not realized that the inspiration for my work could be under my nose. It came as a wonderful revelation to me to discover that my day-to-day chores, my interaction with the people I love, and the objects in my home and garden, could all become the subjects for my work. The mundane and domestic aspects of life have now become full of moments over which to celebrate and linger, rather than a daily grind of predictable necessity.

This chapter looks at work that the familiar, unglamorous and everyday situations and subjects have inspired in me, together with a selection of other artists' work. Our discoveries and struggles from creating the work are shared here to help give you insights and ideas for your own working practice. In some paintings the objects and images are placed in time and history by reference to contemporary objects and situations, as with *Girl on a Phone* by John Skinner. Other images show timeless observations of people and familiar situations revisited time and again by artists throughout history, like the relationship between mother and child.

This chapter is about:

- the relevance of space when composing an image;
- putting the figure in a context, in a space or composed with objects;
- creating paintings where the figure is engaged in doing something familiar and 'everyday';
- how to make studies and use them to make a body of work;
- working in a series, with repetition and development of an idea;
- exercises that look at the idea of 'pick and plonk' – inventive compositions and unconventional space; and
- looking at the work of five artists and their various approaches and resulting images.

A Space for Contemplation

Before we tackle anything to do with the complicated organization of putting figures in spaces, and juggling four motifs at once, I think it is important to turn our attention to what it feels like, and what it means, to compose and work with marks within the defined space of the paper or canvas. This is important because we often forget that once involved in a painting every move, each addition of a fresh mark, changes the impact of the previous marks. The relationships are critical and finely tuned. Exercise 12 has no subject, it just moves the artist to ask very different questions when viewing the work as it progresses and changes.

Once you have done this exercise it may be helpful to look at some artists' work to see if you can see this visual, spatial game being played with the way the open areas and forms talk to each other. Matisse's work is good to consider in this way as his clarity with shapes and colours makes the rhythms and relationships sing out. In the book *Matisse on Art: Notes of a Painter* Matisse talks about the difficulties of the balance and dialogue between marks:

If I put a black dot on a sheet of white paper, the dot will be visible no matter how far away I hold it: it is a clear notation. But beside this dot I place another, and then a third, and then there is confusion. In order for the first dot to maintain its value I must enlarge it as I put other marks on the paper.[27]

You do not want to be paralysed by analysis while you are doing your painting, but with practice your intuition will tell you when aspects of your work do not flow or connect. Being able to work with the whole image (not just parts of it) will help to unify it.

Imagination

I remember being told at college by one of my tutors that part of the problem with my work, at that time, was that I had no imagination. Unfortunately he did not go further and qualify what he meant by this and I was too shy and lacking in confidence to ask for a full explanation. I assumed he meant that I had no ability to create images that went beyond the predictable. I thought that imagination was something that you either had or did not. I thought that without that ability my work would always be pedestrian and predictable; the tutor should not have been so flippant and I should have asked more questions.

I have since discovered that images do not arrive out of the ether, or by some blinding flash of inspiration, they are formed through the process of working with the inherent expressive qualities of the paint and the artist's ability to take information, to play with it, take it apart, put it back together in a different order, harness the accidents and apply it to their knowledge and feeling for the subject.

> Imagination is always considered to be the faculty of forming images. But it is rather the faculty of deforming the images, of freeing our selves from the immediate images; it is especially the faculty of changing images.
> **Gaston Bachelard** [28]

The Best Laid Plans

The prospect of having some time to paint is often exciting. You choose your subject and get prepared with lots of studies from first-hand experience, drawings from your drawings and some photographs. Then you set out your canvas or prepared paper and get your paints out and start. It can all begin well but before long it often becomes disappointing and dispiriting. All your enthusiasm for what had at first seemed like an inspiring subject and a brilliant idea rapidly wanes and is replaced by diminishing confidence.

The first trap many students fall into is trying to copy their drawings into paintings. Do not go there! Planning your paintings by drawing in outline and organizing your composition to then fill in will not work. You need to 'wing it' and paint 'by the seat of your pants', so to speak. Your studies will be helpful; they give a vocabulary of marks and the position and a feel of the subject, but what happens as you paint is altogether more complex and exciting.

For many students this is a tricky and scary concept. Many fear chaos and that muddy paint will appear from their indecision, but mostly they have the misguided notion that they need to know what they are doing, that they must have an image in their head towards which they are striving. However, this kind of pre-planning is the kiss of death for any good painting. You need to ride the wave when you are painting: be positive and clear. Look in the parts of the painting that seem ugly and messy for all the next moves and enjoy the game.

New Beginnings: The Bath Paintings

I produced a total of five bath paintings, two of which are illustrated here. They represent the beginning of my interest in working from 'the ordinary'. Before I embarked on these paintings I had reached a difficult, and unsatisfying, phase in my work. I did not know what I wanted to paint. I became aware that new ideas were not coming from the work itself. I regularly felt numb and blind to the important and often trivial things that make an ordinary subject into something extraordinary. I felt that I rushed my work. I was impatient, had tunnel vision and was without the courage to be playful enough, in an irreverent way.

This work was to be my leap into the unknown through the familiar. In order to do this I had to de-familiarize all that I had taken for granted, and assumed I understood, about the way I put a painting together. I had to shift my focus within the subject I was going to paint.

I chose having a bath as my muse purely because I knew that whatever subject I was to paint had to be something to which I could refer easily, and I needed to be able to recall specific sensations connected to it. I had previously done a painting about cleaning my teeth (*see* Chapter 3), so having a bath was part of the daily ritual and as good as any other subject.

Exercise 12. Tipping the Balance

It is a common mistake to consider the empty, untouched areas of a painting as just blank, waiting to be filled in. However, spaces between objects have to have as much form and presence as any other piece of the work in order to add content and support to the whole image. Students can find this next exercise challenging because they have to make visual judgements based on what is happening to the whole composition on the paper. While doing this exercise you are going to practise being more sensitive to how the balance of the work feels, whether you can be aware of the impact of the size, direction and character of each mark on another. This is very good preparation for painting as it relies on slow, considered moves and sometimes subtle alterations for maximum effect rather than lots of scrubbing and padding.

YOU WILL NEED:
- an A1 piece of paper
- a range of drawing and painting materials and tools.

TO BEGIN
The white, blank paper is beautifully balanced, sitting still; the space has not been tampered with.

- Make one mark anywhere on the paper, with whichever tool or material you wish.

The perfect white space is now out of balance, the space begins to tip and spin. The distribution of space has changed. The way the eye travels around the paper is now guided, influenced by the mark.

- Your objective now is to prevent the space from moving. To ground it, make another mark somewhere in the space of the paper to hold the first mark in check (perhaps to echo it, or perhaps to contradict it with colour, scale or direction).

- If you have successfully balanced it then put it out of balance again, with the addition of a third mark. If it does not look unbalanced then try changing either the first or second mark until you can see a difference.

TO PROCEED
- If you feel that you have successfully put the piece out of balance then your challenge reverts to putting it back into balance. As the number of marks increase, the complexity of solving the problem becomes trickier and more demanding.
- Remember the space around the marks connects them as well as their size and type of shape, colour and direction, creating a visual association.
- If everything appears to float quite centrally then try a mark that hugs the edge of the paper to see how that changes the balance and sensation.
- If your marks are evenly spaced and of a similar scale then create greater extremes and contradiction to see how that feels.
- Keep checking with yourself each time so that you are noticing what effect your marks have on the whole space of the paper.

TO FINISH
- Sit and look at it. How does it feel? How does your eye travel from one mark to the other and around the whole paper? Is the arrangement anchored and balanced?

Throughout this exercise make sure you are looking at the whole sheet of paper and considering the whole composition after each move, before adding and changing elements within it.

Reinventing the familiar

The canvases measured 6ft by 3ft, deliberately a little taller than me. From the outset I knew I needed to strip the paintings of unnecessary seductive marks and to use colours that I found jarring and aesthetically uncomfortable. This would be done in order to reveal my bad habits and to stop myself from being hypnotized by any gestural painterly business that I had come to rely on as my language for all subject matter. There would be nowhere to hide ambiguous 'arty' paint. Any trickery would be exposed. The paintings had to be tough and clear, with every motif clearly described and relevant to the subject. At first the

challenge was paralysing but after the first bold move of creating the large, lime-green shape of the bath it then became liberating and had the desired effect of making me look, select and play in an entirely new way.

As the paintings progressed my friend and writer Jane Nash introduced me to the poem by Stevie Smith 'Not Waving But Drowning' and I immediately felt that the mood and subject of the writing could run parallel with my paintings; it could be borrowed to open up new connections for the visual language. The poem became linked with the titles of the work and seemed to encapsulate the mixture of drama and humour that became associated with them. Jane went on to write about the work:

OUT OF THE ORDINARY

The lime green is the brash, synthetic colour of a suburban bathroom. When this colour is coupled with aluminium paint, it immediately places me in a bathroom environment – I can almost smell the toothpaste! In *Im Not Sleeping* the painterly figure contrasts with the pristine surface of the bath space allowing the skin to appear malleable, melted, exhausted – in stark contrast with the cool bath. The differing qualities of the painted surface and subject create a painting that is at once hot and cold, ugly and beautiful.

Tension is further explored in the macabre and flippant mood of the work. The bath space has been mistaken for a coffin (perhaps unsurprisingly as both vessels are moulded to contain the body), and the body seems somehow separated from the head. However, the painting is denied any serious morbidity by the glibness of the bathroom details. Pink toenails, shower cap, tasselled rug, and the lime green bath (complete with anti-slip surface, taps and plug hole) all jar beautifully with the weight of the body and create a kind of balance that anchors the work. The combination of the sinister and the flippant gives the work a sense of poignancy that touches a vulnerable nerve within me. I respond to Emily's paintings physically because they are accessible, unpretentious and poetic images.[29]

Memory and association through spaces

Everything that influences our perception of the world around us is related to past experiences of particular places, times and meetings with objects and people. These experiences begin at birth as we learn to move and interact with the space and things in our immediate environment. The memory of each experience becomes added to a catalogue of information. Each reference is full of subtle details and combinations of moments that, when recalled, help us orientate ourselves from moment to moment, day to day, making sense of who we are now and how to orientate ourselves in a given moment.

The homes we live in, the furniture that we live with and the very cup we drink tea from, contribute to the building of associations and memories. These everyday spaces become extensions of ourselves: symbolic of our human rituals, aspirations, physical restrictions and needs. We are grounded and reassured by the familiarity of our surroundings. We can cross reference instantly and make sense of where we are in the world by the orientation of the objects around us, the scale of ourselves in relation to objects and our memories of first-hand experiences. So this is all very comforting.

But hang on a minute! I don't want to reassure and confirm what I already know. I want to find out about things that I don't

know, or perhaps I know them but I don't know what they look like, or maybe I know what they look like but have stopped being able to see them. I want to emphasize and explore things and experiences that have become overlooked. I want to savour afresh and decipher very particular gestures and rediscover the things that have become dissolved in the soup of habitual actions and expectations.

These spaces, and the objects and figures in them, offer possibilities for the artist to go beyond observations of a purely functional nature to associations that have the potential to move us, to touch a nerve – as Jane's description of the Bath paintings demonstrates.

It's not natural

The lime-green bath shapes are not supposed to appear like a real bath. They were partially observed, but mostly invented spaces. The shapes serve a number of purposes: to heighten the sensation of being in the bath, to make the bath take over the whole canvas and to create a depth in which to place the figure and bathroom furniture (within it and beyond it). Each painting has a different version of the green space in order to allow for new compositions and selections.

> Space is not the setting (real or logical) in which things are arranged, but the means whereby the position of things becomes possible. This means that instead of imagining it as a sort of ether in which things float, or conceiving it abstractly as the characteristic that they have in common we must think of it as the universal power enabling them to be connected.
> **M. Merleau-Ponty** [30]

The space of your paper or canvas provides an opportunity to make a new world, an artificial space, where you can place objects and spaces in whatever arrangement you see fit. Time and forms are compressed and layered, selected and reworked. The image has its own space and reality and is not a copy of a conventional space. All the motifs in the painting are having a conversation with each other, sometimes arguing but always working together to uncover how the image needs to feel to be resolved.

An image that unsettles our experience of the way we think things should look requires us to spend longer with it. Looking at the work becomes more engaging and perplexing. Its unfamiliar qualities make us search the surface and dig around in our experiences to find other ways of connecting to it. Reading it as a narrative does not work so we have to resort to an emotional and tactile approach. It can be as much about contemplation for the viewer as it is for the artist that made it.

LEFT: *I'm Not Sleeping 1* **and** (RIGHT) *Too Hot* **by Emily Ball (oil on canvas).**

Exercise 13. A Compositional Conversation

This exercise should take approximately fifteen minutes.

YOU WILL NEED:

- two sheets of A1 paper
- paints
- brushes
- some glue.

TO BEGIN

- Create a piece of mark making on A1 paper, as described in Chapter 1, and when there are a good number of marks all over it randomly tear it up into about five or six pieces.
- Choose just one torn piece that is striking or unexpected in its collection of marks.

TO PROCEED

- Take a clean piece of A1 paper and consider where in the space you would like to place the piece of torn mark making. Move it around until its position seems to offer the most possibilities.
- Stick the piece down.
- Now extend and develop from the marks on the torn paper and go on to create a composition, using the same materials you were using in the mark making.
- At first you need to repeat and mimic the original marks, making them grow outwards into the space beyond. Then you can return to the first marks and adapt, modify and invent a new response to the original trigger.

TO FINISH

- Stop as soon as you feel you have produced a striking piece. The aim is not to fill up the whole paper with marks, but to create a strong improvised composition.

Ripping the initial mark making is liberating and anti-precious. The sticking down and extending of the work into a composition requires you to tune in to recognizing the qualities and characteristics of only what is there in order to successfully develop the work. You must use the white of the paper as a shape, mark and form in its own right in order to create tension and balance.

Working in a Series

After I had my first child, William, I felt compelled to make drawings and paintings about him and his world. Far from it being a sentimental recording of my baby, it quickly became an ambitious body of work. I did many studies and paintings over the first twelve months of his life: watching how he moved around, the gestures he made and his gaze. I was getting to know him as I worked. These were all very valuable when it came to the creation of three significant paintings of William in the garden. The same motifs appear in each painting: William, the trampoline, the apple tree and the swing.

The significance and treatment of each motif

- **The position of Will** differs in each painting, as does his gaze and the treatment of his body. His scale and position set the tone for the other elements and heightens the feeling of him being a little child in a big, colourful world of play. In version three the body and head are painted in a fluid way, with less emphasis on the gaze. In the first two his gaze and sculptural head are very important and the treatment of his head and body contrast with the garish trampoline and heavy, structural tree.

- **The shape of the trampoline** is used as a platform on which Will sits. It is a shape that can surround him, to protect and give scale. In version one the shape is pulled and poured down to the bottom corner of the painting, providing a purple backdrop for the Will on the swing to really stand out. In version two the shape has been stretched upwards to the point that it feels more tent-like. In version three the colour has been sucked out of it, the interest instead being more connected to the hoop shape of the handle and the character of the legs and feet of the trampoline. On all three paintings the curved green handle with its loops and washers became an excellent connection from one part of the form to the spaces around it.

- **The tree and swing** elements have more of a supporting role to William and the trampoline. The string of the swing features repeatedly in different places on all the paintings; only in version one is he actually sitting on it. The tree helps to enclose the space of the painting. It is less about a painting of a tree than the feeling of being under the tree, looking through the branches.

I find that when working on three or more paintings, playing in this way, using the same motifs each time, you quickly

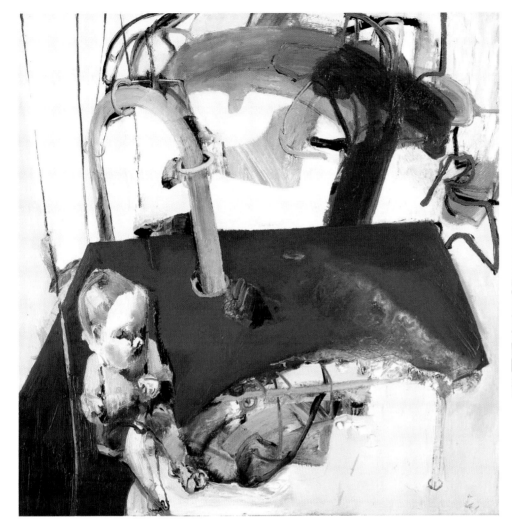

William in the Garden 1–3
by Emily Ball (oil on canvas).

recognize the most successful and satisfying composition. You work faster than you would if you struggled and deliberated over just one image. You begin one painting and take it to a stage that feels interesting but perhaps a little unclear or unfamiliar. Then you start the second with the purpose of pushing beyond the feeling of the first. When you start the second piece you can repeat the position, colours and elements that felt good in the first but can also be free to change and adapt them as necessary.

Each time you work you become more familiar with the visual language you have created and the shapes and spaces with which you are working. If the second attempt surpasses the first you can return to the first painting to make confident changes. I started the final painting of Will before the other two were finally resolved. It was a great release and I was confident by this point to strip away elements and colours to see how it would feel with a very different version. The third painting became the first to be resolved, followed by the first and then second.

Emphasis

Things are what they are; they say nothing on their own.
In copying them you only remark on their existence,
whereas if you select a direction in them, an emphasis,
then you are talking about yourself, your life.
John Epstein [31]

What is it that governs your choice of objects and their position? You need to demonstrate your connection to the object. Show yourself through the way you focus on and emphasize the character of the subject you are painting: exaggerate particular attributes and simplify others.

Inject life and volume into the motifs. A line, shape and colour must have a motivation. There can be no skimming the surface. As you work you are digging around to find a truth about the subject. Noticing the insignificant details and reminding yourself of the things that are taken for granted become necessary so that you can use them to lift and emphasize the image. As Jane Nash has commented in relation to my work:

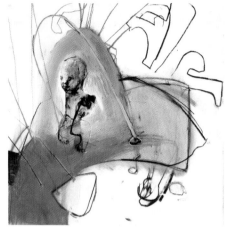

Will in the Garden studies 1 and 2
by Emily Ball (charcoal).

There must be hundreds of gardens where bright, garish trampolines are taken for granted and become accepted, ignored pieces of garden furniture; but in Emily's garden the alien object dominates the landscape. Its unusual shape, colour and texture is explored and accentuated with such vigour that the inanimate object actually develops its own character. Just like Will it seems to bounce and hum with energy.

The motifs' bright colours and bold shapes are in contrast to the way in which Will is described. His body is painted in a softer, sculptural way that reveals the way in which the artist has reconsidered and reworked the portrayal of her son, striving for a real likeness that is tangible not literal.

Will's World

With 'an unorthodox view' of composition the artist can arrange the elements in the work to suit the painting: to find an image that brings back a poetic version of the subject. My painting of *Will's World* certainly does this for me. The toys and furniture are scattered around the edges of the painting. This arrangement not only describes accurately the chaos of toys and untidiness in my home but also provides a huge space that reflects Will's smallness in his world. The zingy yellow is not the colour of my carpet, it is the third attempt at finding and editing colour that would animate the space, objects and sensation of William's soft, peachy, baby skin and his intense, inquisitive gaze, straight out of the painting.

The previous attempts at the right colour had been insipid beige and a rather clichéd baby blue. After these unsuccessful experiments at being gentle and subtle I realized that subtle was not the way to go for the painting. 'In-your-face yellow', however, did the trick and simultaneously helped to resolve the relationship between the space, the objects and Will – as well as banishing any lurking sentimentality that the more tasteful colours had encouraged.

The treatment of his head and face also arrived out of many unsuccessful attempts to capture his intense gaze and his baby-smooth chubbiness. After many layers, over many weeks, frustration eventually took hold and I picked up my large palette knife and repeatedly and systematically scraped all the paint that was still wet on the head, working from the top of his head to below the chin, creating a collar of muddy globs of paint. With the paint stripped away it revealed a history of delicate and

Exercise 14. Pick and Plonk

The term 'pick and plonk' comes from fellow artist and teacher Gail Elson. In true Gail style she stripped away any fancy, arty, academic ideas about composition and whittled it down to an intuitive and playful phrase. It really means what it says. It gives you the freedom to take shapes and marks from any studies or observed subjects and put them where you please, however you please, as many times as you like, in the space of the canvas and paper. It sounds preposterously simple and potentially chaotic, but, as with many of the exercises in this book, it is another means of freeing yourself from the ties of copying actuality. It also exercises your playful, intuitive and creative abilities.

YOU WILL NEED:

- a sheet of A1 paper divided into four equal pieces
- paints and brushes
- a piece of mark making or an existing study for a painting.

TO BEGIN

- Choose three shapes or marks from a piece of mark making or from an existing study for a painting. Ensure your choice is varied in character, weight and direction to give contrast when one mark sits next to, or on top of, another.
- On the first piece of paper copy, as best you can, one of the selected marks.
- Then add the second of the chosen marks or shapes somewhere in relation to the first mark.
- Finally, add the third mark to the composition.

TO PROCEED

- On the second piece of paper, using the same three marks as in the previous drawing, create an entirely different composition in the space. Be more daring in your organization. Deliberately overlap or push marks apart in the space of the paper.
- Follow the same procedure on the third piece of paper to create a composition that challenges the first two drawings.
- Finally, create the fourth drawing to challenge the previous three.

TO FINISH

- Lay out the four drawings and review how they feel to you. Which drawing is the most satisfying or surprising in composition?
- Keep the one you like most separate from the others and put it up on a wall or easel.
- You are now going to change and rework the three other drawings.

This exercise is for you to practise the idea of moving, layering and adjusting the composition. The results shown here are abstract compositions but the principle can be applied to forms that appear in your own paintings and drawings. Once you have done this exercise you will understand a little more clearly how the arrangement of the motifs in the William paintings came about. I moved them around in relation to one another until the painting gave back the right sensation of the subject. In the two drawings that are studies for the paintings it is also possible to see what I have used and adapted using this 'pick and plonk' approach.

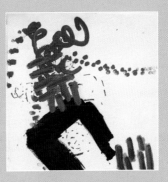
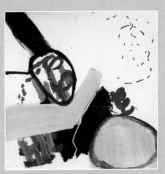

Composition exercise by Gail Elson (oil paint on paper).

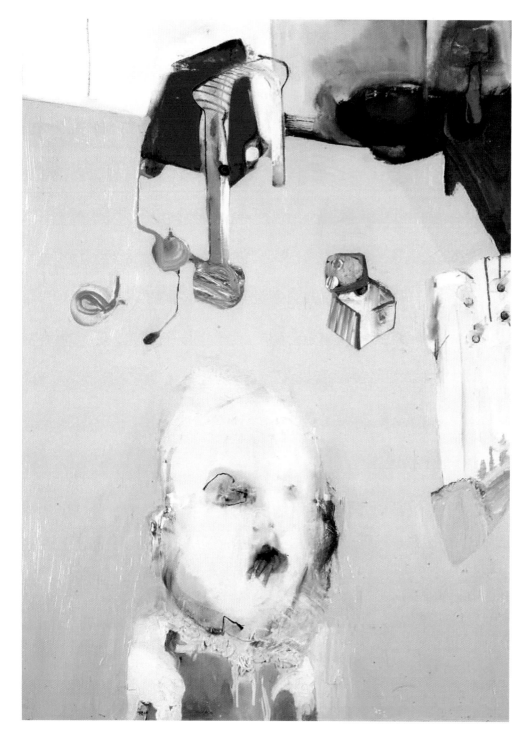

Will's World **by Emily Ball (oil on canvas).**

distressed paint underneath, which uncannily had just the right feel for him. With the bare minimum of marks to the eye, nose and mouth it seemed, miraculously, that the head had been resolved.

Different Views of the Familiar

The issues discussed in this chapter – the value and use of space in a painting, emphasis and imagination – affect all painters, but each of us approaches the challenge differently, according to our particular interests and personalities. For the rest of this chapter I will look at the work of four other artists. I shared some of my discussions with them about how their approach differs and connects with my own thoughts, starting with Georgia Hayes.

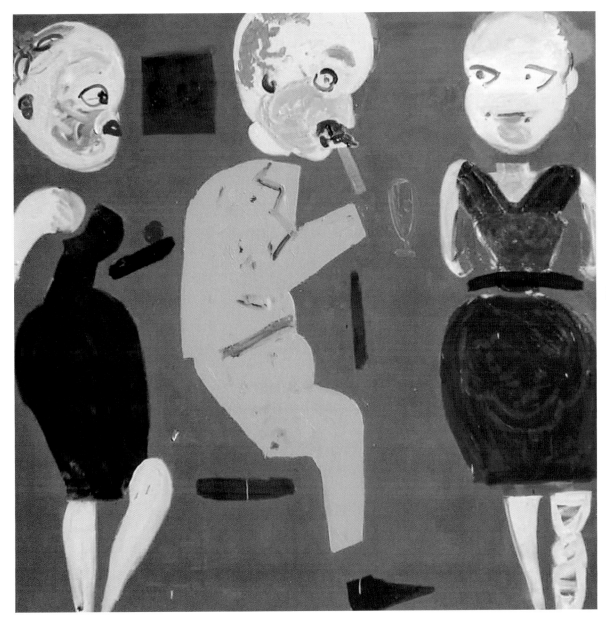

Red Restaurant
**by Georgia Hayes
(oil on canvas).**

Red Restaurant by Georgia Hayes

Georgia's paintings are 6ft square, bold, generous, uncompromising, uplifting and full of unsentimental empathy. Her process is risky and rigorous. She often starts by painting canvas a particular colour. This gives her something to kick against to create an instant dynamic with the marks that follow in the space. In the painting *Red Restaurant* Georgia pulls shapes apart to allow fresh air between the feet and legs and the head and body, dispensing with the neck and ankle. She gives herself the freedom to play, moving, reshaping, flattening and emphasizing all the elements in the work until it feels right. Georgia explains:

> If you see that the canvas doesn't have to hold an
> orthodox view – is a free space as colour can also be free

– then that increases the choices of expanding and contracting and making the rhythm and tensions sing. Of course we are hugely hampered and conditioned by photography which can present an orthodox and limited view all around us, so it's quite hard to get out of thinking like that. Perhaps it's the one wonderful freeing thing that abstraction did for us – showing us how to concentrate on unchained colour and form. I find it so much more interesting when you can put the subject and its particularity back in.[32]

In this painting the central green shape of the man's body is vivid against the deep pink space; flattened, simple, yet brilliantly describing his posture and activity, even down to the well-fed, bulging stomach. The waitresses' dresses, legs and

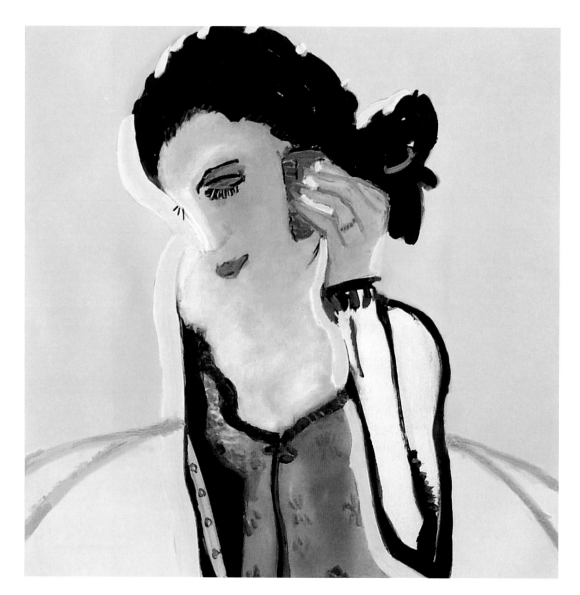

Girl on a Phone
**by John Skinner
(oil on board).**

arms are also shaped, synched and remodelled, not as a state-ment of fashion but as a means to give the maximum inform-ation about the movement and character, using minimal information. The expressions on the faces are equally econom-ical yet expressive, with the waitresses gazing attentively at the customer and the man engrossed, staring vacantly and eating his food. Georgia elaborates:

> *Red Restaurant* is from a series of paintings I did after
> eating on my own in a lunchtime restaurant patronized
> by Swiss businessmen. I watched the waitresses in frilly
> aprons delivering the orders. It was interesting to watch
> the interaction. I didn't like the first painting I did in this
> series, it was a struggle, but this is the third of three.
> I had to change the colours a lot to make it work and
> I took out a lot of objects and moved things around
> before it was finished.[33]

Girl on a Phone by John Skinner

A year after John had begun the *Girls* series he had a show at Lille in France. At the dinner party after the exhibition there was a girl who was constantly on the phone. In some ways he found this both charming and annoying. Present and not present at the same time. Shortly after this he started a painting about a girl talking on a phone. Like all the *Girls* paintings it was a strugglesome thing to make and was restarted many times. He had other versions on the go at the same time, all of which were destroyed. Leaving only the one painting and the one drawing.

When I first saw the painting I made the mistake of thinking that John's work had suddenly become more graphic. I was surprised not to see more evidence of his reshaping of the image, playfully reorganizing the form, challenging the viewer to engage with it and spend more time working out what was going on. However, I looked again to discover that reinvention of the figure was very much at work here. John has played a sub-

Dr Lacra's Cherry Frock **by Rose Wylie (oil on canvas).**

tle visual game of reduction and emphasis, melting away any hard definition of the jawline and allowing the rose-pink mouth to float in pink skin. Her clothes and their pattern hug the body, helping to define the form. The lime-green background accents the edge of the hair, the head, and the hand and arms to unify the image and the space of the painting. It all looks so deceptively simple. Yet it is its clarity that makes it such a startling image. What at first glance appeared to be a more representational image was in fact beautifully reduced, condensed and emphasized to produce a shining, fresh and beautiful painting.

This is a contemporary image. The presence of a mobile phone secures that fact, but John's experimentation with the shiny surface of the painting, using paint resin and oil pigments on a slippery, plastic surface, also contributes to its modernity. All the colours glow and shimmer. It is the acid colour and the tilt of the girl's head, absorbed in a downward gaze, which sets the mood, not just the fact that it includes a mobile phone. There is an intimacy in the observation of this pose, a pose generated by the strange phenomena of our times of often being an unwilling witness to people's private conversations made public. This object clasped to her ear has transported her focus and attention to another place. Her face conveys this absorbed moment, oblivious of everything else around her.

For some years now John has pursued shiny qualities in his paintings, striving to find ways to increase the glossiness of the surface. So, what's with 'the shiny'? Why is it important to him?

This quest for 'the shiny' is a continual search, for me, to get more and more response from the colours I use. Its most recent evolution started in response to working from cars. The shiny surface of cars is interesting because it immediately gives a sense of value and richness; only military vehicles have a matt surface associated with combat and death. In my research for 'the shiny' I spoke to paint manufacturers, the managers of art materials shops, other artists. Eventually, after a few years of searching, I found a Kremer Pigment alkyd medium which I imported from Germany, and is no longer available, which took 'the shiny' to another level and all the *Girls* series are made using this medium. So the technical aspect of paint and its usage is never a given thing for me and is always a significant part of developing a response. Even though I am far from technically minded and it often drives me to distraction.

You will also notice that from *As She Stepped Into Her Car* (1997) [illustrated in Chapter 7] onwards almost all the paintings have a curved horizon line creating an arena for the action. A response to the curve of the horizon I would see every day as I drove to the studio. Interestingly the horizon is an illusion that only exists as an image and keeps changing as we the observer change our position.[34]

Dr Lacra's Cherry Frock by Rose Wylie

The 14ft by 12ft Dr Lacra painting was made with the canvas flat on the studio floor. This is how Rose likes to work on all her paintings. She carries out the painting while standing on the canvas. The resulting footmarks and traces are never removed, as she likes to keep the evidence of the process of making the painting. As one painting is finished and dry she piles the next one on top to begin again. In one corner of the room there is a mountain of paint-covered newspaper used for wiping paint from the canvas and her brushes. Perhaps this desire to present no illusion, no pretence about how a painting comes into being, is part of what makes her images so direct, playful and vital. In spite of working amongst the debris, stepping through in the work, *Dr Lacra's Cherry Frock* is fresh and clear. So who are these girls in dresses?

I liked the photograph of a 30s star that the artist Dr Lacra used in a mixed-media work of his, which I'd seen. I liked the cherry print on her frock and the lit-up kind of smile on her face. These were the starting-off points, and the ones I wanted to spend most time with. The Lacra reproduction

was in black and white, but red seemed right for the cherries (and green for the leaves) and equally right for the Hollywood mouth. The dotted line was a jump and belongs I suppose more to imagination than emphasis.[35]

I love the fact that it could be a smile and the pattern on a dress that provides the motivation to begin a painting. It was Rose's decision to make a repeat of the girl wearing the cherry dress motif that linked it to some of her other work, borrowing from the idea of the 'flick book' and repeat in animation. By adding a friend on the right wearing checks not cherries, in a switch from fruit to geometry, there was contrast. But more to the point she, and her lined frock and her pleats, are made up. Rose told me:

> This could be one aspect of imagination in painting: I once heard from another friend that after seeing the actual fabric Matisse used in his paintings in a London exhibition, he no longer believed in the creativity of Matisse as he had done before, since he'd only copied the pattern of a real fabric, and not invented it himself. What next … but there you are … that is if creativity and imagination are in any way the same.[36]

Rose has not attempted to fill in the background of the work, so most of the canvas is empty. Part of the reason is to keep her paintings more like her drawings: exploratory, unclogged and allowing the air in around the figures. Also, like her drawings, which she often collages, she adds new strips of canvas to extend the painting:

> The joins in the canvas offer another type of space: the space of collage flexibility, and a physical ridge giving object quality to the painting. Most of my paintings evolve from drawings, and most of my drawings build with collage: so here both the painting and the drawing become very connected.

The appearance of the work can seem as though Rose does her paintings without needing to do any repainting, that the first decisions are impulsive and final. How else can she avoid tidying up and making it looked contrived? This is not the case. If necessary she will paint the same picture over and over again to get it right because she is striving for something very particular:

> It has to be like but unlike. There is a keen dividing line between the two.[37]

In the Studio by Roy Oxlade

The artist's studio is a timeless subject. Henri Matisse and Philip Guston are two artists who spring to mind who used this setting many times over in their work, to both of whom Roy Oxlade has made reference in our discussions about his own paintings in this book. For the artist the studio setting is familiar and functional, and the studio equipment and the space are neither beautiful nor profound. This allows the evolving painting to take centre stage as the subject, so the artist can play and invent. The studio provides the setting and freedom for new things to happen on the canvas with the artist animating each character, adding to and editing each motif to find where the image wishes to go. Roy Oxlade takes this theme for his painting In the Studio:

> I probably began this painting with a ground of Venetian Red. I've often used this colour as a hospitable opening. Subsequent events help to determine what may or may not combine to make a painting possible. Speculative marks remain just that, speculative, until their interaction suggest the possible arrival of the beginning of a 'painting', rather than some mere marks on a flat surface.[38]

The painting has a generous, expressive touch with the chunkiness of the application of the paint. Yet particularity is given by the details of the nuts, bolts, screws, clamps and electrical wire included in the forms, helping to bring out the subject and the characters within it. Roy Oxlade made the point to me that for him the space, imagination and emphasis all have equal importance in a painting. They need to work simultaneously together to produce a successful piece of work:

> Since everything in the painting depends upon everything else, nothing is superfluous and there is no emphasis on any particular feature. On the other hand, it is unlikely that the black elements, for example, particularly where there are representational details – the operational parts of the easels, the woman's anatomy and the wires of the lamp – will not be seen as focal points. The space in a painting is virtual and dependent for its success upon the satisfactory relationship of the parts. Everything counts; even the smallest drip must not seem out of place. It may arrive by accident, but it stays by decision.[39]

Even though the painting contains a figure it does not dominate the image. In the painting each easel feels personified. They stand upright, turned towards the centre of the image, yet with an attitude and visible character – more like an audience observing the figure than just objects in the room. The angle-poise lamp, at the top of the painting, inspects the scene and completes the triangle of spectators. Roy explains:

In the Studio **by Roy Oxlade (oil on canvas).**

The image has not been formed mentally in advance; instead it has arrived through a process of trial, error and finally choice. Perhaps the painter can imagine the mood or setting for a painting, something more amorphous, less specific than imagining an object. In this case a studio becomes a theatre for two easels, two lamps, a model, two pots and a pair of canvas pliers: the tools of the trade. Only the lamps and easels were actually there to be painted; the others are the outcome of memory and improvisation.[40]

It's Physical

All the work discussed in this chapter has a life of its own. The space the image occupies within the canvas and the character of each motif within it create their own narrative, one that is not a direct translation of reality as we see it, but a poetic response to it. The responses are fed by our physical experiences as much as our intellectual reflections. It is this physical aspect that is underestimated and underused by many artists and students.

We can move through a space. We can sit, with our weight pushing down on a chair. We can lean forward through the space and pick up our hot cup of tea from the table and sink back into the chair to get more comfortable. We can sharpen our abilities to notice the poignancy of everyday situations and objects. However, all of these physical sensations and experiences are impossible to capture satisfactorily when we are just copying what is there. The infinite space of everything around us stands in contrast to the finite space of the canvas or paper. So a new language that does not attempt to copy or mimic the arrangement of what we see is necessary: a language that can be free to use more than just the visual sense to stimulate creation and response. Even though the canvas or paper is flat the artist can organize the elements within it how they please to create a stage where time and events can be suspended, overlapped and intensified. They can manipulate the surface marks, shapes and colours to create a physical response to it.

Contradiction of our daily, physical orientation and the clichéd order of things can upset, redefine and sharpen our sensation of how things are or how we experience them. So composition is not just a tool to organize your motifs in a familiar space to conform to reality but it also has the potential to create a new sensation, a fresh experience.

Whether in the bath, on the telephone, getting into your car, eating in a restaurant, sitting in your studio or going for a walk, every situation is loaded with potential subjects for painting. Life is a melting pot of ideas.

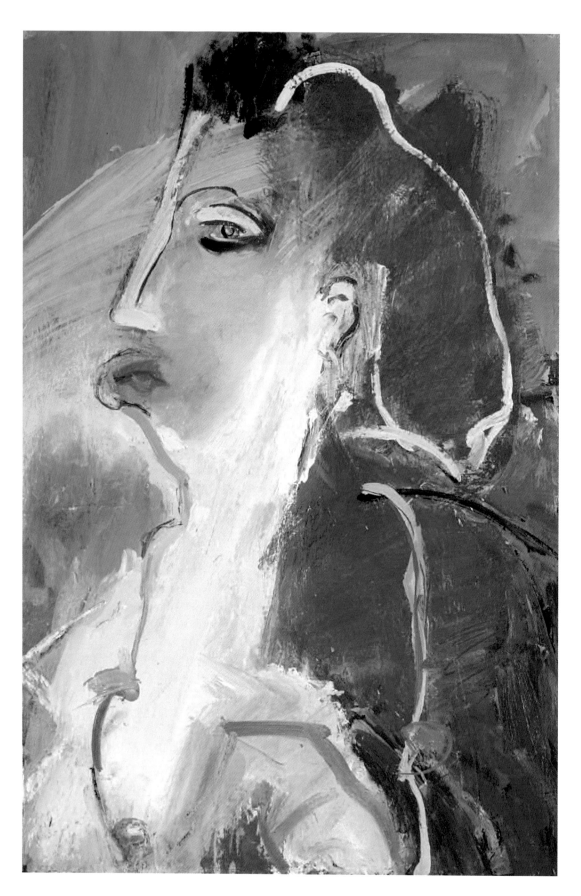

Dossi's Witch **by John Skinner (oil on canvas).**

TO MOVE FORWARD YOU CAN LOOK BACK AND SIDEWAYS

Referencing Other Images

This chapter is about how and why artists use the images created by other artists as a fresh starting point for their own work. This practice has been common throughout the history of art and continues to be an inspiration for contemporary paintings today. Borrowed images might include old masters for their rich narratives and iconic place in art history; images from other cultures such as Japanese, Chinese and African art; or the work of other contemporary artists.

What do you gain from making a direct reference to other artists' images?

- It can provide a change of subject or encourage you to see a familiar subject through someone else's eyes.
- It can make you aware of the work of the old masters not just as pieces of history, consigned to a museum, but instead as images that can be explored afresh and from a contemporary viewpoint.
- It can help you to learn how to unpack a painting. You can go through a process of extracting what you find interesting and then reinventing it to make it your own.
- It can be a visual trigger, a tool you can use as long as you need to, which can be useful if you are unsure what to paint.

In this chapter I suggest ways of unpacking images using both practical exercises and discussions with artists who have used this process often, or occasionally, to give a fresh starting point for their work. The illustrated examples of the original images, and the artist's response to them, will clarify and demonstrate the potential of this mode of working. The artists discuss their reasons for the initial selection of the images and how they went about making their work contemporary and pertinent to them now.

A very successful project I did with groups of children, looking at drawing from the old masters, has also been a helpful experience to share with other artists and mature students. The very young children's ability to connect with the story and to bring it alive, on their own terms, meant that their work carried many of the qualities that we, as adults, often wish we could inject into our work.

Is it copying?

When I talk to new students about transcription or transposition, as it is sometimes referred to, they often ask if they are supposed to be copying the image. My answer is 'No, you are making an image of your own.' You should create your own version and use the composition, the concentration of looking and the reinvention of the original to trigger new ideas and connections. You may select a part of the image or move elements around to create a new composition. It is your interaction with the image that is of interest, where you impose your own personal stamp. It might be an interesting exercise, for example, to make classical or iconic images contemporary.

Climbing into the Painting

I went on a school trip to the National Gallery once. It was exciting. Everything was big, grand, old and busy. We looked at some paintings. A lady who worked in the gallery came to talk to us and we all sat on the floor in front of a huge picture of a landscape. The lady asked us what we thought it was about. She asked us what we noticed: I remember that there was a house, trees, a muddy track with a cart lurching down it, horses, tired looking men with guns, an excitable dog and birds flying home to roost in the sky with a setting sun reflected in the windows of the house. There was so much to see and talk about. I was aged thirty-nine and the trip was for my five-year-old son's class.

The talk was aimed at young children but the way the questions were asked opened up doors for new thoughts. They helped me to wander about inside the painting, to linger and wonder. The children were very happy doing this; they easily

put themselves in another place, pretending and imagining. They were not searching for the meaning of the painting, they were stepping into the painting like Alice stepping through the looking glass. They could look round corners to see what was just out of sight, pretend to pick things up, talk to the hunters, throw a stick for the dog or sit on a tree stump and watch the sun go down. As soon as they engaged with the painting it became animated for them, an ongoing, unfolding idea.

As adults and artists we are no less receptive to this method of viewing a piece of artwork but for some reason it can feel like an intellectual distance is expected – that the historical context, the craftsmanship and the process should take priority instead. We need to be reminded (by the children's response and their work) of the essential engagement that brings the experience of the work alive for us, that makes it real, makes it 'now'.

Young Masters

Young Masters was a project I undertook with my colleague Jane Nash. Working with children from five to seventeen years old, we used transcription as our subject. It was an inspiring and reaffirming experience. The children's work reminded us of the immediate, joyous and vital qualities that drawings and paintings can have: the quality of the unpolished marks, the direct, unfussiness of their selection, the untrained assembly of the image. A lack of formal training or over-exposure to outside influences helped the work to be poignant, beautiful and uncomplicated. When I asked the children what various parts of the drawing they were describing they answered clearly and deliberately. There was no padding or vagueness. It is hard, if not impossible, to retain this straightforward confidence and clarity as you mature. By the time you are an educated adult it has been eroded away, often by the education system itself. We have to relearn it.

> A child's state of knowing is often lost on the adult.
> Making with our hands saves us.
> **John Epstein** [41]

The image we chose to work from was *The Portrait of Giovanni Arnolfini and His Wife* by Jan Van Eyck. It proved to be a successful choice for several reasons: the painting suggests many possible narratives and associations, it has rich and varied details and the children loved the dog in it. The two figures are holding hands, immediately providing a focus, encouraging a link, and providing empathy and shared experience to which the children could relate.

From my teaching and painting experience I was confident that our approach to the project would be very inspiring and

Jan Van Eyck *Portrait of Giovanni Arnolfini and his wife*, bought 1842. (© The National Gallery)
OPPOSITE: **Arnolfini Drawings 1 & 2** by pupils from Ashurst CE Aided Primary School.

productive for the children, and not what they would normally experience in a classroom environment. So with the knowledge that these children would be in my teaching studio, using the equivalent of a whole academic term's worth of paper in two hours, and encouraged to think freely and play with their materials and the images they made we were confident to set out some clear and bold learning objectives to share with their teachers:

● Children will explore different processes and ways of looking at a painting.
● They will be encouraged to celebrate their individuality through drawing.
● They will learn how to select, invent, edit and use rich mark making in their drawings.
● They will strengthen their skills in evaluating and making judgements about their work and the work of others and use this to develop and progress their own work.

- They will learn how to work from an image without copying it.
- They will reflect on and rework their drawings.

We only had a short period of time with each group of children (two and a half hours) so it was very important to catch their attention and fuel their desire to play creatively. Before we began doing any drawing the children engaged with the characters of these paintings through discussion and role play. We wanted them to focus quickly so that they noticed subtle and important qualities in the characters and objects and the relationships between them. We gave them fabrics and objects to feel that were similar to those in the painting and clothes to dress up in so they could empathize and use this knowledge of sensation and first-hand experience when they came to draw.

Two children at a time volunteered to come to the front of the group to take up the same pose as the two figures in the painting, paying special attention to the direction of the gazes and the position of the hands. They had help from the other children who directed them on how to stand and the expression they should take. We asked them what other details they could see in the painting and they enthusiastically pointed and reeled off lists of things they had observed. Jane and I were amazed and

delighted at how engaged and animated they had become about the story and characters, and at the keenness of their powers of observation and deduction.

While they were all so focused we got them to start drawing. They began, as I would ask any students to do, with mark making, experimenting with the drawing materials that we had

Arnolfini Drawing 3 by a pupil from Ashurst CE Aided Primary School.

ABOVE: **Arnolfini Drawing 4 by Serena Coomber from Joelsfield C of E Primary School.**
LEFT: **Arnolfini Drawing 5 by a pupil from Ashurst CE Aided Primary School.**

provided: charcoal, black and white chalk, an eraser and felt-tip pens. I had to encourage them to experiment as much as I would my adult students. When they had warmed up I asked them to work with the marks they had created on the paper and to make an image appear in response to the original painting.

Making it Strange

In the following sections I am going to describe the various exercises that we asked the children to do. I have not gone into step-by-step detail because they are variations on ideas I discuss earlier in the book, but you can easily adapt them to suit your own needs.

Upside-down drawings

I wanted to get the children to really study the image through drawing it, but I also wanted to free them from feeling confined by this so I turned the Arnolfinfi painting upside down and asked them to draw it as they saw it. This exercise helps to undermine assumptions, tricking your eye and your brain by confusing the expected order of things. It is very simple and requires no special equipment or materials, just paper and something to draw with. Just turn the reproduction of the original image upside down and draw it, so that you end up with upside-down images too.

I found that this process enabled the children to study the painting by moving from space to space and form to form with great freedom and focus. The logical order of things is upset and subsequently the identity of things is now confused. If you do this exercise yourself you will find that you have to look more intently, as if you had never seen anything like it before. The bottom of the painting is now the top, the spaces between things are full of volume and the details are more strange and beautiful. Allow your eye and hand to travel around the image just selecting and exploring what interests you and leaving out areas if you wish. As ever, you need to be direct and versatile with your touch and to leave evidence of your search and play on the paper, to increase the chances of making a good drawing.

Once you turn the images upright (assuming that you want to) you will see that crawling through the strange upside-down world of the painting can work to your advantage: the unfamiliar shapes and junctions, far from creating a confused and incoherent image, come together to create not only a likeness but also inspiration and fresh starting points for future work. Importantly this simple reversal can break the spell of wanting to copy an idea of what is there.

Selection and connections

For another drawing we asked the children to look at the upright Arnolfini painting and to draw just the expressions on the faces, the position and gesture of the hands and some selected pattern from the image. They could position these wherever they liked on the paper, doing their own version of 'pick and plonk'.

Taking a line for a walk

In a very similar way to the method described in Chapter 2 the children also did an exercise where they started their drawing from the edge of the paper and crawled, with a continuous line, in and around the picture, looking at the Arnolfini painting as they did it. They did not lift their charcoal off the paper and did not look at the drawing as they did it, only the original picture. This was an excellent way of getting them to really focus on the painting and investigate it to see what they could find.

Chinese Whispers

The second part of our project was to use the work created by the younger children as a trigger and inspiration for the final group of students who were aged between sixteen and seventeen years old. Rather than continuing to refer to the original painting this became rather like a game of Chinese Whispers, with the five-year-olds' drawings being their only reference for what followed. The reason for doing this was, once again, to

LEFT: **Arnolfini Drawing 6 by pupils from Ashurst CE Aided Primary School.**
ABOVE RIGHT: **Arnolfini Drawing 7 by a 17 year old pupil from Steyning Grammar School.**
ABOVE: **Arnolfini Drawing 8 by a pupil from Ashurst CE Aided Primary School.**

challenge the inevitable desire to copy the original image. The more processes an image experiences, the more it adopts its own identity. As discussed in relation to the gaze in Chapter 3, drawing from a drawing gives the work its own value, making the artist reinvent, develop and sharpen their intentions by responding only with the visual language created on their first impulse.

Looking at these apparently uncomplicated drawings by the smaller children the task initially seemed an easy one, but time soon revealed that from a teenager's point of view this was a difficult task. Initially I think it was something to do with them not taking the work seriously. It seemed that asking these young

adults to improvise drawings in response to younger children's beautiful squiggles and blobs was alien and uncomfortable for them.

The comfort of conforming, for things to be 'right', is totally challenged in this situation. 'Right' in this situation refers to the conventional idea of objects being in representational proportion to each other and the demonstration of a slick craftsmanship. Diminishing confidence and self-consciousness can be obstacles that suffocate creativity and they appear to be a natural by-product of the transition from childhood to adulthood. In many cases it follows us into adulthood and the door to having a playful, open mind can become difficult to open again.

Working with eyes wide shut

As an antidote I kicked into gear with fast-moving exercises that carried them through the discomfort without any time for faltering or apprehension. I wanted to remind them what it felt like to generate marks that had wonderful immediacy and spontaneity. They were each given a fat brush and a pot of ink and had thirty seconds to make each drawing. The change of tool and material immediately broke the paralysing spell. Then, working with eyes shut and from memory they did yet more drawings. Not only did the drawings move into a new league of confidence and quality but the students really began to enjoy themselves and leave their insecurities behind them. They had managed to create powerful drawings that had some of the direct clarity and non-crafted ingredients of the drawings of the younger children but with a more intense and sophisticated edge to them.

Showing the mature students, whom I teach on a regular basis, all these drawings and describing the process made me think: 'Why don't we do this ourselves?' Why do we reserve this for children as if in some way we no longer need that kind of stimulation – the stories, the dressing up, the role play, the fast, non-judgemental studies, the discovery and the engagement? Are we beyond all this as adults? Permission to play should increase with age, not diminish.

TV Mother Hug

I have worked with transcription on several occasions and each time it has provided a helpful breathing space. One where I can look around at the view and feel less pressurized by the question of what subject I should be painting. My group of four paintings titled *TV Mother Hug* began with a transcription drawing of *Las Meninas* by Velasquez.

These paintings are still all based on my home and my son but

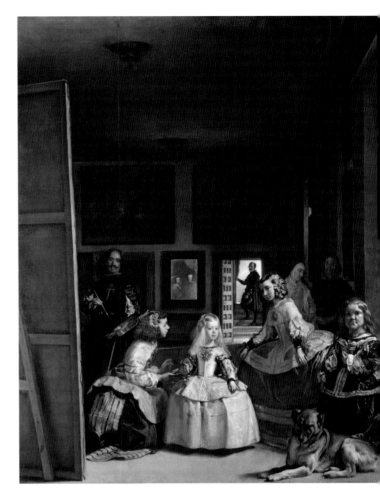

Las Meninas **by Diego Velasquez, Catalogue No: 1174.**
(© Museo Nacional Del Prado, Madrid)

for this my attention shifted away from the garden and outside playtime to indoors. I think this might have been dictated by the seasonal weather but certainly I wanted to tackle a new set of motifs that was part of our daily routine – and one that featured not just Will in absorbed isolation but reflecting how he was now interacting and responding to me.

Feeling a little blank I remembered how helpful it can be to do a transcription and immediately knew that Velasquez's *Las Meninas* would be a good place to start my ideas. It had some wonderful ingredients: a child as the central figure; other people attending that child; the artist present in the image; a mirror; the sensation of being in a room with doors and light fittings; and characters whereby some are gazing out of the image and some are absorbed in their own thoughts.

I did a drawing to investigate what I could use. Although I was noticing and reusing the positions of all the figures present in the painting, even at this stage I was replacing the characters with my own – William, myself and other members of the family – and considering what I might select and focus on to create my new set of paintings. Which room in my house? How many

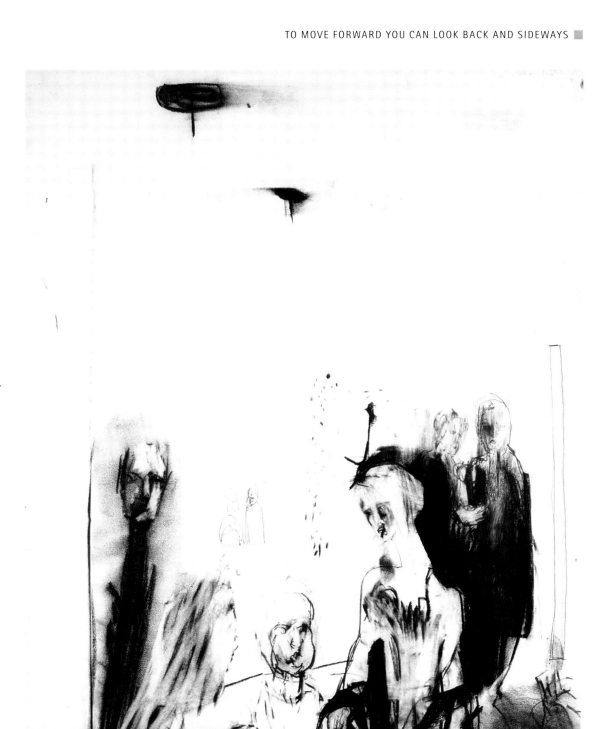

'The Family' After Velasquez
by Emily Ball
(charcoal).

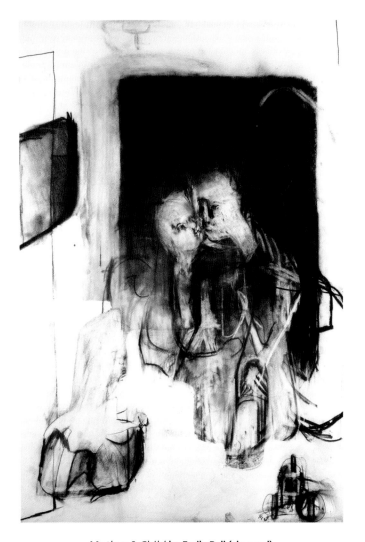

Mother & Child **by Emily Ball (charcoal).**

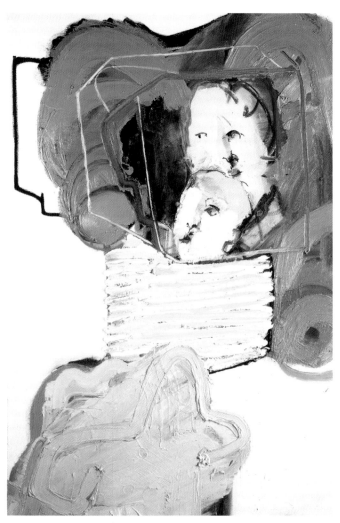

figures and who? How shall I represent the room I choose, which objects would work with the figures?

The second drawing I did radically edited out all but three figures. The setting was my sitting room with the television. A toy tractor sat where the dog had been sitting in the foreground of the original painting. The suggestion of the perspective and height of the room was kept and so was the light fitting. I put away the Velasquez; it had done its job.

The resulting paintings bear no resemblance to the original image of *Las Meninas*: I had just used it as a trigger to create my own work. The motifs in the work are just three: Will and myself, with heads touching, and the sofa and television. Each is a portmanteau (*see* Chapter 1) because of its capacity to contain many different meanings and character traits. Rather than being props to support a portrait of Will and I, domestic objects are invested with personalities that actually define the portrait. The connection between figures and objects is so strong that it is difficult to tell where one stops and the other starts. The envelop-

ing hug of the sofa shows Will and me firmly contained within its maternal embrace. It is the presence of our figures that accentuates the sofa's character, transforming it into a hugging, loving space. As discussed in Chapter 5, the second version of this painting gave me the opportunity to explore other options within the language and selection of motifs.

Theme and Variation

Roy Oxlade has also created paintings and drawings in response to *Las Meninas*. I asked him about the motivation for these and what criteria he has for choosing an image from which to work:

> One factor might be that a painting like *Las Meninas* has
> become a familiar challenge, for any number of reasons.
> It's known widely. Its 'story' is intriguing. It's become a
> standard like a tune to be exploited in variation form.
> I talked about this in a dialogue with the painter Marcus
> Reichert for the catalogue of my exhibition 'Standards'.

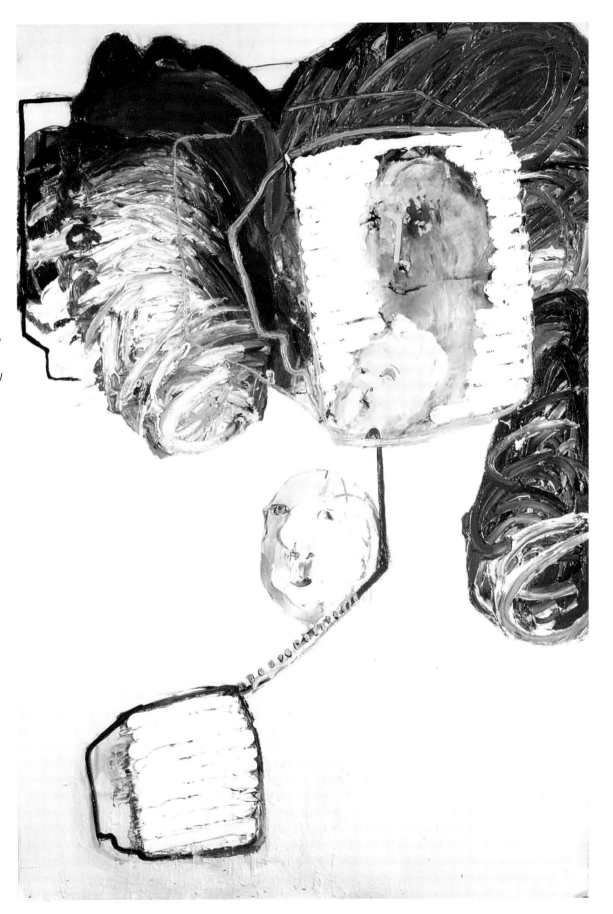

OPPOSITE RIGHT:
TV Mother Hug I
and (RIGHT)
TV Mother Hug II
by Emily Ball
(oil on canvas).

TOP: *Las Meninas IV* and *Las Meninas VII*
by Roy Oxlade (charcoal).
ABOVE: *Green Las Meninas* **by Roy Oxlade (oil on canvas).**
OPPOSITE: *Las Meninas* **by Roy Oxlade (oil on canvas).**

There are other paintings I've used which are much less well known, such as Dutch still life paintings, because I like their simplicity and also because often, in their own way, they themselves work within a commonly shared idiom – variations upon a theme of pots, fruit, baskets, plates, cakes, etc. I have more recently nodded to a favourite Matisse – the studio painting with aubergines in the museum in Grenoble.

I think I have chosen these paintings to work from because I think there is something in them that I can work with, in just the same way that I think I might try to work from an object or two in the studio. They are vehicles for opening up possibilities. The relationship between my painting and its parent is an added interest or not, depending on how you look at it.[42]

During the course of creating his paintings Roy will remove as much paint as he applies. This is not due to indecision or lack of skill, quite the opposite. He is constantly moving and changing the relationship of elements in his search for 'oddness, strangeness – peculiarity, irreverence – even absurdity'[43] in the resulting image. His work has qualities that remind me of the joyous and beautiful children's work but with added doses of

110

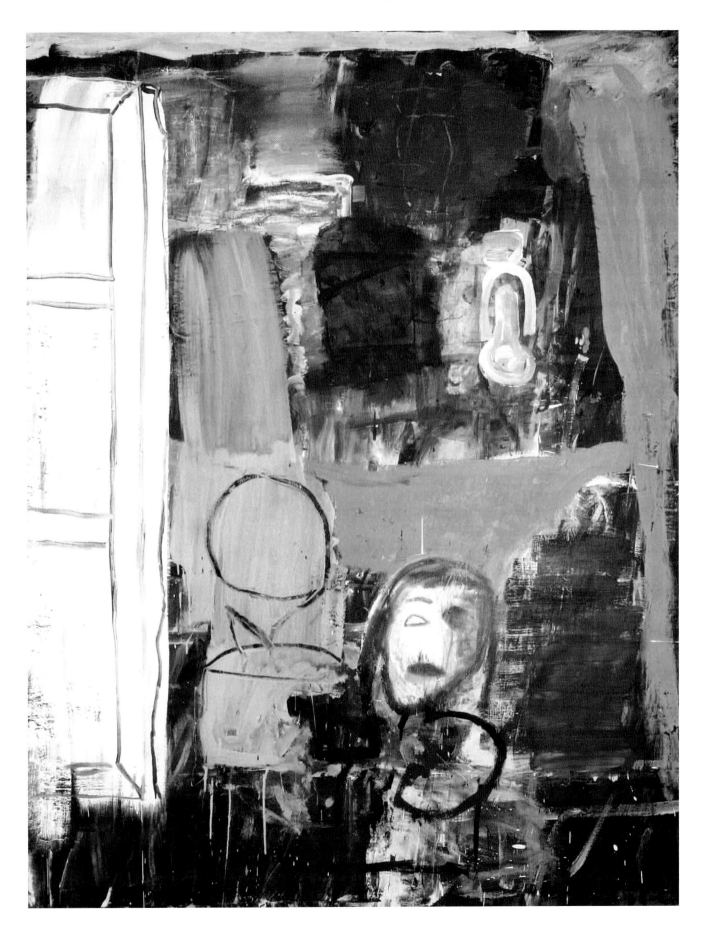

sophistication and knowledge that no child could deliver with such cutting confidence.

Allegories of Love

In the National Gallery there are four very large, square paint- ings called *Allegories of Love* by Veronese. I had never really noticed them on my few visits to the gallery but was first intro- duced to their amazing qualities by John Skinner. John always shared his discoveries generously with us and these images were, at the time, new and inspiring to him. He had come to the end of a commission and what had become a big and impor- tant body of work called *Air, Sea and Hills*. I asked him what had prompted his new radical change of subject after the consum- ing Dorset Coast:

> Sometime after the end of the *Air, Sea and Hills* series, when I was lost for a subject, I went to the National London and saw the four Veronese allegories. I actually did some little studies of them. They seemed to me to be like extraordinary machines, like clockwork, where every bit fitted together with precision. Like bombs waiting to go off. I went round and round them. Later I took a group of students there to see them, and it was like visiting friends. Those paintings helped me a lot. Perhaps this is a reason for making a transcription from an old master. One aspires to draw the strength of the old masters into your self, like a cave painter drawing a horse or a buffalo: an intrinsic empathy.
>
> I remember having a 5ft square canvas spare and started making a transcription from one of the paintings. They are called 'Allegories' but what they are allegories of nobody really knows. I started to work from Scorn. The painting was a disaster. The whole subject was just too big for me to handle. So I continued concentrating on the two female figures in the left-hand corner using much smaller canvasses. I liked the closeness of the heads, their eroticism, their expressions, all their jewellery and finery and started madly reinventing these women. I even invented my own allegory with the titles: *Two Scornful Women Watching as Their Lover is Being Beaten to Death by Lust*.
>
> The 5ft canvas later became the painting *Vanitas: An Homage to Helen Chadwick With Nine Roughly Painted Penises and Ten Vaginas On Strings*. With this title people thought I was being disgracefully unpleasant so it eventually got shortened to *Homage to HC*. Actually I was very upset by Chadwick's early death. She was a contemporary of mine at Brighton and I followed her

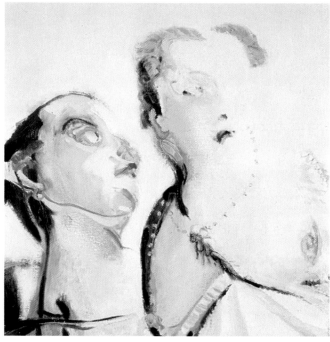

Allegory of Love II ('Scorn') by Paolo Veronese, bought 1891 (© The National Gallery, London), and *Scorn* by John Skinner (oil on canvas).

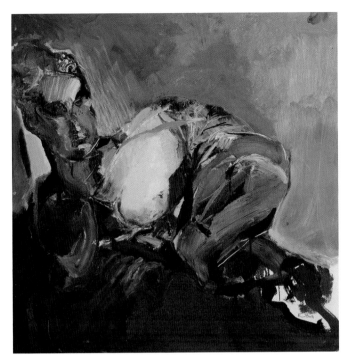

Scornful Woman **by Emily Ball (oil on paper).**

career with interest and sometimes envy. The painting is a transcription of one of Chadwick's *Vanitas* photos (a beautiful photo), which are her rephrasing of the *Vanitas* genre. So my painting is a transcription of her transcription.[44]

My version

I also painted a version of the *Allegory of Scorn*. I was striving for the expression of complete contempt in my version of the scornful woman. I cannot quite remember if I was using memories of dumping a past boyfriend but I definitely found myself exaggerating the hands on the hips, the angle of her head and her piercing gaze with great relish! I was not turning it into a self-portrait but it was essential for me to engage and play along with the narrative and empathize with the character. Unlike John, who noticed her finery and seductive qualities, I just connected with an angry young woman. Perhaps I was one. I cannot remember now.

Painting your Desires

In discussion with John about his paintings of heads he mentioned that on several occasions he imagined he would have liked to have been a portrait painter, especially after seeing the amazing portraits by Gainsborough and Titian and countless

other artists. He had asked people to sit for him but felt that he had never been able to produce anything good in this way. Instead he found making transcriptions was a way that he could cover similar ground.

When selecting work for this book there were two particularly striking paintings by John that I felt had to be included. These are two versions of Ghirlandaio's *Ideal Portrait* that John had seen on a visit to the Accademia Gallery in Florence. The piercing gaze and presence of the woman looms out of the darkness, with some parts of her body melted away in the velvety gloom. Their appearance and strangeness is eerie and wonderful. The reason for this appearance became clear when John described to me why he liked the original image by Ghirlandaio:

> It is a long time ago now but I remember being drawn to the weirdness of it. I have said it is sort of proto-Cubist with its main view being a traditional profile but the eye looking straight out at the viewer and then one breast sort of pointing left and the other again pointing towards the viewer; that decorative headdress gives a massive quality to the head.
>
> Also it is the kind of image that I have made throughout my life, a single monolithic image within the

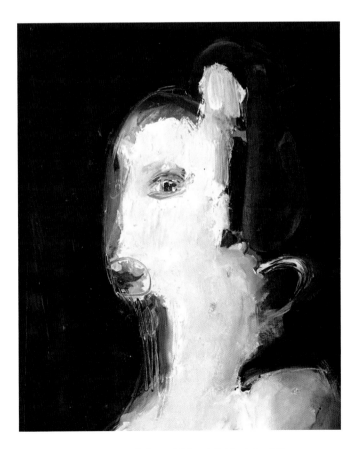

Ideal Portrait 1 (after Ghirlandaio) **by John Skinner (oil on canvas).**

113

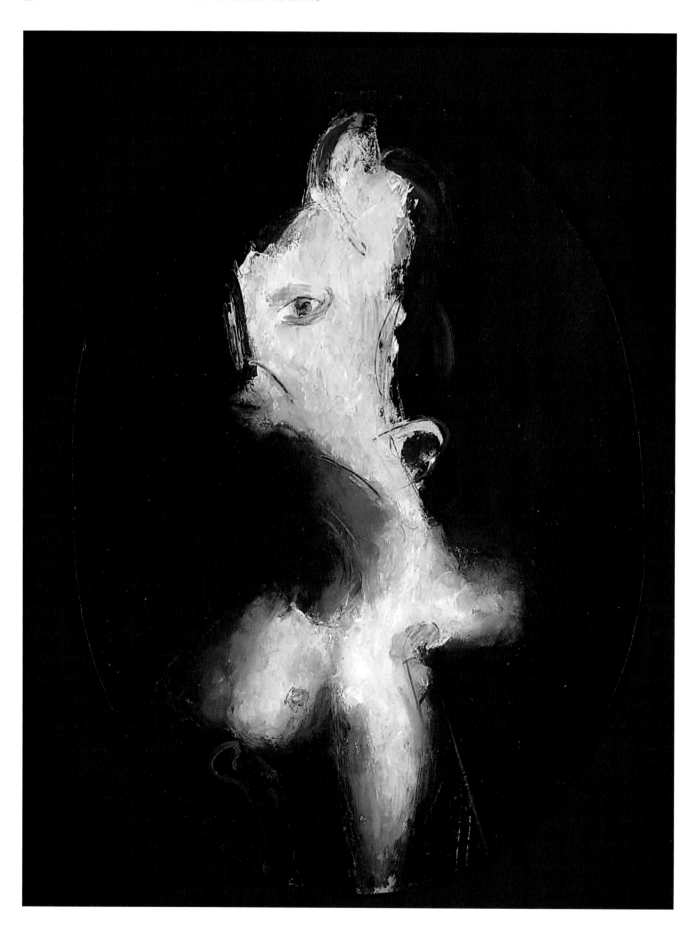

Ideal Portrait III (after Ghirlandaio) **by John Skinner (oil on canvas).**

frame. Also it is oval: when I put a single image in the middle of a rectangle I always had formal problems about what to do with the corners (now I just ignore any formal problems and leave white space): an oval neatly solves this problem but of course immediately presents others, such as the damn things keep rolling over when you try to stand them up and they are very, very expensive to frame.

At that time I was really struggling to make anything decent in painting so when I got back to England I still had the ideal portrait fresh in my mind and started to make drawings of it and almost immediately these went quite well. So I started painting and eventually made four paintings, three of which are oval formats.

On the same trip to Florence John visited the Uffizi Gallery, including the Vasari Corridor, which is full of self-portraits. He did lots of transcriptions from artists such as Velasquez, Delacroix, Rubens and Elizabeth Vigee Lebrun. He found that he was on a roll with the whole series and they came quite easily, which amazed him because they are not easy paintings.

Japanese Prints

A single image can be significant in itself for the artist, as we have discovered in the previous choices of painting, but equally it can be a style of work. The alien arrangement or flattening of the picture space, the simplification of forms and features or the use of pattern are appealing and tempting to play with. In Chapter 3 I talked about my drawing of Eve, and her gaze, I made reference to my interest in Japanese prints. I had been searching for a new visual language to help me to describe her porcelain features. In finding a connection through a series of Japanese prints I also uncovered other qualities that I enjoyed and wished to investigate in my work.

My painting *Japanese Lady Running* seemed to arrive when I least expected it. I was only warming up with a piece of mark making. I had adopted the tall, screen-like format of the Japanese print and was practising working with my new rigger brushes and experimenting with marks and colours, which were my interpretation of a more oriental touch. I was hoping that these would begin the process of generating a new language for a painting I wanted to do about Eve in her high chair. The marks were randomly scattered and layered but when I chose to edit I looked up at the image of the group of Japanese ladies walk-

ing, selected an area of the mark making that seemed rich and full of possibilities and created the shape of a figure from it. My running, or walking, woman appeared. The accidental layering and directional marks worked to my advantage to describe the draping of fabric over the body and gave me spaces to develop her other features.

The image still needed to be clarified so I gave character and movement to the figure by adding the hands within the pattern of her clothes and imposing her head in a convenient space at the top of the body. I spent the most time working on her feet; they seemed to quite literally carry the image of the woman. Perhaps this is where I departed the most from the original Japanese image because I cannot imagine how the original figures could have walked with such big steps wearing Kimonos. My lady is much less formal and correct; instead she is striding out confidently and purposefully.

The pattern and rhythms on the clothes, appearing and disappearing, to describe the body, the importance of the expression of the hand held to the face and the active toes finishing the form were all qualities that were also important when it came to paintings of Eve in her high chair. Flat backgrounds, selected spaces and floating lines completed the language. I painted three versions of this subject, each different and each moving away steadily from the initial inspiration, retaining and developing just enough to remind me of the refreshing effect of exposing my work to borrowed new influences.

Unfashionably Good

Rose Wylie is not interested in good taste. Her paintings are raw, direct and true. I feel exposed and slightly uncomfortable, but in a good way, standing in front of work that is so uncompromising. I applaud the 'cut the crap' attitude of her work and that of Roy and John. Rose's approach has sensitized her to notice both the most unusual and ordinary things she could use as her subjects. She uses anything that grabs her interest. She will slice, collage, fill in and extend her work to create a certain likeness, a memorable image. There is nothing abstract about what she does. She wants it to be like her subjects but with piercing particularity. Hers is not a slapdash and ill-informed approach but is sharp, witty and sincere.

She finds her inspiration from nature and from culture: birds, trees and flowers as well as television, consumer catalogues and newspaper stories. Rose's eclectic taste also extends to using the work of other artists:

If I made a transcription, it would have to be of something that just captured my attention in a way that could be

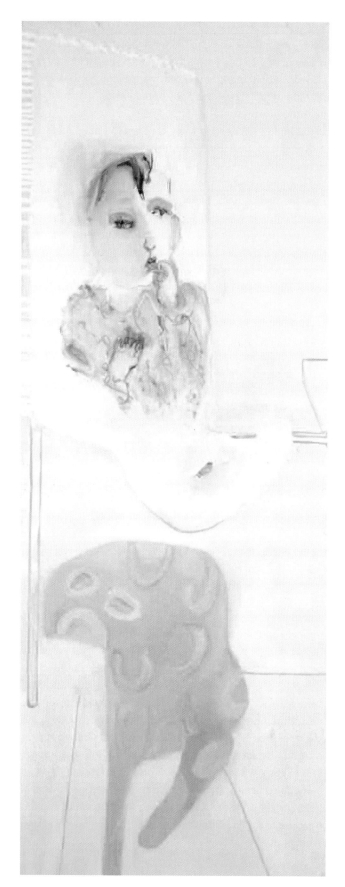
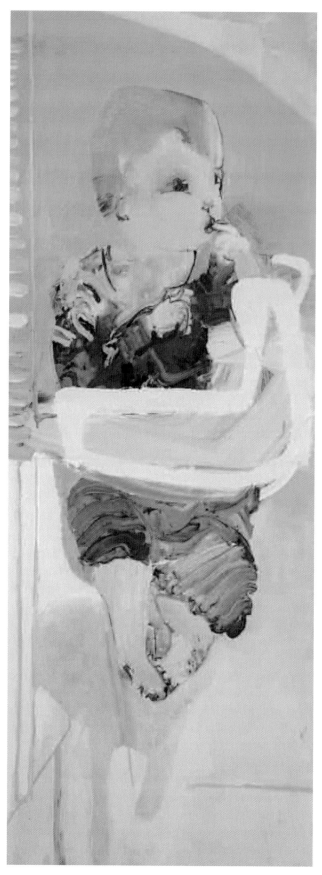

A single image can be significant for the artist – *Eve* by Emily Ball.

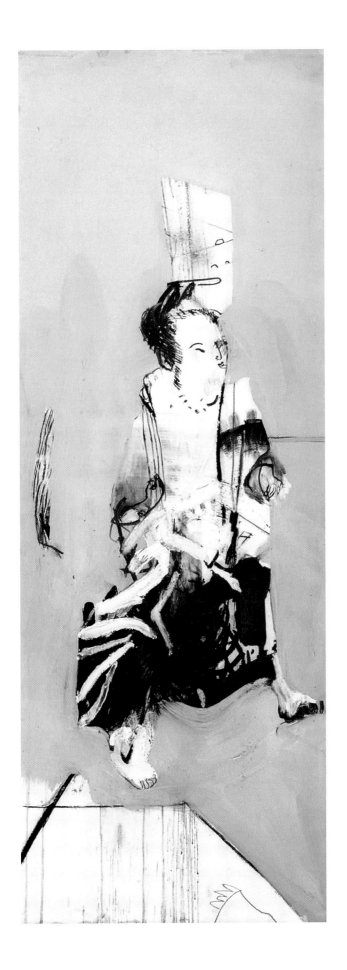

used: which could mean something shared between me and it, or which suggests a way in which I would like my work to go, or something new.

I have made transcriptions from established paintings – Sassetta, Titian, Cranach, etc. – but more recently I don't. Instead, I have been using contemporary work, perhaps more as assimilation rather than transcription. I look at work particularly from Africa, Korea, Vietnam and China; but only commercial/popular art, and not from High or Museum art. I find this non-Western work, folk, or indigenous work distinct from 'gallery art'; exciting, non-arty and visually obvious – the clearest example of what it is, and nothing else: cliché even, but brilliant in an untaught way. African Lorry Art being a good example of this.

 The sort of thing I'm talking about doesn't get huge or much respect from the Western art world I don't think. Actually it is usually thought of as the worst kind of art. This is the stuff I want to see and think about, give a place to and to work with.[45]

Past, Present, Future

Using the work of other artists for reference is not about harping back to the past or a lack of imagination on the part of the artist but is a necessary part of the process of learning from others, to be aware of what has gone before and what is going on elsewhere to inform your own work. It can also help you stand back from yourself and review where you are and what interests you – how you could sharpen your practice and make your images speak about you, now. Perhaps, like John with his desire to do portraits, there is a subject you have always wanted to tackle but have never been able to achieve to your satisfaction. Using the work of another artist could be the way of resolving this and reinventing your work at the same time.

 We are all influenced by what is around us, more or less: by our culture, our gender and expectations. However, your individuality is in your touch and your selection, what you notice and the way you organize it on paper or canvas. So much choice can bring confusion and a loss of identity. You are responsible for finding your own voice, for being focused and inventive. This does not require seclusion and isolation from the world around you. It means that you have to immerse yourself in it and see what floats to the top. John remembered an email conversation between himself and Roy concerning this very subject:

Japanese Lady Running **by Emily Ball (oil on paper).**

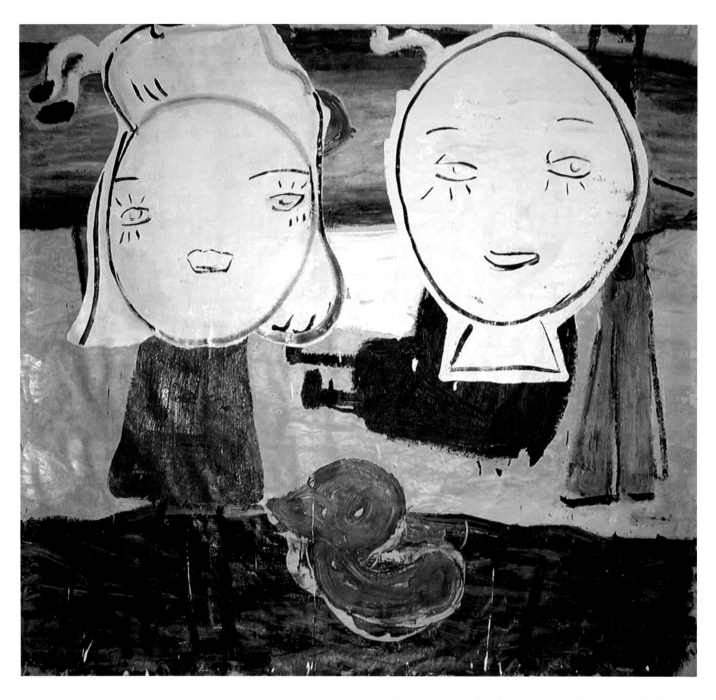

White Faces **by Rose Wylie (oil on canvas).**

Roy: There's no escape from the 'prevailing culture' as an Eagleton might say.
John: There may be no escape from the 'prevailing culture' but at the moment it feels like there is room within it for us all to do something good.

Climb into your own work and look around at the view. What do you see? Is there enough there to sustain you, make you inquisitive and curious? Do you feel that you notice things, the quirky, interesting details, the things that are overlooked by everyone else? If the answer is 'no' to any of these then try the following: take yourself to a museum or gallery for some visual feeding. Draw for no particular reason other than the feeling that you like the look of something. Do not justify, analyse and plan how you might use what you are doing. Just do it. Give yourself time to becoming absorbed in looking. Resist judging whether your work is good or bad, contemporary or saleable. Find a space, both physically and mentally, to give yourself permission to play.

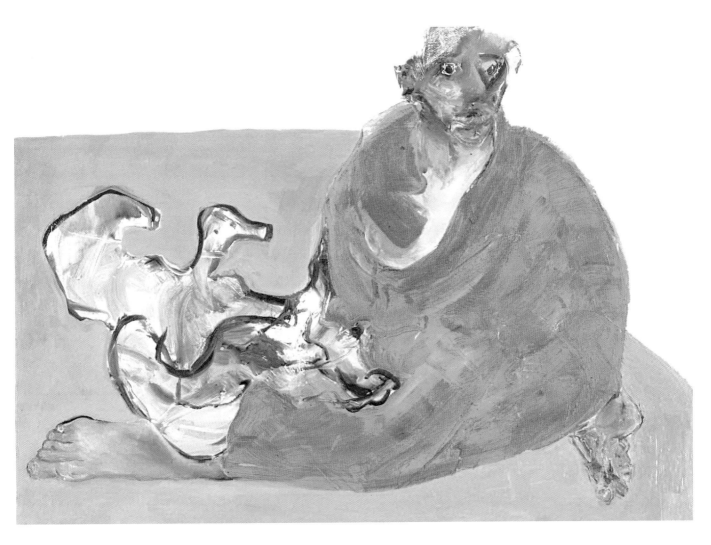

Freud's Dog and Woman **by Juliet Robertson (oil on paper).**

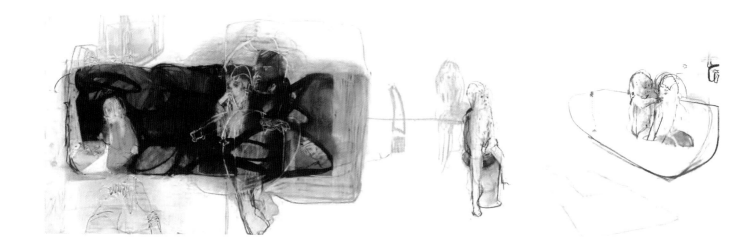

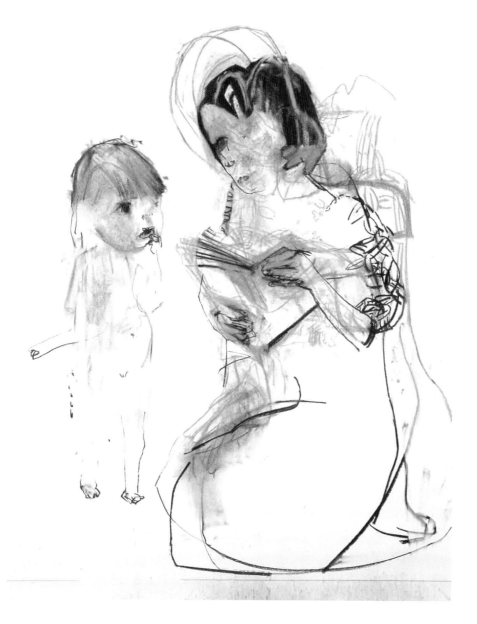

ABOVE: *Calm Moments* (pen, chalk and charcoal); LEFT: *Story Time* (detail).

ARTISTS IN THEIR OWN WORDS

You can create paintings and drawings that are purely about physical things connected to the figure. The figure is the subject. You can also create work that includes the figure but as an element of a bigger subject, carrying many meanings and connections. Essentially, once you have moved away from the idea of creating portraits and copying what is in front of you, the content of the paintings can be rich, humorously absurd, layered and complex. A range of associations – physical, sensual, mythical and emotional – can result from the way the figure is painted or drawn or its relationships to other elements within the image.

In the process of developing the painting the image of the figure may all but disappear; there may only be remnants, suggestions of the original starting point. This does not diminish the significance or impact of the subject. In fact, it can strengthen it. The selection of just part of the figure, an absence or residue of it, can become more striking and evocative to the mood of the work. The understatement and reinvention triggers new connections and possibilities.

This chapter is an opportunity to revisit some of the philosophies and approaches to working from the figure discussed in previous chapters. You will see them applied by the artists illustrated in this book. These artists all share their thoughts generously about the content of their work and their starting points, struggles and discoveries to clarify the important, consuming, sometimes even bumpy, creative ride. Some of the areas revisited are:

- 'Pick and plonk' as a compositional tool to generate new readings of the subject and space of the image;
- the primitive and how it is found, used and strived for;
- the benefits of a 'visual shock' and how to undermine becoming 'slick' and desensitized to making a true response to the ongoing work and subject;
- a modern-day *Venus* (de Willendorf) – sensuality twenty-first-century style;
- how portmanteaus are made and used to create mythical forms;

- 'the paint embodying the subject' – what it means to find the image as you paint; and
- using a drawing to unravel time and events in one composition.

Family Drawings

At the same time as I started to write this book I made four 8ft by 3ft drawings. I wanted to start a body of work that was bigger, more ambitious and more challenging than anything I had done previously. In a way it was, or should I say is – the work is still ongoing – an ambitious way of testing and stretching what I had already discovered over the last six years. It also helped me examine some of the processes and content of this book.

My subject remained my home and my children. The assembly of images and my approach were helped and influenced by many strands in my work: bath time, the television and sofa, children playing, my interest in Japanese and Chinese art and my love of drawing. The choice of scale and shape, influenced by a Chinese scroll painting, instantly created practical and compositional challenges that proved awkward but also enjoyable.

The drawings are in response to moments of my daily routine with the children, in different rooms in our house. I made no attempt to connect each figure or motif together with linking marks or make reference to the space of the rooms.

Practising what I preach

My pace of working was very different to previous pieces of work. This was partly due to practical constraints connected to the size and shape of the piece and my ambition for the work based on previous drawings. I worked slowly and steadily, finishing each group of figures before moving onto the next. I wanted to capture a feeling of the way figures interacted with one another or how they were absorbed in their activities. I did

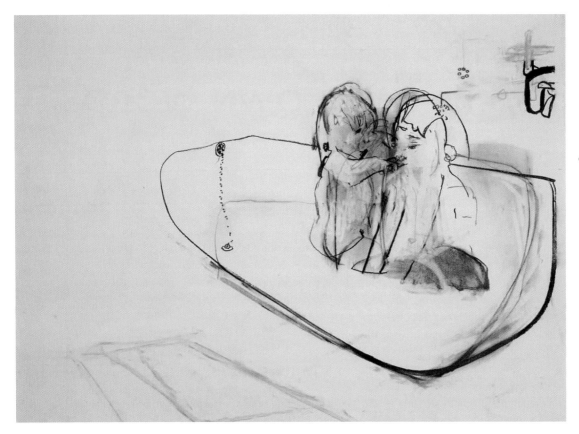

Bath Time **(detail – charcoal) by Emily Ball.**

not work from left to right; I moved more randomly, leaving gaps and returning to them from right to left and left to right, 'picking and plonking'.

This process was very freeing. I drew only what interested me and did not worry about complicated, staggered positioning or changes of scale to suggest perspective. However, I realized that this method would only work if each part of the drawing were depicted concisely, explicitly and clearly. Whether in the bath, watching television, playing the piano, playing with their toys or being read to every figure in the drawing had to have the 'particularities' of the gaze. The gestures that implied the poses and the sensation of the subject had to be concise and inventive so that each could stand alone in the overall composition.

Drawing economically and inventively became an enjoyable process. If I failed to achieve the desired result in the first attempt I only allowed myself to work with what was there, the accidents and the debris. I did not permit myself to rub things out, only layer and adapt. This constraint made me more versatile, more positive in the changes I made and more aware and inventive about the way each mark could connect together in some way to describe the figures.

The long horizontal space

There is no logic to the order in which the figures appear. There is no narrative that can offer clues to the time of day or indeed whether the events are taken from the same day. I like this ability of the image to create its own time, space and reality. This is an aspect of painting and drawing that provides great freedom and helps the possibility of the painting to have layers of meaning. I have given no reference to particular rooms and I have not linked the groups of figures in any way. In spite of this they work together on the long piece of paper as one composition. The clean, white spaces between the images became an important part of the drawings. Although the drawings are finished the paintings of the same size and shape are still in progress and are proving to be the challenge I had wanted!

Revisiting the Primitive

The primitive is the first response, not derivative, original.
Georgia Hayes [46]

The fresh directness of those first marks applied to a canvas have an energy and resonance that Georgia Hayes would love to aim for in each of her paintings. She would like to do paintings that could be done in one hit, with the first marks ringing true, without being tidied or tampered with. This is rare, however. Even if it happens in parts of the work then some other aspect of the

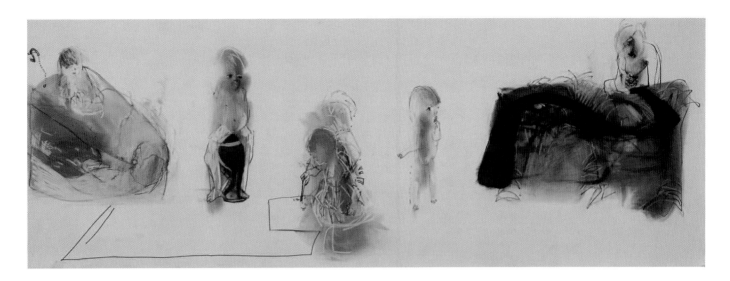

Moments of Calm, Moments of Play **by Emily Ball**
(pen, chalk and charcoal).

painting will often refuse to arrive so spontaneously. Georgia made a painting about her granddaughter feeding one of their sheep. At first glance it is a simple painting: there is a chubby child dressed in pink and a sheep standing next to her. When you look further you notice the most wonderful gaze between them, each slightly suspicious, nervous and hesitant of how to react to the other:

> My granddaughter came to visit, aged about two, and the treat was to go and feed our sheep. They are mostly quite tame and this one particularly so. She towered over the little girl who was holding out bread and being brave about it. I was moved by the oddness and possible misunderstandings between them. It was a moment full of possible outcomes.
>
> I had been drawing the sheep a bit and thinking about the old ones, the specially trusting ones and having to kill them when they get too feeble, all of that farming stuff which concentrates the mind. So this incident struck in a way it might not have otherwise. Also it was an older child. I mean, I had been painting my daughters and their babies for several of the previous years. The transition of the daughters to mothers was a big thing for me. Here was one of those babies a stage further on. Also I was noticing the way little children stand when they aren't that used to it so I did some drawings from that memory of her in her blue suit. Her mother had one just like it so it reminded me of past times too.[47]

Georgia Hayes told me that she could remember she had found doing the painting a bit of a marathon. Everything about paint-

ing the child came about easily and quickly, with the direct freshness to which she aspired. She felt that she had caught a likeness of her granddaughter and the nervousness of her stance. She was pleased with it. The sheep proved much more difficult to resolve though – especially the wool. So it was half a quick painting and half a slow one, as the sheep required endless repainting so that it worked alongside the image of her granddaughter.

Subverting What You Learn

> You have to know a lot about what you want to avoid (which changes and gets added to anyway) and you have to subvert what you learn as you go.
> **Georgia Hayes** [48]

Subverting what you learn is an interesting aspect of creating work. Our day-to-day life requires us to be able to do many things on autopilot. We know what things are by small visual references, sounds, smells, touch and taste. We learn and improve the things we do through trial and error, repetition and practice. All the things I discuss in Chapter 5 about our relationship to domestic, everyday objects and spaces applies here too. We are creatures of habit, of routine. It is reassuring to practice what we know but this also leads to habitual behaviour, skimming the surface of our understanding. A general idea becomes adequate to get us through a situation.

This is not a good recipe for creating paintings and drawings, however. The exercises in Chapters 2, 3 and 4 provided ways for the artist to disconnect from the visual and our learned assumptions about the head and the figure by reconnecting them with the physical sensations. However, even these processes can lose their ability to surprise and refresh the work if the artist forgets

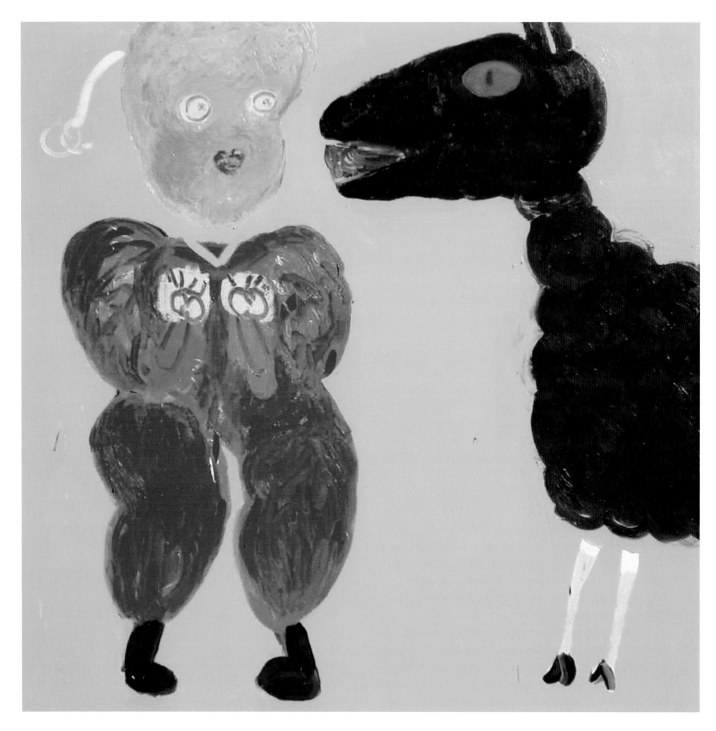

J Feeding Sheep **by Georgia Hayes (oil on canvas).**

preparation for a few moments of innocence – of desperate play! To learn how to unlearn.
Philip Guston [49]

to remain focused and critical. In order to sustain your creative practice you have to catch yourself out and be surprised and challenged by what you produce.

> To know and yet how not to know is the greatest puzzle of all. We are primitives in spite of our knowing. So much

How do we prevent ourselves from becoming slick? How do we stop ourselves from just going through the motions? When are we just recycling our visual language because it has become our style, what we have learnt? What Georgia refers to as 'subverting what you learn' is exactly this. You have to be on your guard to always challenge your own assumptions. Georgia Hayes

Feather Weight Champion
by Georgia Hayes
(oil on canvas).

values awkwardness in a painting. She has come to realize that this is a quality that maintains and nurtures the artist's engagement with the process of creating an image. Traditional ideas of craftsmanship and crafted beauty, tidied and refined, do not interest her.

An onlooker might feel the approach to be destructive or deliberately ugly but this is a misunderstanding of the situation. The whole reason for this subversion is to keep the game in play, to prevent stalemate, to remain receptive to seeing the image that the painting wishes to become. It is important to strive for an image that comes into its own, with strength and independence. The arrival of the final image will most likely bury much of the previous attempts, leaving just traces and ridges. As the quote from Philip Guston suggests, often you can work for days or weeks on a painting for it to be covered over, in the end, and reworked in the necessity of finding the image.

It is the most difficult moments – when the work looks boring or one is a bit stuck – and you decide to let go. It seems like you are throwing a dice, win or lose, could undo everything, risking everything – these are the moments which can turn something ordinary into something extraordinary. Without them the work often seems pedestrian.
Georgia Hayes [50]

Using your acquired skills is essential. Building on these is important too but treating them as a failsafe, fixed repertoire soon dulls their impact. You lose your ability to create images that have particularity and freshness, which is brought about by risk-taking. You have to work with confidence even if you do not feel confident. Reach for the primitive again. Play with your hands to find that child's inquisitiveness within you. Remind yourself of your individuality through your touch and a lack of self-doubt.

Belgian Painting: Cloven Shoes **by Rose Wylie (oil on canvas).**

Ordinary Yet Extraordinary

My first meeting with Rose's painting *Cloven Shoes* was a 'visual shock'. The 'red legs painting', as I always called it, was the first painting I saw as I walked through the door of the gallery and was my first experience of Rose's work. My general appreciation of painting was much more conservative at that time and I was both baffled and uplifted by those outrageously wonderful red legs and shoes. I started asking myself, 'Why did she only paint the legs?' Then in the same breath I thought, 'Why not, when just legs and a great pair of shoes can have so much impact and personality?'

I remember my colleague, Gail Elson, giving a talk about her own work to a large group of students and at the end of the talk offering the opportunity for further questions. I can vividly recall one rather indignant lady asking her why she did not want to do 'proper' drawing and painting. The implication being that Gail's direct and unfussy approach, without its apparent use of measuring, tonal shading, perspective and realism had considerably less merit than work that appeared polished and crafted in a traditional manner. If that same lady had been confronted by Rose's 'red legs painting' I think she would have been equally dumbfounded. I know that even some of my most experienced students still find the work of Rose Wylie, Roy Oxlade and Georgia Hayes difficult to take on board. If you share similar thoughts and feelings when looking at work of this nature then suspend your judgement. Remind yourself of the children's drawings in Chapter 6 and of the artists' desire to free themselves from the habitual, repetition of stylish tricks.

Uncomfortable but memorable

If I am describing Rose Wylie's paintings to someone who does not know them I start by telling them about my experience of the 'red legs'. It was a 'penny dropping' moment and recognition that a piece of work could disarm the viewer. It made me question my own playfulness: how much I was relying on attractive, gestured marks and colours to cover up a lack of real connection to my subject? If they were stripped away, what would I have left? I doubted that there would have been enough there to make a striking, memorable image. Was there any poetry and humour in my bones? I felt uncomfortable, not because her painting was uncomfortable but because I suddenly felt exposed. I had recognized something in her painting that was missing in my own work.

Rose is not making fun of the viewer. She is not superficially trying to be irreverent or rebellious in the way that she paints. She is painting for herself, using imagery in a way that brings the particularity of the subject back to her. She is aiming for a likeness in the most direct way:

While the Surrealists used dreams as a direct route, unprojected to their image making, I like the non-arty common ground of whatever it is that stereotypes come from ... this isn't rebellious on my part, it is a way I like to work and you need a way to work: I like accessibility and inexpensiveness.[51]

It is wonderful that an artist should grab onto the taboos of working with a cliché with such relish (as I discussed in Chapter 3 in connection to Rose's drawing of her niece). Embracing this and making tough and contemporary paintings in the way that Rose does is challenging and demanding for both the artist and viewer.

A Contemporary Venus

Gail Elson always uses her first-hand physical experiences to inspire and generate her work, as her paintings shown in Chapter 4 demonstrate, where she was dressing up to enable her to transfer the sensation of wearing the clothes into the paintings.

Letters from a Monastery I **by Gail Elson (oil on canvas).**

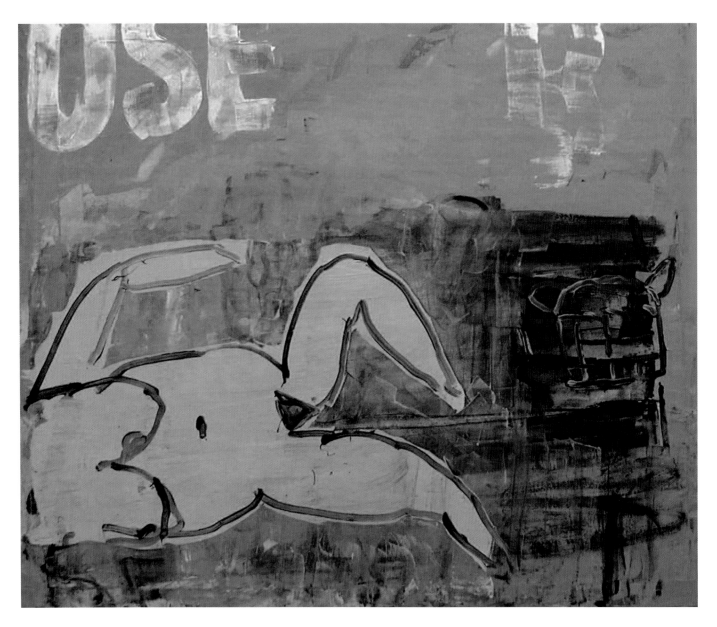

Ose **by Roy Oxlade (oil on canvas).**

I asked Gail how, when she is working from such a close subject, she knows when a painting is working or resolved:

> I just know that the work feels good. Words and concepts
> fail paintings for me. It is a visual language and I use my
> own sensations to give a reality and integrity to the work.
> How it feels is the true test.[52]

Letters from a Monastery share this approach but have an added passion and presence. This time there are two undressed figures, intertwined and embracing.

The forms of the two bodies merging together, loving and lingering, are wrapped like a blanket in sensual, soft layers of marks – like the tingle and softness of skin, the flutter of excitement and sexual pleasure. Their forms remind me of the *Venus de Willendorf*, with the focus given only to the heads, torso and tops of the legs. Like the Venus, the coupling of the two forms creates one generous and voluptuous body shape. Gail ornaments the body with multiple flower-shaped genitals and mouths. The paint is applied thickly and lusciously, with each brush mark wrapping and revealing the closeness and clinging of the bodies.

They are beautiful, physical paintings. They are erotic but that is not your first impression when you first see them. It is the closeness, tenderness and sadness they convey that I feel most of all. The paintings are about a secret, intense love affair: one that could not continue.

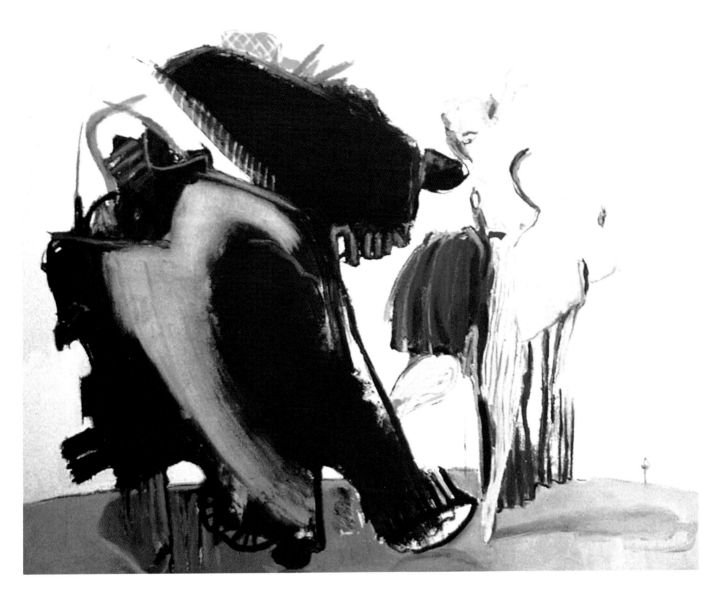

Go On: Take a Risk!

As She Stepped Into Her Car She Smiled At Her Reflection In The Wing Mirror **by John Skinner (oil on canvas).**

I want authenticity, clarity, and a certain peculiarity.
Roy Oxlade [53]

Every artist represented in this book is used to the idea of changing their work in order for the image to evolve but Roy Oxlade, perhaps more than any of them, embraces the coming and going, the changing, scraping and reapplying of the paint and image in a vigorous and generous way. He does not cover his tracks; in fact, he makes a feature of the struggle and the rehashing. Every scrape, drip and edit contributes to the success of the image. He ignores none of them. What is even more impressive is that he allows the painting to call all the shots. Although he may start out with a figure in a studio, with all the paraphernalia and their resident natural colours and positioning, he feels in no way tied to this arrangement, the colours or even the subject.

129

He may put in the figure and objects initially but instead of slavishly working the objects around the figure he may decide that the colour and space does not need the figure and will remove it. He is ruthless yet sensitive to the needs of the painting:

> Perhaps the process could be described as an attempt to provide a coloured environment for the subject. If the subject doesn't fit, I make changes to the 'environment' – the organization of the canvas. That's one way. The alternative is to maintain the environment and look for another subject.[54]

In the painting *Ose* any visible structure of a room given by objects, reference to edges of furniture or corners of the room do not exist, whereas perhaps they did at one point. All that remains after the layers of painting, scraping and repainting is a headless pink figure, spilling off beyond the space of the canvas, with some large lettering and a strange basket-like object. I love the figure. I like its shape and awkwardness, its scraped irregular edges of pink, with the image disappearing beyond the edges of the canvas. I can tell that Roy Oxlade has scraped back a pink figure shape and then drawn the figure on top of the pink not the other way round. I like the almost collage-like quality of the scraped edge. The flat, opaque, pink shape feels full of form, fleshy and naked against the scraped, blurred history of the previous rejected arrangements. Roy Oxlade is non-sentimental about the subject matter and the process of creating the painting and produces striking and beautiful images.

Mythic and Modern

There are a unique combination of qualities and themes that have come together in the painting titled *As She Stepped Into Her Car She Smiled at Her Reflection in the Wing Mirror* by John Skinner. It feels like a coming together of many different strands of thought and experiences that had been bubbling away for some time. There are two forms in the painting, one is a car and the other a female figure. Both have been through a complete makeover to transform them from the recognizable car and woman to figures that carry mythic properties, loaded with many more associations and possibilities. The bubblegum-pink figure is, in fact, a Nereid, an image of the sea: '...like an ancient Greek goddess a personification of the sea, alas there is no ancient Greek personification of the car so I had to invent one'.[55]

This potential for images to give form to mythic qualities is liberating and poetic. What is really happening, as it does in the Greek, Roman and Egyptian myths, is that the artist has the opportunity to create images that give form to forces and events that are too complex and layered to be explained logically.

Without the mythical explanation and imagery the wonder and spiritual significance of an experience would be lost. For example, we now know that the sun does not actually set in the sky – it is the earth that turns. However, in Egyptian mythology their explanation of the phenomena of the glowing red sun sinking in the sky at the end of each day was Ra, the god of all light and life of all things, sailing his fiery sun boat. The image of a sun boat sinking in the sky captures the imagination and gives a magical and memorable form to the unexplainable. To give it form keeps it in our consciousness and gives it significance and context. It makes it more real to us. It deepens our connection and understanding of where we fit in the great scheme of things.

After discovering the Greek myth of the Nereids, John became irrationally frightened to swim in the sea for fear of one of the goddesses reaching up a hand from the dark depths and grabbing his ankle to drag him below. Until, that is, someone suggested to him that rather than grab him, with the intent of drowning him, perhaps the Nereids of the sea wanted to grab him to kiss him! He says, 'I am not physically strong and I don't have a macho relationship with Nature; I suppose I have a much more emotional relationship to the sea.'[56]

John's image of a Nereid evolved through several previous paintings purely devoted to discovering the potential form of a goddess of the sea. In these paintings she has a less recognizable human form but it is possible to see the beginnings of her fleshy shape emerging, her floaty garment, her rising and writhing in the foaming sea. The Nereid standing next to the car feels like she has been poured into the space, she is part of a crashing wave in suspended animation. Pink with lips, breasts and a bottom.

Observation + sensation (+ invention) = portmanteau

Creating a portmanteau (*see* Chapter 1) is the idea of slamming together two different things to create a third new thing. In the case of painting and drawing this can be a combination of sensation mixed with observation. Creating the visual equivalent of a sensation requires invention using the expressive qualities of the paint, layered and reworked until the artist feels a connection with the subject again. What is selected from observation can be tailored and attached to the painted sensation to clarify its form. The resulting image is like the original subject but also not like it. John Skinner achieved this to create the motif of the Nereid and the car. Although it does not look like a 'car' as we know it, the wing mirror, the hubcaps, the shiny red paint and the hinged opening part of the overall shape – revealing some kind of seat and steering wheel – all hint strongly at its origin. It feels like it is hard, heavy, powerful and potentially fast and

ABOVE: *In the Street* (acrylic) and (RIGHT) *In the Country* (pencil)
by Gary Goodman.

fumey. So the flip side of the awe and poetry, the modern twist in contrast to the classical Nereid of the sea, is the metal beast of the road.

I love the situation implied by this painting and its title, and the glamour and character given to a car, more animal-like in its character and physical assembly than machine. The whole painting is a portmanteau, too. By putting two mythical motifs together in one painting John has created a whole new concept: the Nereid's elegant pink limb stepping forward to get into the car, with the car bending forward to greet her and assist her to glance in its wing mirror. There is a humorous, reciprocal relationship implied. The goddess of the sea is not sailing a fiery boat across the waves; she is about to get into her fast car and go for a drive.

An Internal World

I first met Gary Goodman in 1992. I was working as an exhibition organizer and I came across his work in a group show for which I had been curator. I remember visiting his studio in Brighton, a cluttered space full of strange but wonderful flat cardboard sculptures of weird beasts and figures, tabletop scale and colourfully painted. They were the stuff of scary children's stories, painted in a direct and childlike way with the heads exaggerated, the hands larger than life and the bodies dwindled and deflated. This flattened world was also where Gary liked to be in his paintings.

All of Gary Goodman's work has a slightly sinister fairy-tale quality. The world of his paintings is sometimes a wooded landscape or a white space with figures meeting. There are recurring motifs and each of them feels as though it has symbolic meaning; metaphors for emotions and events, ways of resolving unexplainable dreams and nightmares. Although they appear to be completely fictional they are also autobiographical. They are about accepting the torments of life. His images have many different combinations of trees, woodland, girls, birds and beasts. Many seem wistful and sad, but they are playful too. They reveal Gary's gentle melancholy and dry humour. They are also inextricably connected to his love and fears for his eldest daughter who was born with an incurable metabolic illness, a fact that he has never chosen to hide. The girl in his work often represents her.

Gary Goodman is aware that viewers of his work do find it sometimes too sad and wistful to feel comfortable with it, but he does not respond to his work in the same way:

> There is often a contradictory and usually very strong response to my work – not simply that people either love it or hate it; it's more about them saying that they really connect with it and like it but couldn't actually live with it because it's too sinister, or too scary. I think that's fair enough, but my own feeling is that they are a bit more wistful than people imagine and are actually genuinely funny – they make me laugh anyway.

In 1997 Professor Norbert Lynton wrote in an essay about Gary Goodman's work:

> We are not very good in this country at accepting pain in art (it is a fact that Goodman has a wider public for his art in Germany, with its experience of Expressionistic modes in art, music and literature, than in Britain). ['Gary Goodman: A Carnival of Sadness'][57]

Gary Goodman responds to life and painting emotionally not intellectually. He is intuitive and non-judgemental. He does not plan and he does not fight it. On the wall of the studio where I and my team of tutors – Gary being one of them – teach we have a board to stick up scraps of paper with 'wise words'. There are many wonderful erudite quotes from famous artists that students have put up. Gary stuck a small, modest piece of paper up there saying: 'Art, Just do it!' It's succinct. It cuts out the navel-gazing and says what we all know we should do:

> Where's the magic in constant analysis? It's the same with painting – I'm not sure where things come from and I'm not too keen to find out – I'm intellectually lazy. I want to feel my way through life.[58]

A Circle of Life

Katie Sollohub's large drawing entitled *Circle of Life* has a direct autobiographical reference. This unusual and beautiful charcoal drawing began its journey as an idea of exploring story and narrative. Two concentric circles lead you into the very heart of the drawing. Along the way are images that reference the activities and objects that represent the lives of two different people who never met. Katie had initially created work about her daily journeys to the station and she had painted these works onto old music records – partly as an experiment to work on different surfaces but also because she was interested in the way a circu-

lar space could hold a story in a different way to a rectangle or square. As a record, it could spin around its centre point, with no up or down motion. No beginning or end. It seemed to fit with how she sees things:

> As this project developed, I was also reading my Grandmother's memoirs, about her growing up in Imperial Russia, her marriage, her life, her children, her escape from the Russian Revolution. I wanted to make a piece of work about this, but fit it into my own autobiography. I had never met my grandmother. She died before I was born. I worked out a way that two spirals could fit together inside a circular drawing, spiralling one inside the other, each starting from different points on the outside edge of the circle, and finishing at different points in the centre, back-to-back. As if parallel, never meeting. So our two journeys begin, each with a footprint: hers booted in the snow, mine barefoot, as I used to be so often as a child. Our lives spiral inwards towards the centre; some things echo each other – our love of horses, our pets. In the centre of the circle, we sit back-to-back, she writes about her life, and I draw mine.[59]

Katie Sollohub enjoys the challenge of creating new ways of seeing and unpacking things. She does this by using limited materials, constructed structures or a restricted process. This prevents her from being overwhelmed by choices. It grounds her so that her mind is quiet and receptive only to making visual and intuitive decisions for the needs of the work. So even though this drawing appears complicated and packed with imagery, Katie's unusual format and invented process have allowed her to play freely and cleverly with the space and subject.

Choices

The different 'take' that people have on things is what makes expression, creativity and communication so fascinating and challenging. This chapter has provided a window into thought processes of a selection of artists at a given point in time. However, none of these artists feel that they have 'arrived' or are self-satisfied with their expertise. They are driven to extend their knowledge of the medium of paint and the processes they can use with it in order to continue to respond to the world around them in a poignant way, in a way that gives them meaning.

The most important point to take from this chapter is about the choices you make for your work. Your choices will affect not only how your work will look now but also how it will develop in the future. If you choose to make it an important part of your

An Autobiography **by Katie Sollohub (charcoal).**

life then the more time you devote to it the better it will become, the more fluent and tuned in you will be. You have to choose what interests you about painting and how to focus on a subject that does not just skim the surface or become pedestrian. Along the way you have to choose the right moves to change your work. Most challenging of all is the choice to not compromise the way the painting needs to look.

If you choose not to play safe with your work then you are guaranteed some wonderful discoveries and surprises – but they will be mixed with lows and frustrations too. The gains always outweigh the losses, though. Be ambitious, courageous and generous with yourself and your work will reward you.

La Cornichienne Does Her Exercises **by John Skinner**
(oil on board).

OPEN THE DOOR

'You are an artist.' You have had a chance to read and hopefully to try out some of the exercises but I am aware that at the end of Chapter 7 I left you in a scary place, dropping a small bombshell in your lap by saying that even with all of these resources there will still be lows, frustrations and even despair that creeps in. Having led you to this point, where I hope that I have demystified the process of moving away from copying and illustrating, it would be irresponsible of me to leave it here. I need to tell you more about the moments of despair and how to deal with them.

Desperation

At times in every body of work there are moments of despair. These are triggered by boredom with one's work and frustration. The frustration can often be caused by the apparent failure of an idea to work or the loss of contact with the original source of inspiration. At such moments these feelings are not just mild annoyance and irritation because the work will not come together. They can bring about paralysing desperation and a crushing loss of confidence. My experience of this with emotional students has lead to uncomfortable situations such as the student bursting into tears, running out of the room, stonewalling me and being defensive and verbally aggressive. This may sound very melodramatic to someone who is not developing their creative practice but if you talk to any artist who is serious about pushing their work forward they will instantly empathize with this situation.

The chances of these feelings arising are increased when you make the leap of wanting your work to be a poetic response to a subject as opposed to copying what is in front of you, or only working with a repetitive, manicured style. The exercises in this book give a sense of purpose, a meaningful structure to discovering what your response can look like. Simultaneously they can reveal that there are infinite possibilities and outcomes that can, at times, feel unattainable. The feeling of being tongue-tied, inarticulate and lacking the skills to invent new solutions can be unbearable. The good news is that this uncomfortable situation and the feelings of despair can trigger a response that turns a negative situation into a positive one. Rather than just being the inevitable dreaded by-product of creativity, frustration features as an important motivating force, releasing the artist from self-imposed constraints and ideals. One of my tutors at college was the first to make me look at the situation positively by saying that if my painting was really bad then what did I have to lose? Just rework it. I found this anti-preciousness very liberating.

> You only work well when you are desperate...
> **John Epstein** [60]

This chapter acknowledges that such feelings of dissatisfaction with yourself and the work are inevitable, and often necessary, during the process of creating work that is meaningful to you. When I am teaching there are many occasions when I feel that students shy away from confronting this uncomfortable point in the development of their work. They are either too scared of losing what they have or too satisfied with something that is competent but missing an essential quality that lifts it to something extraordinary and surprising. Hearing that professional artists struggle too does not necessarily ease the frustration of resolving your own work, but it is always good to know that you are not alone. In fact, what you are feeling is expected if you are passionate about what you do.

Good but not good enough

I asked John Skinner about his experiences of this sense of desperation:

Bar du Theatre Sete, 03/05/07, 9hr
Last Thursday I left home for the studio having said to
Mary that I was going to f — up my most recent painting.
I had been working on it every day for a month and it was

Goodman NOV. 01 4/8

LEFT: *Everything's Upside Down* (acrylic) and (RIGHT) *Vision in the Sky* (acrylic) by Gary Goodman.

courage to change your work. What John says about a piece of work being 'good but equally not good enough' rings true. If after a day of working on a painting it does not give back to you the feeling of the subject then it has to change. If it is too vague, stylized and a repeat of everything else that you have done previously then it also has to change. However, you have to be able to see and make that judgement about what the painting needs. This requires experience through practice and time spent with the work, with plenty of occasions when you get desperate and dispense with the rational and logical approach.

When I talked to Gary Goodman about those tricky creative demons he explained:

> I am fully conversant with the idea of the 'Oh, f— it' moment – however that moment usually lasts from the beginning to the end of each and every painting nowadays. It's actually rather liberating to have an empty mind as well as an empty canvas ... I don't want to stalk it I want to attack it immediately ... My preferred attitude I guess is one of not caring too deeply about something that I care very deeply about indeed, just to make myself feel less emotionally b—ed and enmeshed.[62]

When you let go of your desire for the painting, as a result of despair or a need to feel liberated, you allow the work to find its own voice. You can revisit the subject with fresh eyes. It rejuvenates a forgotten closeness and allows you to make fresh connections through your language with the paint. The paralysing spell is broken and you are off again, discovering your subject through the painting.

nearly there, like a bus arriving. French friends of mine had all looked at it and were nodding and smiling. One even said in English, 'You are a f—ing good painter.' I smiled and we nodded in unison as though dancing or singing rhythmically like a poem, a gathering of spirits. We all agreed the painting was good, it pleased us, but... I knew that it was good and equally not good enough.

Ah, f— it! So what, it is just paint on paper like all the rest.

So last Thursday I walked into the studio. Maybe if I just add a bit of blue here or ... or ... hoping that it would somehow just come right. Then I just attacked it, obliterating large areas. Working fast, extemporising, painting, f—ing it up big time.

I have been away since then and it is there on the wall in the studio waiting for me.[61]

The emotional roller coaster on which a painting can lead you is often baffling and extraordinary. It is testament to the potential of a work of art to move you in its making but also in its resolution. It requires an uncompromising single-mindedness and

Positive Action for When You are Stuck

It can be good just to improvise on your work but if this does not come easily perhaps you can give yourself a strategy for coping, getting focused and avoiding your old habits. My more experienced students and I came up with a list of things to remember when inspiration and confidence seem to seep away:

- Be patient with the work and yourself. Do not expect instant results. Ideas and images will unfold gradually.
- Do lots of studies as preparation for your paintings.
- If there are several elements to the painting then look at them individually. Do studies exploring their qualities to find a visual language that fits.
- Revisit the original subject. Ask yourself specific questions about what really interests you about it.

- Inspire yourself with visual information: work by other artists, visits to a gallery or museum, images from magazines, television and personal or found objects.
- Try and see the whole painting for what it is not what you had hoped it would be.

Change is inevitable and necessary

- All changes should be made positively and confidently, without hesitation.
- Change your tools – new brushes, rags or trying using your fingers could add a new quality to the marks and also connect you to your subject again in a more direct way.
- Change the pace at which you work – either slow down and look more than you paint or speed up the way you work to give you less time to think (but remember to stand back regularly).
- Alter the physical distance and orientation of the painting to you, perhaps on an easel, put flat on the floor or on the wall.
- Colours do not have to be limited to the colours of the original subject. Try an unexpected colour that is not harmonious with the rest of the image, or a colour that you do not like.
- Composition can change – move elements around, overlap them and change their scale in relation to each other.
- You can repeat motifs many times to help unify the image.
- Throw in a new motif using the 'pick and plonk' method.
- Put space and fresh air back into the work.
- Always insert your corrections before you take away your mistakes. You may end up rather liking the history of changes and could find a new form from them.

Be clearer

- Make drawings from your painting to help you stand back and study what is working and what needs attention.
- Make a list about the tactile qualities of your subject.
- Emphasize only what you are interested in.
- Remove unnecessary clutter – edit areas of the painting that seem superfluous and then develop what you have remaining.
- Work in a series – use several versions of the same subject to test out the image and the visual language.
- Make small three-dimensional models of the painting or the subject so that you can work directly from something physical in front of you again.
- Use props that you can touch, hold, wear and observe to feed fresh information back into the painting.
- Be courageous and trust your judgment.

Find ways of clearing your head

- Go for a walk.
- Take attention away from your head (the concepts and intellectual analysing) by making something with your hands a collage, a cutting and sticking arrangement, and so on.
- Read a book or some poetry.
- Do twenty fast ink studies or drawings (of only two to three minutes each).
- Revisit the mark making and experiment with the paint and mediums with no attempt to make it into an image.
- Go with the paint and enjoy the game.
- Stop worrying about what others might think of your work.
- Invent new solutions.
- The answers are in the painting. Sit and look at your work more.

Finding a New Level

Throughout the months of writing this book there has been great generosity from each artist and a sharing of experiences in relation to the areas I felt were important to cover to make this an informative book – a book that would give courage to those that would like to take risks with their work, one that could help artists move away from the more conventional approach but feel a sense of purpose and structure to their journey. I began this book by acknowledging the influence of the writing of John Epstein concerning the importance of touch to help you see, understand and extend the potential visual language of response. His words opened a door to the potential of trusting your judgement, being generous with yourself and finding out about what you are painting as you go along. Your job now is to build and extend your own visual language and your capacity to recognize and use what you discover along the way.

As artists we are not setting out to paint what we already know. We are not setting out to shock either. We are making a response to the world around us in a vital and poetic way, guarding against superficial niceness, cutting through the barriers of culture and language to produce universal images. It is a language that everyone can receive and to which all can respond. Indifference to something is the most damning response of all. Better to stir some reaction with a painting. Better still for the effect of seeing a painting to stay with you and for the experience to change the way you see something.

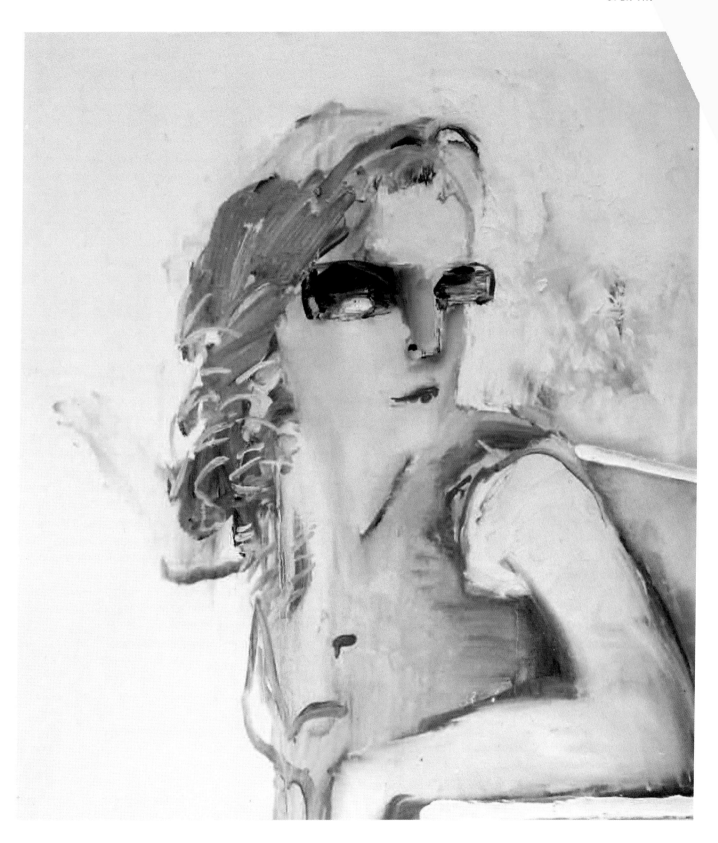

Film Star Emily by Emily Ball (oil on canvas).

REFERENCES

1. Epstein, John, *Drawing from Life: A Selection of Drawings and Essays* (self-published, 1980).
2. Ibid.
3. Jacobson, Howard, with preface by John McDonald, *Seeing with the Ear* (The Claridge Press, 1993), p.4.
4. Personal communication with the author, 4 April 2008.
5. Hudston, Sara and John Skinner, *Switch Off the Light and Let Me Try on Your Dress* (Agre Books, 2002), p.33.
6. Gaudin, Colette, in 'Foreword', Gaston Bachelard, trans. Colette Gaudin, *On Poetic Imagination and Reverie* (Spring Publications, 1998), p.lvii.
7. A phrase used by John Skinner when he was teaching. He sometimes did his 'crap into gold' lecture when his students were in the doldrums about how bad they thought their paintings were.
8. Rae, Fiona, The British Art Show catalogue (The South Bank Centre, 1990), p.92.
9. Carroll, Lewis, *Alice Through the Looking Glass and What Alice Found There* (Macmillan, 1995), pp.126–7.
10. Georgia Hayes, personal communication with the author, 30 October 2007.
11. Henri, Robert, Art Spirit (Iconic Editions, 1984), p.26.
12. Fuller, Peter, 'Rocks and flesh', Foreword to exhibition catalogue, Norwich School of Art Gallery, 1985, p.7.
13. This is a reference made by Francis Bacon when he talked about his interest in the mouth in his paintings in an interview with Melvin Bragg, South Bank Show (dir. David Hinton), 1985.
14. Personal communication with the author, 11 April 2008.
15. From an essay by David Harding commissioned for the catalogue of the exhibition 'Arts: The Catalyst – Craigmillar', City Arts Centre, Edinburgh, October 2004.
16. Curtis, Gregory, *The Cave Painters: Probing the Mysteries of the World's First Artists* (Anchor Books, 2007), p.12.
17. Personal communication with the author, 5 May 2007.
18. Powell, T.G.E., *Prehistoric Art* (Thames and Hudson, 1966), p.17.
19. David Sylvester in interview with Francis Bacon, *Arena* (BBC Television, 1984).
20. Jacobson, *Seeing with the Ear*, p.18.
21. Personal communication with the author, 8 February 2008.
22. Ibid.
23. Personal communication with the author, 4 February 2008.
24. Ibid.
25. Ibid.
26. Taken from unpublished text that accompanied my MA exhibition at the Surrey Institute of Art and Design, May 1999.
27. Flam, Jack. D., *Matisse on Art: Notes of a Painter* (Phaidon Press, 1973), p.37.
28. Bachelard, *On Poetic Imagination and Reverie*, back cover.
29. Jane Nash, unpublished text that accompanied my MA exhibition at the Surrey Institute of Art and Design, May 1999.
30. Merleau-Ponty, M., trans by Colin Smith, *Phenomenology of Perception* (Routledge, 1998), p.243.
31. Epstein, *Drawing from Life*.
32. Personal communication with the author, 22 February 2008.
33. Ibid.
34. Personal communication with the author, 4 February 2008.
35. Personal communication with the author, 5 May 2008.
36. Ibid.
37. Ibid.
38. Personal communication with the author, 4 April 2008.
39. Ibid.
40. Ibid.
41. Epstein, *Drawing from Life*.
42. Personal communication with the author, 4 April 2008.

43. Ibid.
44. Personal communication with the author, 4 February 2008.
45. Personal communication with the author, 5 May 2008.
46. Personal communication with the author, 7 May 2008.
47. Ibid.
48. Ibid.
49. Mayer, Musa, Night Studio: *A Memoir of Philip Guston* (Da Capo Press, 1988), p.83.
50. Personal communication with the author, 7 May 2008.
51. Personal communication with the author, 5 May 2008.
52. Personal communication with the author, 6 May 2008.
53. Personal communication with the author, 1 April 2008.
54. Ibid.
55. John Skinner, personal communication with the author, 23 March 2008.
56. Hudston and Skinner, *Switch Off the Light*, p.28.
57. Gary Goodman, taken from an essay written in 1997 by Norbert Lynton about Gary's work.
58. Ibid.
59. Katie Sollohub, personal communication with the author, 11 April 2008.
60. In reference to John Skinner's memories of John Epstein's teaching mentioned in the introduction and the title of a photocopied sheet handed to him.
61. Personal communication with the author, 7 May 2007.
62. Personal communication with the author, 12 May 2008.

INDEX